PRAISE FOR THE WORK OF FRANCENE HART

"Francene Hart provides us with powerful and compelling images for personal divination. She has created very good medicine indeed."

HANK WESSELMAN, PH.D., ANTHROPOLOGIST, AUTHOR OF
THE RE-ENCHANTMENT AND THE SPIRITWALKER TRILOGY,
AND COAUTHOR OF *AWAKENING TO THE SPIRIT WORLD*

"Francene Hart sees and paints what is glorious about life. She puts one into a space of timeless wonder."

SONDRA RAY, AUTHOR OF *ROCK YOUR WORLD*
WITH THE DIVINE MOTHER

"Francene Hart's evocative imagery combines geometric symbolism with complementary, soothing art to provide a cosmic glimpse into the universal consciousness."

RETAILING INSIGHT

"Francene Hart encourages you to look into your own life as well as the larger patterns of the universe in order to better understand your situation and connection to the world. Her majestic watercolors are spiritually inspiring"

FEMINIST REVIEW

SACRED GEOMETRY
of NATURE
Journey on the Path of the Divine

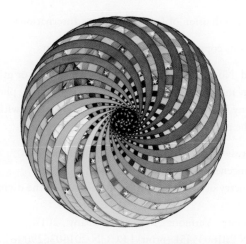

Francene Hart

Bear & Company
Rochester, Vermont • Toronto, Canada

Bear & Company
One Park Street
Rochester, Vermont 05767
www.BearandCompanyBooks.com

Bear & Company is a division of Inner Traditions International

Library of Congress Cataloging-in-Publication Data
Names: Hart, Francene, 1948– author.
Title: Sacred geometry of nature : journey on the path of the divine /
 Francene Hart.
Description: Rochester, Vermont : Bear & Company , 2017.
Identifiers: LCCN 2016035451 (print) | LCCN 2016036290 (e-book) |
 ISBN 9781591432739 (hardback) | ISBN 9781591432746 (e-book)
Subjects: LCSH: Hart, Francene, 1948- | Hart, Francene, 1948-—Themes,
 motives. | Spirituality in art. | Watercolorists—United States—Biography.
 | BISAC: BODY, MIND & SPIRIT / Inspiration & Personal Growth. | BODY,
 MIND & SPIRIT / Spirituality / Shamanism. | ART / Individual Artists
 / General.
Classification: LCC ND1839.H375 A2 2017 (print) | LCC ND1839.H375
 (e-book) | DDC 759.13—dc23
LC record available at https://lccn.loc.gov/2016035451

Printed and bound in India by Replika Press Pvt. Ltd.

10 9 8 7 6 5 4 3 2 1

Text design and layout by Priscilla Baker
This book was typeset in Garamond Premier Pro, with New Aster and Futura
used as display typefaces

To send correspondence to the author of this book, mail a first-class letter to the
author c/o Inner Traditions • Bear & Company, One Park Street, Rochester, VT
05767, and we will forward the communication, or contact the author directly at
www.francenehart.com.

CONTENTS

LIST OF PAINTINGS

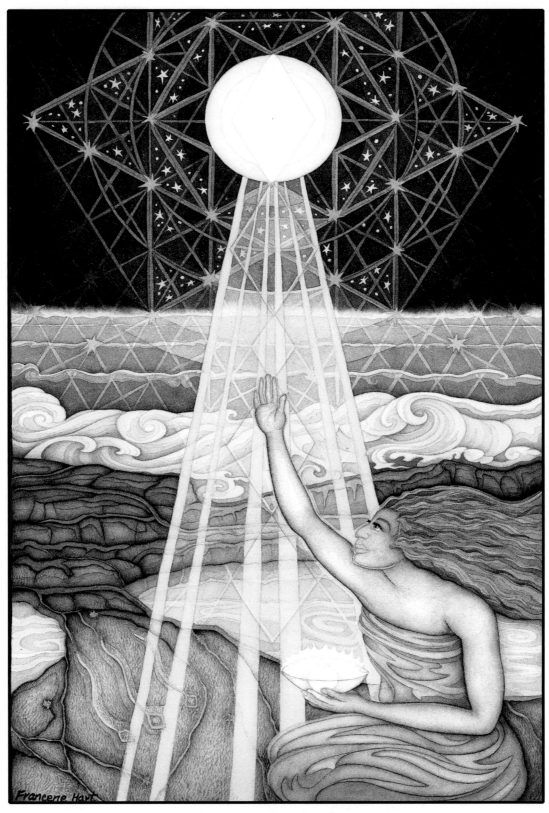

Replenishment, 2016

This piece was inspired by Ka Lae, the southernmost point on Hawaii Island,
a place said to be like a rift in time. The figure replenishes her bowl with
light from the full moon. Embedded in the scene is cosmic grid geometry.

INTRODUCTION

Artists become visionaries by looking beyond themselves and the society in which they live to cultivate their instinctual creative spark. Creating and living with foresight and imagination assures a visionary path.

This is not limited to artists. Each and every one of us has the potential to receive visionary experiences and integrate them into our lives. It is our innate ability to connect with our intuitive center that guides us to fulfill our unique soul's purpose.

Sacred Geometry of Nature: Journey on the Path of the Divine is the unfolding account of my passage as a visionary on the physical plane. I have been privileged to be able to follow my bliss and realize my dream of making my way in the world as a fine artist. The universe has given me paintings and narratives as a way to share my visions reflecting collective mind and cosmic creativity.

My lifetime has been one of passionately choosing and pursuing adventures that stimulate and inspire the creation of art. Nothing has been more dear or certain.

This book is not intended to be a narrative of an individual ego; rather it describes how I, like many artists before me, have sought out magic, mystery, and experiences that inspire.

The ongoing quest for inspiration is an enormously moving adventure. Vision has its own life and vitality, which, when consciously tapped, can yield extraordinary revelations. I am honored to participate in the process of interpreting and translating vision into artistic form. This is the path I was always meant to follow.

It has, however, taken years of effort, exploration, and finally, acceptance of this path as a sacred responsibility to feel the depth of the mission.

Nature, spirit, and sacred geometry have been my primary themes.

Travel, visioning, and divine guidance have supported the purpose of my art.

The telling of stories changes as time goes on and life experiences color memories of earlier adventures. As stories evolve, they shift and transform. This adventure is guided by creative stimulation and makes little claim to exact facts. Sometimes there is a linear time line, but most parts of this exploration are woven like a tapestry of a series of experiences with enduring themes. Paintings interspersed throughout the book may have been inspired years apart, yet follow lifelong thematic threads.

I will name only a few individuals and exclude exact locations, except where those details feel essential. When I say "we," there will be some who recognize their parts in the experience. Friends and traveling companions may remember some stories differently. I ask only that they appreciate how they helped me to grow and create. I honor each and every one of them and offer gratitude and appreciation for their contributions to my heart and soul, and, of course, to the art.

If I am fortunate, these words and paintings will encourage and support progress toward conscious evolution for those who encounter and are touched by them, as they have for me. Nearly seven hundred paintings have moved through my heart and paintbrush to this date. As I share tales of their conception and how they have inspired my artmaking, the words and paintings continually evolve into something beyond this simple artist's abilities. I humbly ask you to join me on this adventure . . . following the path of the Divine.

FORMATIVE INFLUENCES
Notes from the Beginning

I grew up in the American Midwest. The temperament of the people was kind, honest, and conservative.

My grandparents had been homesteaders, a demanding life that left little time to think about art. Both of my parents wanted to be artists, but life circumstances found them other vocations. However, they both committed themselves to art after retirement. I came into this life an artist, and from first memory I knew that was my calling. No other choice seemed possible.

One of my first art memories, when I was very small, was drawing on the wall of our family home in an alcove in the shadows. I thought no one would find my creation in this dark corner. Of course the light changed and my effort was revealed. Rather than discipline me, my parents set up a space at the dining room table with paper and art supplies. I am grateful that they encouraged my siblings and me to develop our creative interests.

More Than Imagination

As a child, developing a rich fantasy life and vivid imagination felt completely natural. Special places in nature became my private personal domains, my secret gardens. It was there I discovered an ability to commune with nature spirits. Sitting quietly, watching everything in my surroundings, encouraged enchanting

experiences filled with all manner of things I wanted to make into art. Magical encounters were part of that play and were included in early drawings.

I was continually told, "You must have quite an imagination," or "Where do you get this stuff?" My explanation that there is magic in nature and people was not always received positively. I quickly learned it was easier to simply say yes, it comes from my imagination. Using language as a cloak when talking about the experiences of conceiving art felt safer than telling stories that might upset someone. This also helped shield my natural tendency toward shyness and self-doubt.

Growing up in the 1960s, which included such dynamic issues as the civil rights movement, Vietnam War protests, and the fight for gay rights, gave rise to lively and sometimes rancorous dinner table discussions. I am thankful to have come of age in a time that encouraged (or perhaps mostly tolerated) freedom of expression, speaking out for what we believed, and thinking creatively.

I attended art school in the late 1960s. Most of the art I produced during that period, including large acrylic canvases and soft sculptures, would be termed "Abstract Minimalism." Even while producing this work, I recognized that I was consciously trying to fit in to the modern art world. My paintings were gender neutral by intent, largely because few women artists had yet been given voice or recognition. I also studied color theory extensively. This information was fascinating and complex, helping me to become more comfortable with the use of color in my paintings. I learned a great deal, yet continued to feel there was something missing in the direction this art seemed to be heading. It felt empty and unfulfilled, certainly not what I was hoping for in following my heart as an artist.

Experimentation with various consciousness-altering techniques revealed insights into a vast cosmic archive and was instrumental in giving me a sense of being part of amazing changes taking place on the planet. These experiences initiated essential aspects of the visionary process.

Part of this development was some experimentation with

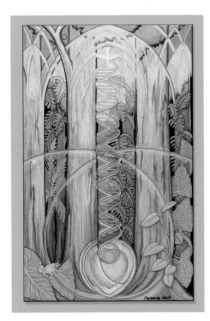

SANCTUARY

Formative Influences

psychedelics, which included a life-defining transcendental experience of knowing I was part and parcel of every molecule in creation. Without doubt the experience birthed a conscious connection to the life flow of the universe. It was a truth beyond anything I'd previously considered. This experience of cosmic awareness initiated recognition of the truth that everything has a living presence and consciousness. We are connected intimate particles of "all that is."

Accepting this certainty as essential truth did not require repeated replication of the experience. Rather the experience became a lifelong reference point, or doorway through which to access universal wisdom. There are many pathways to the Divine, and each visionary develops unique processes for accessing inspiration. I made a deliberate decision to seek inspiration through meditation and visioning, which helped me develop the gift of intuitive visualization. Nurturing these practices to enhance my visions and heighten inspiration attracts experiences that might otherwise go unnoticed.

After I finished art school my family lived in Colorado for a couple of years. There I encountered many alternative spiritual concepts, and began to differentiate their attraction from their craziness. I will not dismiss the sacred paths of other seekers, however much of what was bubbling forth at the time seemed foolish, ungrounded, and ultimately for me, untrue. We each must find our own spiritual path, and personal discernment will help lead the seeker to truths that feel genuine.

At that time I was swept up in counterculture ideas and nearly ready to toss it all away and head for California to be part of the "Summer of Love," when fortunately for my personal development, I became pregnant. The beauty of childbirth and sacred bond of motherhood likely saved my life. Accepting responsibility for this tiny living being permitted me to see beyond my own small existence, bringing me to a much-needed place of genuine personal growth. Living as a single mother for a couple of years helped foster a greater sense of self-reliance and brought forth a willingness to look more deeply into the divine nature of reality.

The emerging feminist movement also captured my attention

at a pivotal time. Opening to that mind-expanding information helped me to mature into an awareness that did not require me to hide or shy away from being a woman, and gave cause to celebrate my femininity.

Experimentation in art and life and a conscious rejection of the politics of the modern art world became increasingly part of my awareness. Examining what I thought was expected of me stimulated a desire to find personal authenticity. I was young and this was a process of individualization. During this time I started a long-term yoga practice.

Introduction to Mythology

An important aspect of both my personal individualization and development as an artist came about when myths and symbols became a part of my reality. In some ways it felt like an extension of the magic I had perceived in my childhood world.

Making Sense of Incongruities

When I first encountered the great mythologist Joseph Campbell, his writings and responses in interviews felt like lightning bolts of truth. His investigations brought together and made sense of cultural and religious incongruities I had wrestled with for years. He presented an interrelated interpretation of the multitude of myths that cultures and religions have for eons utilized as teaching tools. His work helped make sense of my confusion as to how it was possible for so many religions to believe theirs is the one true path. It was as if I'd had a weight of falsehood lifted from my psyche and I was flying.

Campbell's writings helped expand my view of who we are. This important turning point gave rise to a more genuine understanding of the brilliance and diversity of human nature and our interconnectedness.

Finding My Artistic Center

The Sanskrit word *mandala* means "circle and center." In spiritual practices and in psychology, it denotes circular imagery that

is painted, drawn, constructed, or danced. Mandalas are outward expressions of internal processes and can be viewed passively as centering devices or meditations. Individuals may also create mandalas to connect with their core philosophies and perceptions, thus initiating healing and transformation.

Mandalas came into my life at a time when my living situation offered me no space in which to paint. It was a time of extraordinary change and metamorphosis. I fully realized how important this process was and that for sanity's sake it was essential to continue creating. Thus began years of drawing in a journal, working with colored pencils and pens on a daily basis. This is an excellent way to connect with your higher self.

One day while visiting a friend, I saw a reproduction of a beautiful medicine shield from the book *Seven Arrows,* by Hyemeyohsts Storm. I realized I had never produced art in a circular format. This prompted a series of groundbreaking drawings. Working within the circle I was surprised and sometimes a bit unnerved by the images and symbols that surfaced. I had been an abstract artist for years. This was new for me, and it was fascinating. Serendipitously, a Jungian psychologist came to visit my housemate. He looked at my drawings and knowingly stated, "You are creating mandalas," and handed me a copy of a little book by C. G. Jung titled *Mandala Symbolism*. I read the book in awe, my mouth agape. Not only was I creating mandalas, it felt to me as if Jung had written my story.

These drawings launched years of fascination and exploration into the symbolic meanings revealed by mandalas, as well as their interpretation of both the depths of one's individual development and a greater intelligence Jung termed the "collective unconscious."

The painting *Emerging* was the culmination of a series of drawings and paintings created during my initial experiences with mandalas, and is the only remaining example of work from that time. Several of the symbols contained within this painting have remained with me to this day. Water lilies represent our potential for enlightenment. A golden sun orb rises from the field of all possibilities and accents the potential contained

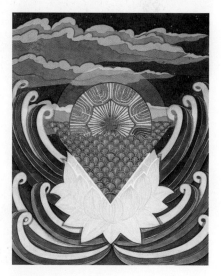

EMERGING, 1973

Formative Influences

7

in the downward-facing triangle, which is traditionally viewed as feminine. Waves enveloping the center represent change. As if emerging from a dream, this painting ushered in something fresh. Looking back to this piece from 1973, it is clear that sacred symbology and geometry have long been developing in my awareness and helping my expansion as a visionary artist.

Following years of personal exploration and self-healing, I began teaching mandala drawing classes to a wide range of people, from art enthusiasts to Girl Scouts, from seniors to gifted and talented programs in public schools. I was also a creative arts instructor for eight years at a treatment center for emotionally damaged teenagers. Each boy would draw a mandala on his first and last day of residence, and we created mandalas as a class once a month. The changes in a student's mandalas were vastly varied and always revealing about their individual development.

Mandalas continue to be part of my creative process and were precursors to future investigations into sacred geometry.

In 1996 I created the *Sacred Round* mandala using the numbers associated with a cycle at the heart of the Maya calendar called the Sacred Round, or *tzolkin*. The calendar is ordinarily depicted as a 20:13 grid, with twenty named days and thirteen numbered days, both continuously repeating. Seeking an alternate rendition, I painted a spectrum of thirteen colors moving as a wave twenty times around the center. It was an intuitive concept based on the sacred name of the calendar. What a delight it was to watch the colors generate this gorgeous pattern.

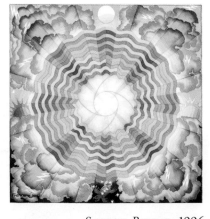

Sacred Round, 1996

Emerging, 1973

A golden sun rises from the field of all possibilities and accents the potential in the downward-facing triangle, traditionally viewed as feminine. Waves enveloping the center represent change. As if emerging from a dream, this painting ushered in something fresh.

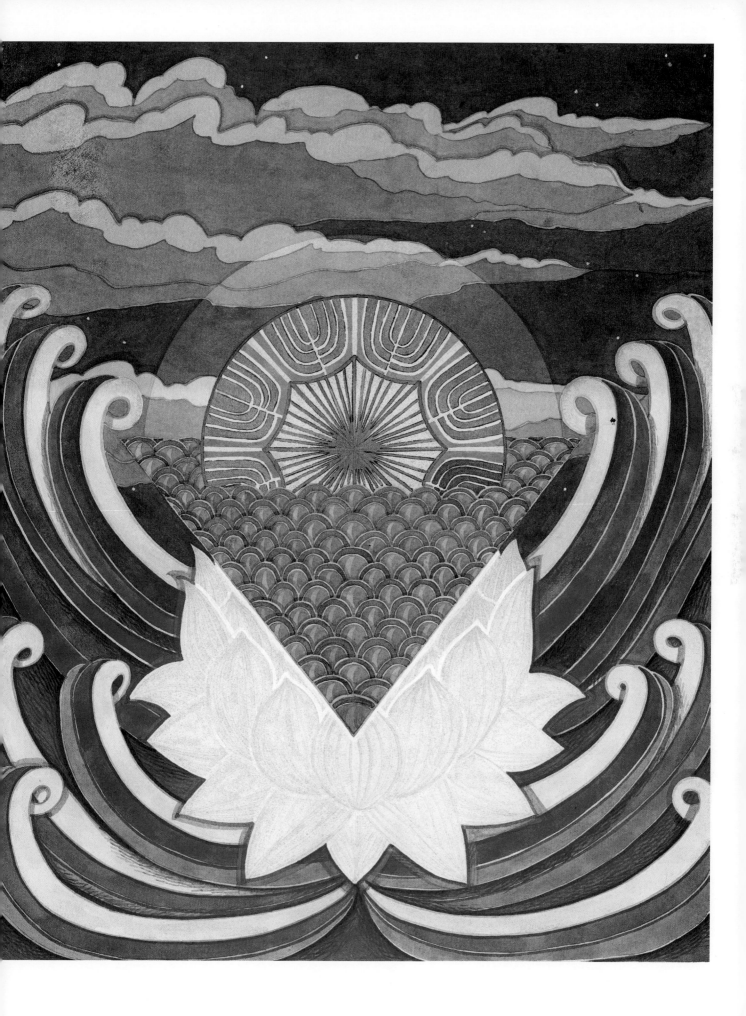

SACRED ROUND, 1996

The Sacred Round cycle in the Mayan calendar is ordinarily depicted as a 20:13 grid.
Seeking an alternate rendition, I painted a spectrum of thirteen colors moving as a
wave twenty times around the center.

In 2013, now living in Hawaii and having recently moved to a different house, I began anticipating what might inspire paintings at this location. Loving to discover what type of birds live in a neighborhood, I always fill several birdbaths first thing. The following morning I awoke to a wonderful surprise. One of the birdbaths was completely ringed, body touching body, with honeybees. I sat on a little stool and watched them drinking, their tiny bodies pulsing rhythmically. After a very short time watching these beautiful bees, a flood of emotion overtook me that felt exactly like falling in love. Inspiration had arrived.

The painting *Bee Mandala* is intended to honor the magnificent honeybees who live in hives and thrive as communities. Their lives and work transform nectar into honey, and perhaps even more importantly, their service of pollination makes food and flowers possible. They are currently under threat from many sources. Their future and ours may be at risk, and we must protect them in all ways possible. The hexagonal shape of the honeycomb is based on the design of the flower of life, a geometrical figure that contains the pattern of creation and is found in many of the world's religions.

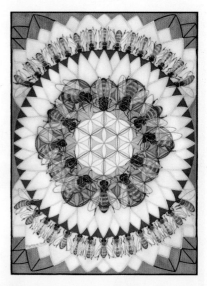

Bee Mandala, 2013

Hexagon

Living in the Forest

In 1977 my family moved to the forest, which was a lifelong dream. I was comfortable on forty acres of northern Wisconsin woods from the moment I first viewed the property. The land, and especially the trees, spoke to me immediately. Walks in the woods became joyful daily exercise and afforded an intimate connection to the forest and its inhabitants. I soon became friends with several very old trees, including a 400-year-old white pine I came to know as my Wise Friend, who was teacher and guide to me for the twenty-five years I lived in the north woods and inspired my painting of the same name.

Ancient trees are wisdom keepers. They hold vast libraries of knowledge, history, and Earth mysteries within their bark and branches. This grandfather tree offered me comfort,

Wise Friend, 1997

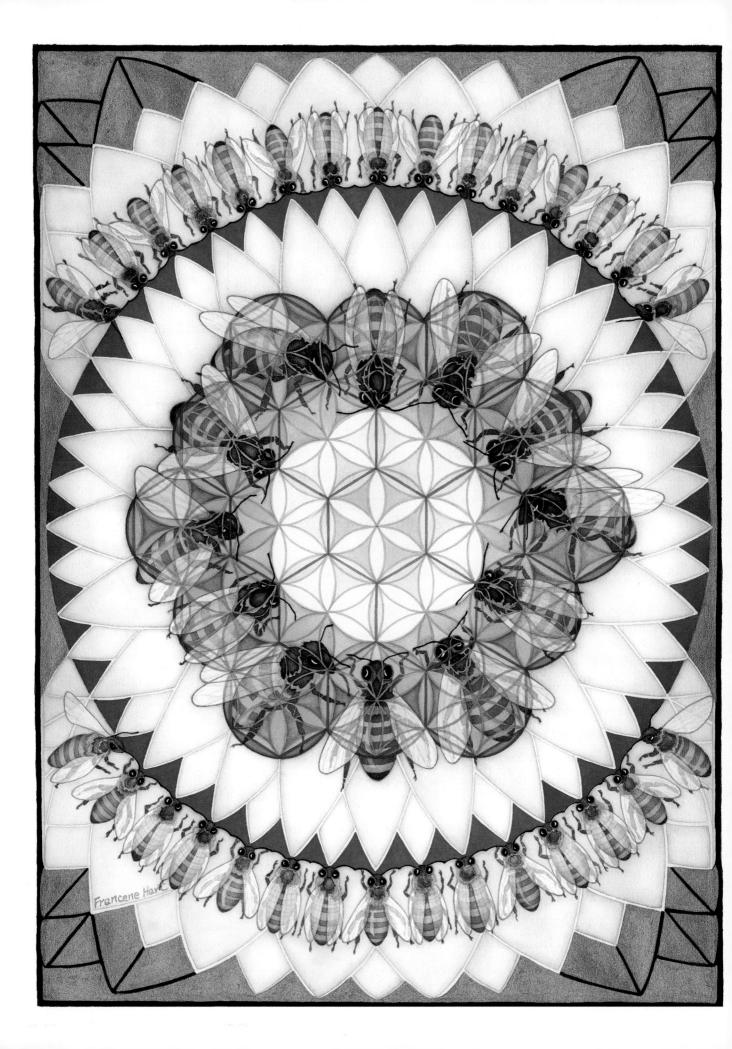

Francene Hart

shelter, and advice. He taught me that I am of the tree people. Being near, touching the bark of this ancient spirit, and listening for messages offered a great deal of information about opening to guidance. This was an observable reference point, one that helped me develop a greater appreciation of the wisdom inherent in nature everywhere. There is crystal geometry in this composition, and four little owls. The garden bench offers size perspective and invites you to sit and experience the wisdom of this great teacher. I acknowledge nature as my greatest teacher.

Crossing Paths from 1993 celebrates other encounters in the forest. As we walk in the woods, or simply along life's path, we occasionally cross paths with other beings, igniting for a moment, or sometimes a lifetime, a connection that goes beyond time and space. In this painting wolf and dragonfly had just such a meeting and were forever changed.

Above and Below was inspired by a meditation focused on perceiving the flow of sap and life force in a particular tree. This painting embodies an awareness of the unifying flow of life force, moving from earth through the tree to heaven, and back again into the earth. Busy ant people and a diminutive mouse contribute a morsel of humility to the scene.

Homesteading

There was much work and great delight in the undertaking of homesteading and the shared vision and labor of living from the land. Over a number of years we built a beautiful log home amidst sixty acres of forest, a process that taught us a great deal about coexisting with nature.

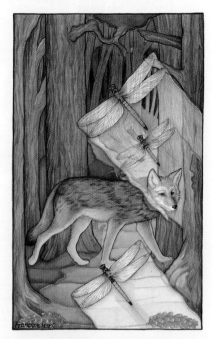

Crossing Paths, 1993

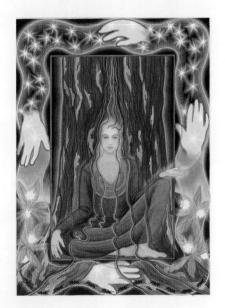

Above and Below, 1991

Bee Mandala, 2013

The hexagonal shape of the honeycomb is based on the design of the flower of life, a geometrical figure that contains the pattern of creation and is found in many of the world's religions.

Formative Influences

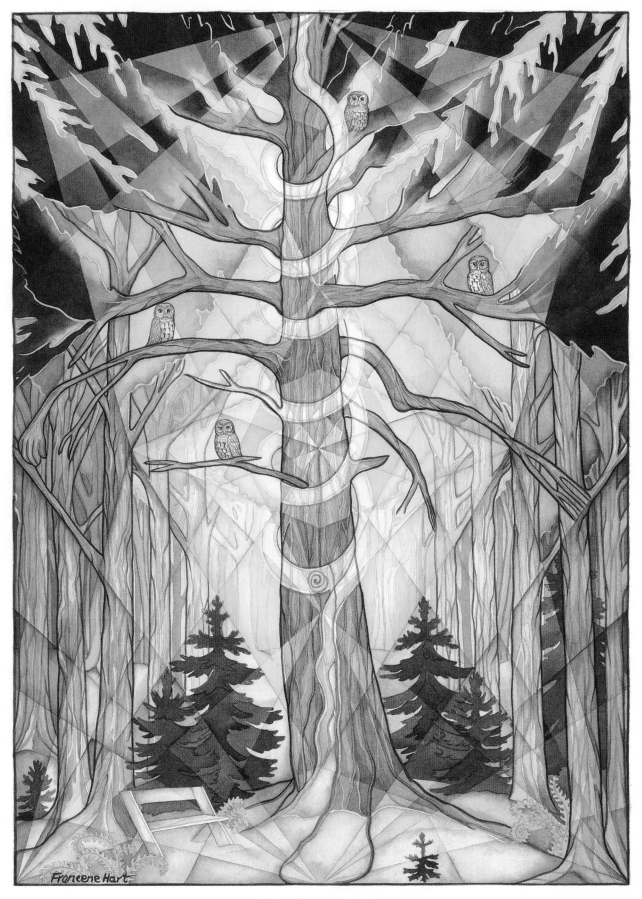

WISE FRIEND, 1997

There is crystal geometry in this composition, and four little owls. The garden bench offers size perspective and invites you to sit and experience the wisdom of this great teacher.

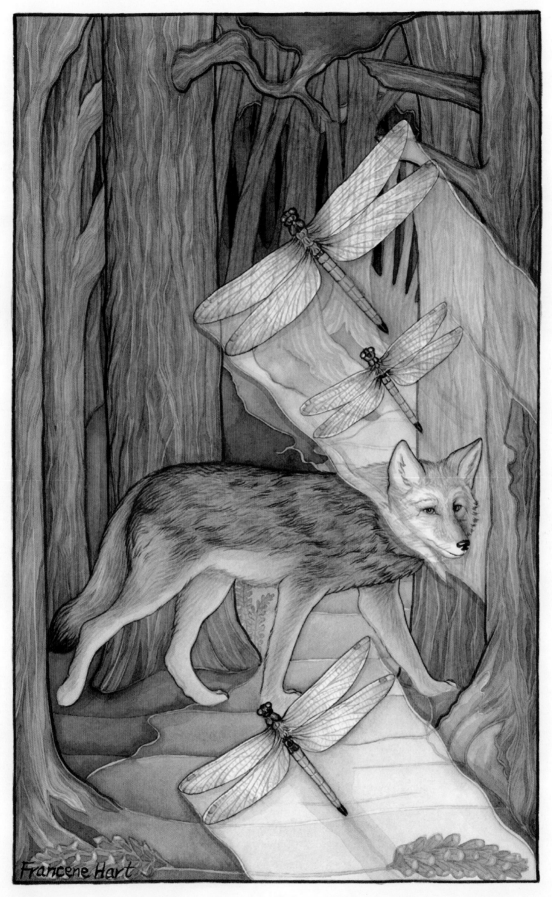

CROSSING PATHS, 1993

As we walk in the woods, or simply along life's path, we occasionally cross paths with other beings, igniting for a moment, or sometimes a lifetime, a connection that goes beyond time and space.

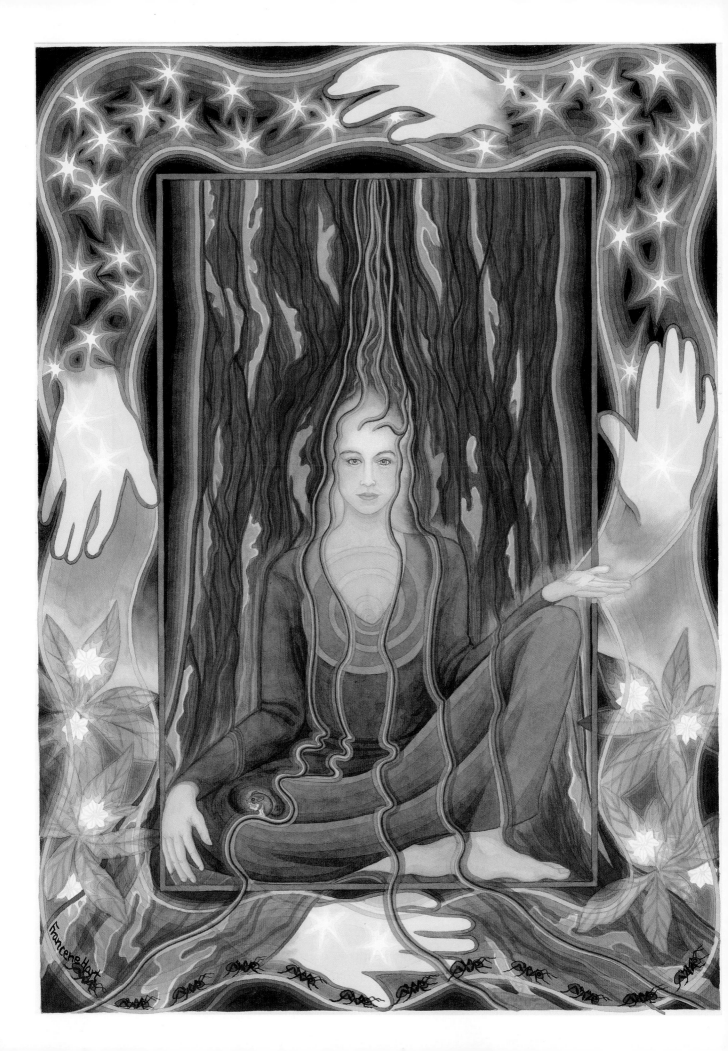

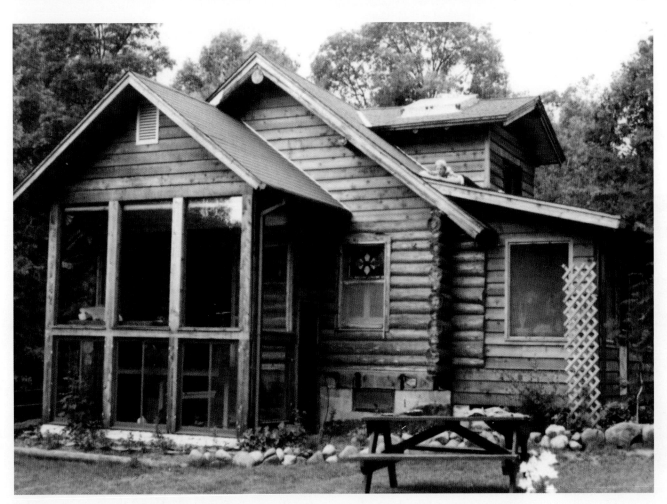

The beautiful log home we built was surrounded by sixty acres of forest.

Preparing for Winter

Gardening and preserving food for the entire long winter involved a huge learning curve and was definitely a labor of love. I developed a deep passion for growing my own food, and although I now no longer live in the north woods, that love remains extremely important. Growing even a small garden connects us with the earth and gives us options and greater appreciation for what we eat. I consider gardening to be an important part of my spiritual path.

The pantry was full and so was the woodshed. We experienced the satisfaction and hard work of heating our home with

ABOVE AND BELOW, 1991

This painting embodies an awareness of the unifying flow of life force, moving from earth through the tree to heaven, and back again into the earth.

Formative Influences

wood from our forest. It was comforting to know we would be warmed throughout the long winters.

I loved cross-country skiing out my front door, and the first warmth of spring was always welcome.

Loneliness and Listening

In winter much of the forest sleeps. Things become quiet and at rest. In this stillness there arises another kind of ability to hear. The trees and animals, water and rocks, sun and wind, moon and stars all speak clearly if we take the time to listen.

Winter Ravens explores this winter stillness. Raven, according to legend, embodies many attributes and is cultural hero, creator, seeker, magician, contradiction, and mischievous trickster.

In the beginning of my time in the forest, amid this stillness, I experienced profound loneliness. My son and husband were away long hours, and there were stretches of several weeks at a time when I saw only them and the lady at the grocery market. I had not known loneliness before, yet this solitude activated a desire to look more closely at what might arise creatively from the process of eliminating the chatter of modern life.

Listening is a captivating and extraordinary thing. It is a creative force. When we listen, it creates us and helps us to unfold and expand. Ideas begin to grow within and come to life. Learning to listen to the voices of the natural world, be they wind and wave, bird song, thunder, or simply our own breath, helps activate a different kind of knowing from the kind we acquire from books. When we listen closely, we can hear the voices of trees and rocks that connect us with the Earth and her immense wisdom. Wherever I travel around the planet, the trees call out in celebration of our connectedness to the sacred in nature and

MORNING MEETING

WINTER RAVENS, 1995

Raven, according to legend, embodies many attributes and is cultural hero, creator, seeker, magician, contradiction, and mischievous trickster. Can you see the sleeping rock people?

Formative Influences

18

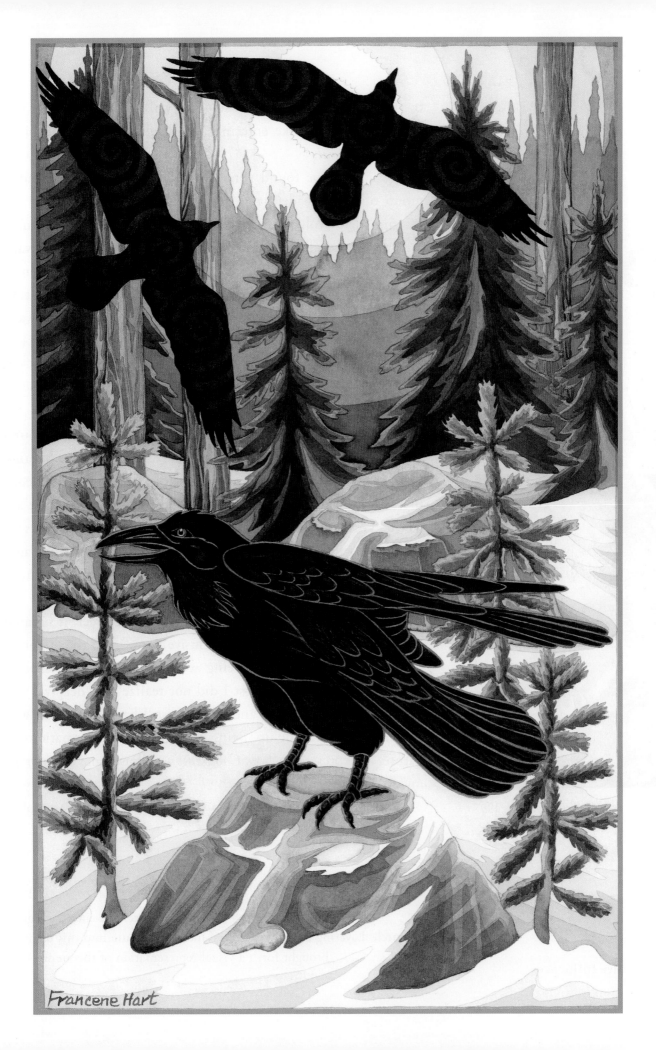

Francene Hart

to the Divine. I have always felt like walking in the forest is a sacred experience, like entering a great church, which inspired *Forest Cathedral.*

Over time we found community in a diverse, like-minded group of homesteaders and peace and justice activists. In the interim there evolved first acceptance, then comfort in solitude. As I slowly became more content in the forest, loneliness vanished. The practice of listening to the voices in nature around me and the voice of heart wisdom within became my meditation and everyday reality. Settling into a natural inclination toward privacy, I embraced a reclusive lifestyle.

Finding My Authentic Artistic Voice

In the north woods there were plenty of indoor winter hours, which allowed time and space to reinvent my art. It became clear from the direction in which these paintings were leading me that I no longer wished to follow the whims of the art world. Guidance was requiring me to listen to the voices of nature and develop a style that reflected the powerful magic and mystery that Earth's natural environment was awakening in my consciousness.

The art continued to change. No longer abstract, it became increasingly personal. Living a reclusive life offered the opportunity to release fears of not being accepted or having to explain my art at every turn. At first I did not realize how deeply I was transforming, as a person and as an artist. I had been hiding and sleeping. I was waking up. Being close to the transformations in nature, as expressed in *June Companions,* allowed me to embrace my own transformation.

Around this time I began to work exclusively in watercolor.

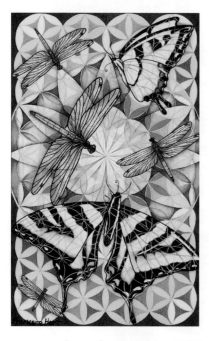

June Companions, 1997

Forest Cathedral, 1992

Walking in the forest is a sacred experience, like entering a great church. Layering classical cathedral-like architecture into this painting brought forth a visual representation of this impression.

Formative Influences

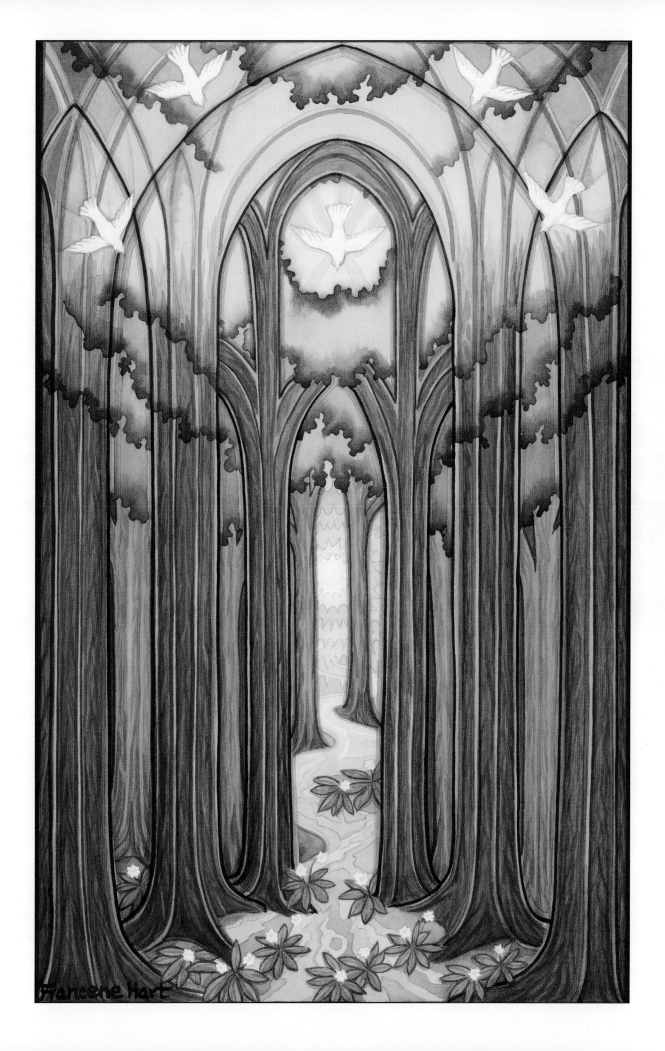

Drawn to the colors, transparency, and nontoxic nature of the medium, I realized the technique I was developing of layering multiple transparent washes related directly to my evolving view of the nature of reality. As delicate washes of watercolor are layered, it is also possible to see through the surface to what is hidden beneath. Looking beyond the observable to hidden unseen realms, enhanced by this painting technique, was the ideal expression of the multidimensional nature of existence I was experiencing.

Returning, a starry scene with northern lights, was inspired by a guided meditation that involved reaching out to connect with celestial realms. The objective of the meditation was to seek wisdom and communicate with the ancestors, then return to our sacred home in this reality.

As we journey around the wheel of life and venture into other dimensions, it is also important to honor the beauty of this earthly plane. This painting is a medicine wheel and meditation in celebration of the magnificence of celestial energies and the beauty of returning home.

Indigenous Neighbors

Living close to native peoples brought more depth to my view of cultural diversity and respect for the Earth. We lived in the vicinity of the Anishinaabe-Ojibwa people, the St. Croix and the Lac Courte Oreilles Bands of Lake Superior Chippewa. Their traditions were born of life in the forest, communing with nature, and living in balance with the seasons. The influences that inspire their traditions also genuinely inspired me. The forest had become my heart-place.

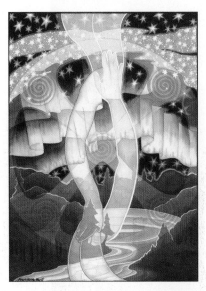

Returning, 1992

June Companions, 1997
Dragonflies and swallowtail butterflies adorn this painting and speak of transformation. The flowered background holds the complex geometric informational system of the flower of life formation.

Formative Influences

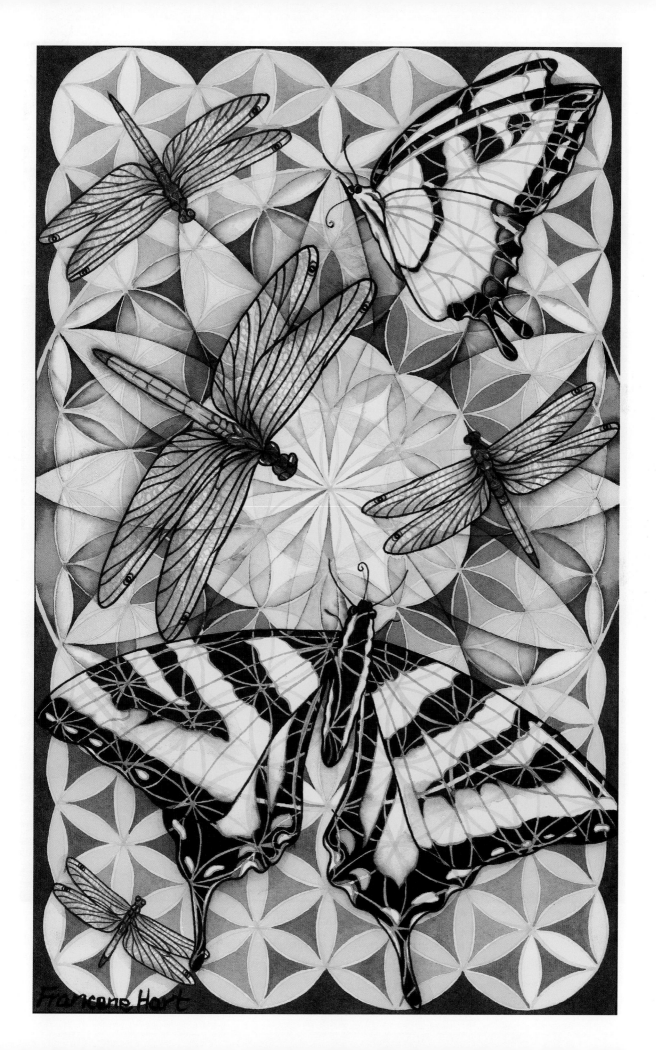
Francene Hart

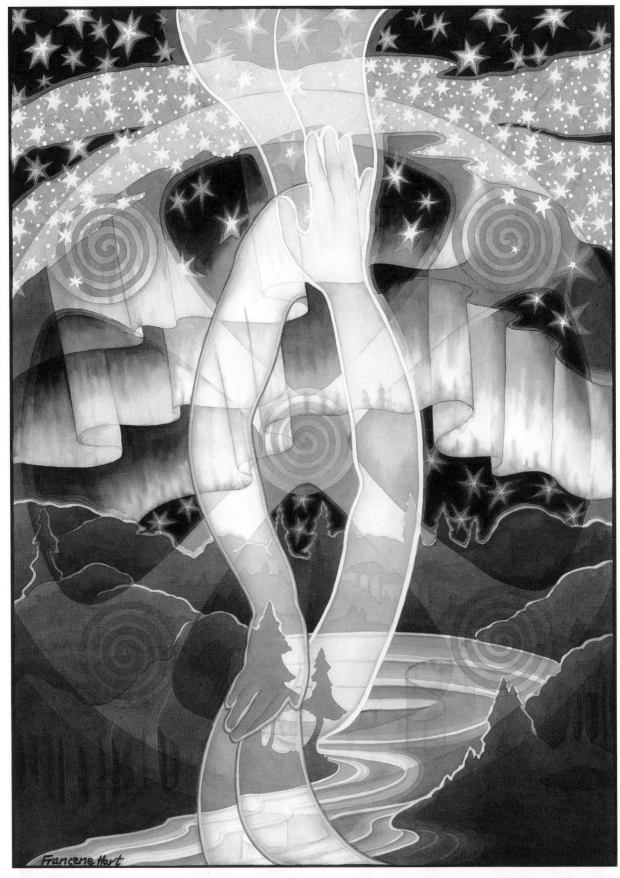

RETURNING, 1992

This starry scene with northern lights was inspired by a guided meditation that
involved reaching out to connect with celestial realms. The painting is a celebration
of the magnificence of celestial energies and the beauty of returning home.

I contributed art to a Native American news publication and was part of a group of peace and justice activists who supported treaty-rights issues. Their concerns were our concerns as proponents of environmental justice. In supporting their attempts to preserve the environment and their indigenous rights, we shared the experience of frustration in attempting to hold government and corporations accountable.

Join in Stewardship sprang from a compassionate understanding of the way our indigenous brothers and sisters respect and utilize the environment, understanding and honoring the land as part of their souls and protecting it for future generations. This resonates as truth. The intention of this painting is to revere tradition and the joining of energies for the stewardship of Mother Earth.

Join in Stewardship, 1991

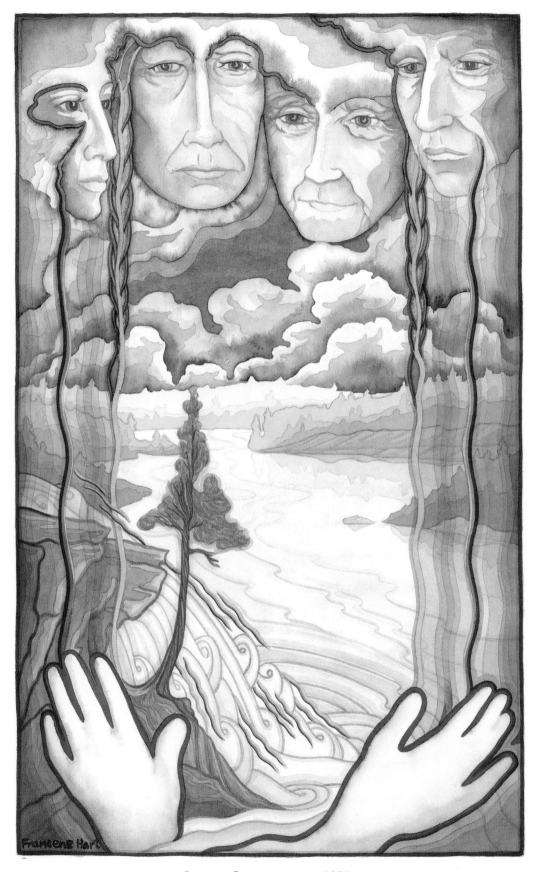

JOIN IN STEWARDSHIP, 1991

This painting sprang from a compassionate understanding of the way our indigenous brothers and sisters respect and utilize the environment. Its intention is to revere tradition and the joining of energies for the stewardship of Mother Earth.

Unearthing the Source of Inspiration

Tapping into Energies beyond Normal Understanding

Inspiration refers to being "in spirit" . . . inwardly receiving or bringing forth communications from the vastness of creation . . . from the field of all possibilities.

The stimulus for the painting titled *Invitation* arrived during a meditation. Its gridlike structure represents a doorway, portal, or star gate and is meant to depict one means by which universal intelligence enters consciousness. Appearing as grids or matrices of light, geometric vibrational fields connect everything in existence.

Light workers everywhere are exploring and adventuring into the realms of energy, light, and vibration. Various techniques, including meditation and visioning, enable travel to other dimensions of time and space. These places may not even exist in three-dimensional reality. Gather your courage and venture into the mystery. The two guardian figures flanking this starry grid will act as guides and protect you on your way. Celebrate the journey!

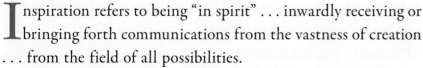

INVITATION, 1997

Look for Inspiration Everywhere . . .

Visualize your creative brilliance as a flow of ever-evolving source energy, similar to a wild river continually flowing. This creative

current is available to every one of us. It is spirit, intelligence, imagination, divine spark . . . whatever you choose to call it. See and feel into the images that are offered. In what way are you opened by this practice?

The visionary's mission is to filter what emerges from this flow of images. It represents the vast potential of all we see, dream, imagine, and experience. Innovative concepts, part or whole, originate from an immeasurable creative intelligence, which is available to every one of us. We select an individual image or concept, embrace it as creative food, and then bring it into form.

Inspiration arises sometimes as a subtle inkling, bringing with it a peaceful awareness and sometimes a rush of energy that propels body, mind, and spirit into altered states of consciousness. There may be a tingling, accelerated heart rate, or perhaps a simple sense of anticipation. Open your heart and mind and be prepared at every moment to receive revelations. Try not to judge what comes into consciousness; rather, observe, discern, and contemplate how these ideas might become a work of art, writing, or song.

The figure in *Receiving* is charged with readiness and receptivity. Her outstretched arms and open-hand chakras are expressions of trust, expansiveness, and potential. She is a lightning rod and receptor for universal information and divine wisdom. DNA spirals on either side appear as pillars or antennas in support of her readiness. Embedded in her dress and the background is beautiful geometry borrowed from a crop circle. Every year I choose a crop formation and layer it into a painting to explore the information that is offered.

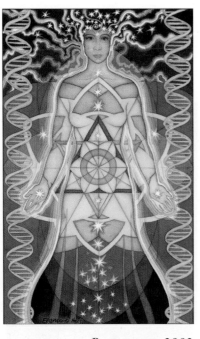

Receiving, 2003

Invitation, 1997

The gridlike structure of *Invitation* represents a doorway, portal, or star gate and is meant to depict one means by which universal intelligence enters consciousness. Appearing as grids or matrices of light, geometric vibrational fields connect everything in existence.

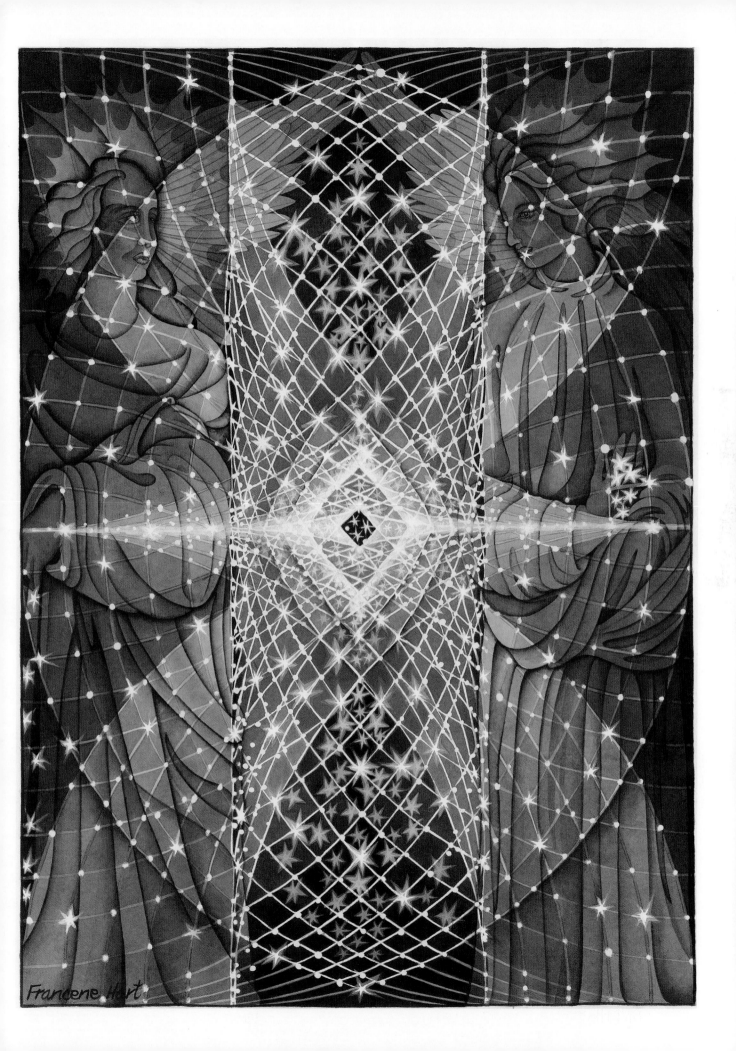

Francene Hart

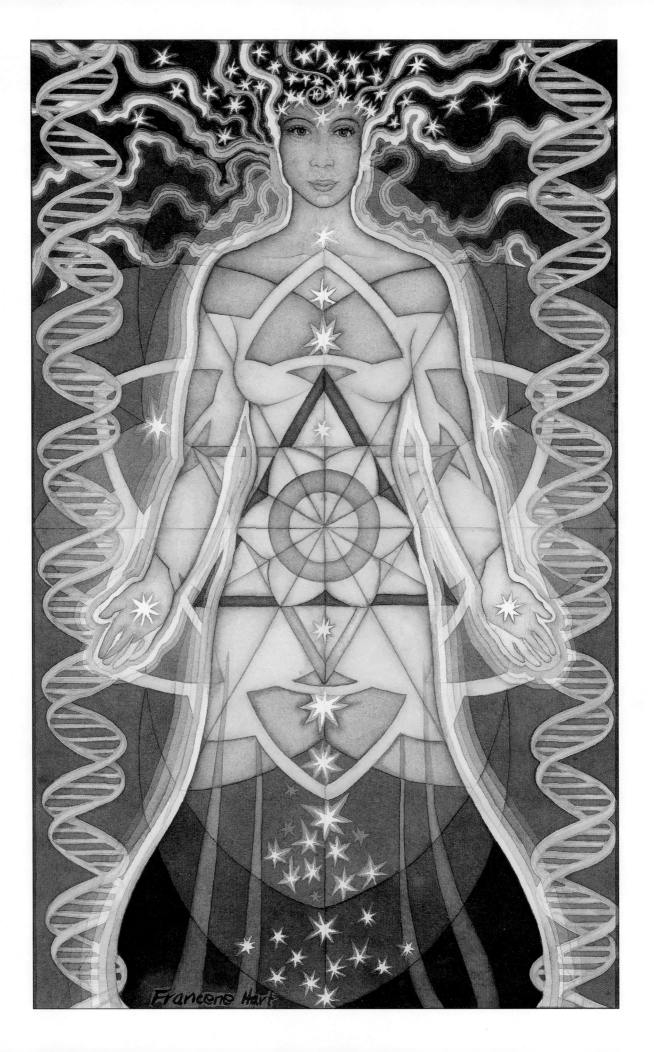

Francene Hart

Meditation and Visioning

Meditation and visioning are invaluable techniques for receiving inspiration. I have always considered painting to be a form of meditation, particularly if I am stirred by a compelling awareness.

A vision is sometimes a motivating interpretation of the future. It creates pull and gives direction. Imagine a brilliant future. Think about what you are trying to achieve. Go out into the future; look around and see what is there. Feel into the information you are receiving and use personal discernment to help you choose an idea that feels nurturing for your creative process. Return with glimpses, or perhaps complete concepts.

Yielding To, Not Resisting Vision

Most of us were told that our visions must not be real if they run contrary to scientific fact or cultural traditions. Some believe we should resist these concepts. Artists are allowed greater leeway because our work has not traditionally been seen as truth. When vision becomes the artist's reality, the doors of perception open wide, making way for a vast flow of universal truths. Yielding to creative vision is accepting authenticity.

Purification Meditation was created as a meditation and contemplation of the process of purification. Whether the desired purification is physical, emotional, mental, or spiritual, part of the process will be connecting to your sacred center in order to balance all aspects. Golden spiral hearts hold the energy of love, both within the meditating figure and as she expands into radiant universal love. She sits in meditation, willing to forgive herself and all beings, ready to purify her life with compassion and integrity. Flames consume all that does not serve our most

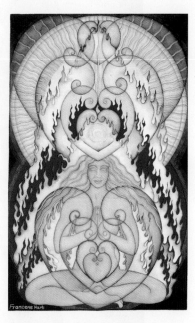

PURIFICATION MEDITATION,
2007

RECEIVING, 2003

The figure in this painting is a lightning rod and receptor for universal information and divine wisdom. DNA spirals on either side appear as pillars or antennae in support of her readiness.

Unearthing the Source
of Inspiration

31

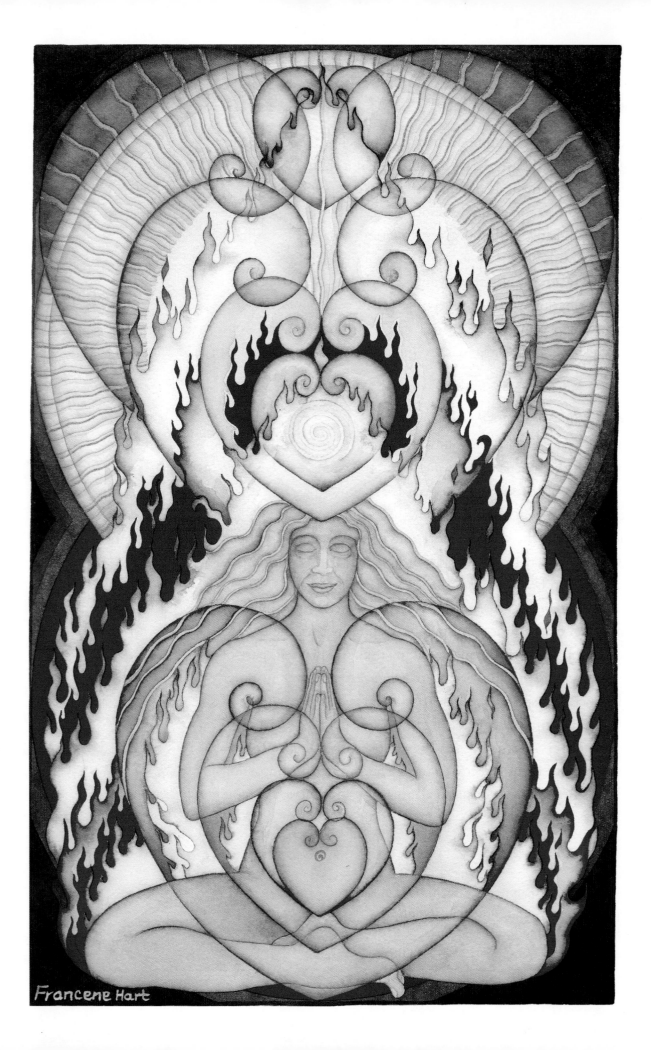

Francene Hart

loving, kind, compassionate, true selves. The blue flame is that which burns away ego.

The Power of Observation

Learning how to truly "see" is another means by which to call in spirit and inspired insights. Seeing with all your senses, opening body, mind, and spirit magnifies the probability that you will connect with something extraordinary. What have you seen lately that might become a painting or poem? What are the whispers in the wind telling you? What are the rock people communicating? Look beyond the obvious to the place where magic lives and art finds life and vitality. Learn to trust your instincts and inner guidance.

Bringing Spirit into Form . . . Stars and Star Visions

There is an inherent creative principle woven into the fabric of the universe. It is the task of the visionary to bring this intelligence, through awareness, into physical form. Art can be the bearer of heavenly presence and cosmic grace. We are all visionaries . . . the key is finding a way to naturally manifest this potential.

Star Woman II was a pure gift from spirit, and I have come to recognize her almost as a universal icon. Star Woman arrived during a powerful massage experience. First I saw her surrounded by trees (which led to the first painting with this name); then she sprouted wings and became this angelic representation with hands upraised to a golden orb. The circle is the basic form and foundation of sacred geometry. It symbolizes perfection,

Star Woman II, 1993

Circle

Purification Meditation, 2007

Whether the desired purification is physical, emotional, mental, or spiritual, part of the process will be connecting to your sacred center in order to balance all aspects. Here, golden spiral hearts hold the energy of love, both within the meditating figure and as she expands into radiant universal love.

Unearthing the Source of Inspiration

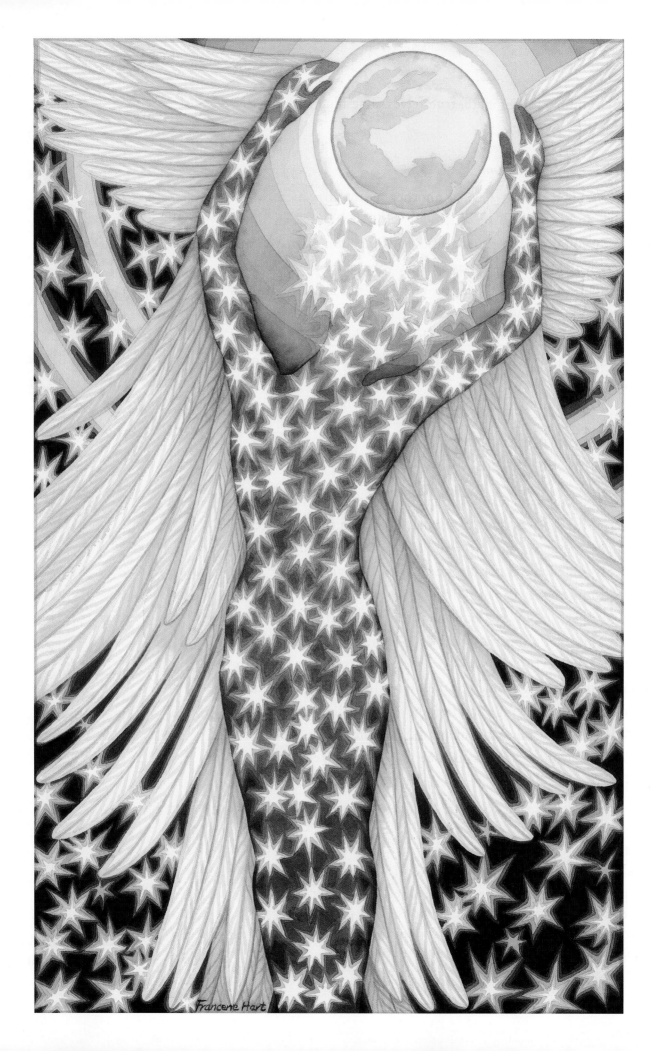

Francene Hart

wholeness, unity, and eternity, and personifies the feminine principle.

Star Woman II is recognized by people from many walks of life and varied spiritual traditions. She activates profound remembering in each observer. This painting, more than most, touches a place shared with the star beings and activates personal stories. How does she speak to you?

There are doorways and portals through which artists and seekers access other dimensions. *Divine Doorway* invites you to contemplate a connection with your inner adventurer. This angelic figure tenderly touches a spiraling vortex and is ready to move through this doorway into undiscovered realms. The spiral infinitely curves back in on itself, as the doors to perception endlessly open to reveal previously undetected realms.

Within the design theme moves an invisible number pattern borrowed from the ancient Mayan calendar. Four water lilies symbolically suggest an awareness of our potential.

As I gazed at the vast expanse of the universe one starry autumn evening, a fabulous shooting star seemed to ripple its tail as it darted through the sky. It felt as if I might be able to catch this moment and bring it into form as art. The swirling goddess in *Catch a Falling Star* is ready to catch the star as it streams through the night sky and enfold it in the spiraling galaxy of her bountiful skirt. May you collect your own abundance of stars and know that when you act from your heart with clarity of vision, dreams really do come true.

Stardust is about bringing in that star essence. Drawing in energy from the infinite cosmic star-pool, the figure stands steadfast in her position as transmitter of stardust. She is assisted by sacred geometry, which whorls golden spirals into a dynamic phi flower, perfectly balanced in the golden ratio. By moving this

Divine Doorway, 1996

Catch a Falling Star, 1996

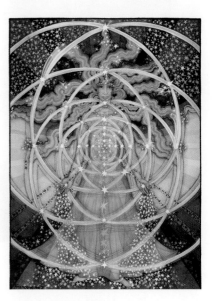

Stardust, 2015

Star Woman II, 1993

This figure is recognized by people from many walks of life and varied spiritual traditions. She activates profound remembering in each observer.

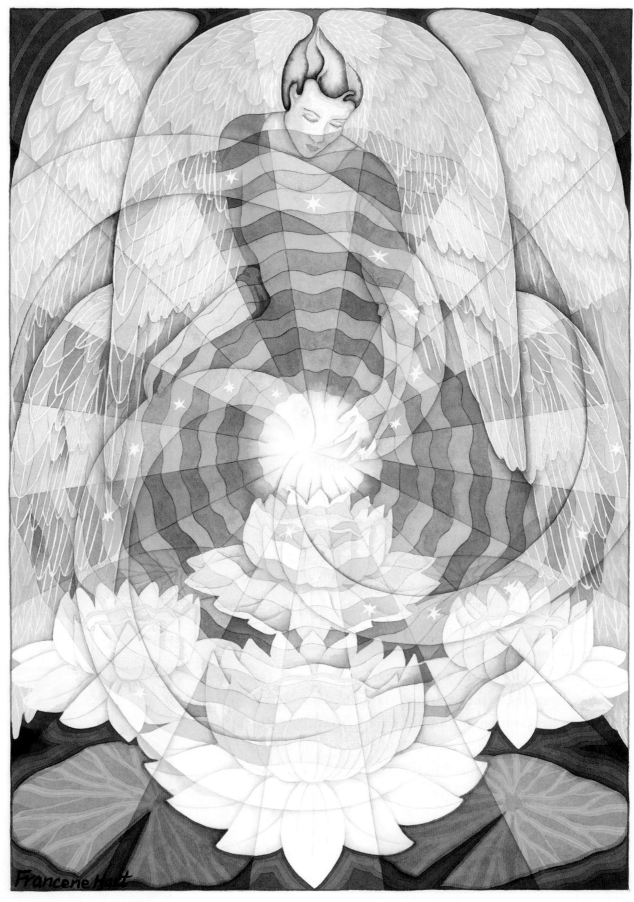

DIVINE DOORWAY, 1996

The angelic figure tenderly touches a spiraling vortex and is ready to
move through this doorway into undiscovered realms.

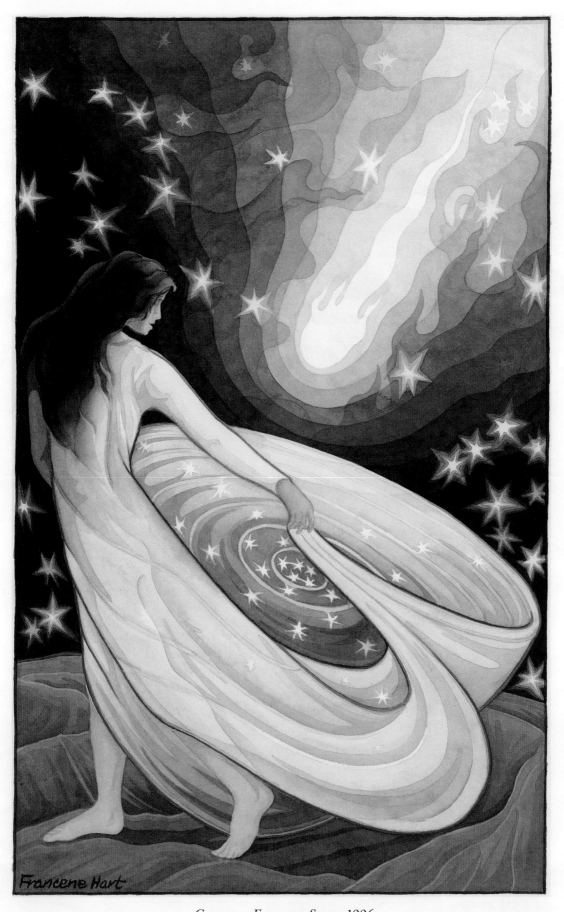

CATCH A FALLING STAR, 1996

The swirling goddess is ready to catch the falling star and enfold it in
the spiraling galaxy of her bountiful skirt.

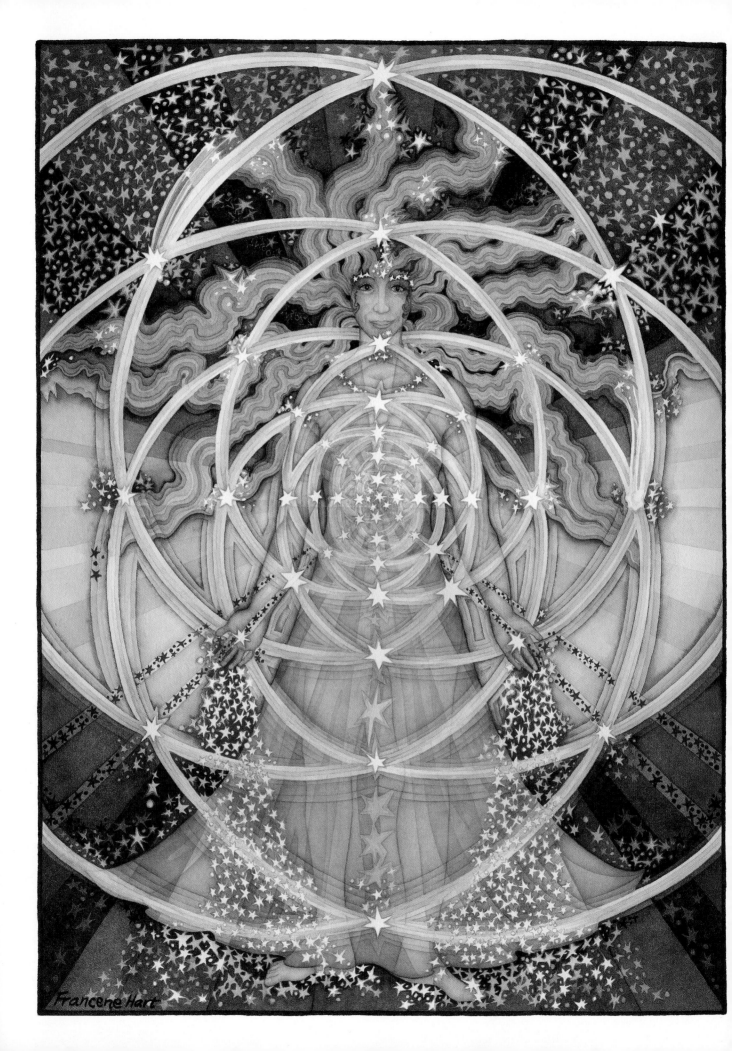
Francene Hart

dazzling energy through her body, she is transmitting or seeding stardust into this reality.

Path of Heart . . . Living and Creating from the Heart

The torus is a form in sacred geometry that governs many aspects of life. It is composed of a central axis with a vortex at both ends. It is the primary shape in existence and the shape of Earth's magnetic field. It looks something like a doughnut when viewed from a three-dimensional perspective.

The human heart has seven muscles that form a torus. Toroidal energy connects you with the intelligence of your heart and asks you to become conscious of the effects emotions have on your ability to fully experience life. Emotions open the heart and lead to a deeper connection with self and others, allowing each of us to feel more at peace and balanced. Allow yourself to feel gratitude for your very human ability to experience emotions. *Heart Torus* expresses the dynamic spin of the torus that, coupled with heart energy, creates an energetic portal through which to connect with the intelligence of your heart.

Recognizing the intelligence of the heart and the manner in which heart intelligence connects us with our deepest selves unites each of us with a type of intuition not bound by time and space. Learning to utilize the intelligence of our hearts will expand and deepen our current levels of physical, emotional, and mental intelligence, and help us respond to life from a place of love, compassion, and acceptance. This is the process of

TORUS

HEART TORUS, 1998

STARDUST, 2015

Drawing in energy from the infinite cosmic star-pool, the figure stands steadfast in her position as bringer of stardust. She is assisted by sacred geometry, which whorls golden spirals into a dynamic phi flower, perfectly balanced in the golden ratio.

Unearthing the Source of Inspiration

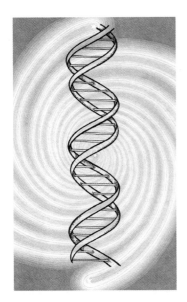

DNA Spiral

Rainbow DNA, 2001

integrating heart, body, mind, and spirit so that we can access the heart behind the heart. It stands at the center of both mental and emotional intelligence and, when fully activated, can harmonize the brain, connect us to our brightest potential, and even activate dormant DNA. This is especially helpful as we initiate intuition, creativity, and receptivity to visionary thinking.

Human DNA uses the phi ratio (also known as "golden ratio") to form the wave that spins our genetic codes. Decoding and activating the full spectrum of insight and understanding creates a rainbow of possibilities that corresponds to the science of conscious evolution as depicted in *Rainbow DNA.* Part of that activation process is learning the subtleties through which evolution does its transformational work. By responding to these dynamics we can intentionally apply them to transform ourselves and our world. Acting from our hearts, we contribute to the intentional conscious evolution of humankind and the healing of the planet.

Opening to heart intelligence will enable us to access the unlimited resources of universal wisdom that move through our hearts, and help transcend mental or emotional blocks that may have been keeping us from experiencing who we truly are. By living and creating from the heart, we become better able to take inspired action, live more fully, love more openly, and develop a passionate creative impact that nurtures the lives of others.

Sacred Relationship

One of the essential ongoing themes of my painting has been a compassion-based exploration of love. Throughout this entire lifetime I have sought to illuminate the beauty and coherence exemplified by love. This has been a tall order to express both in life and in art, as love is one of the most intrinsic, yet indefinable human emotions.

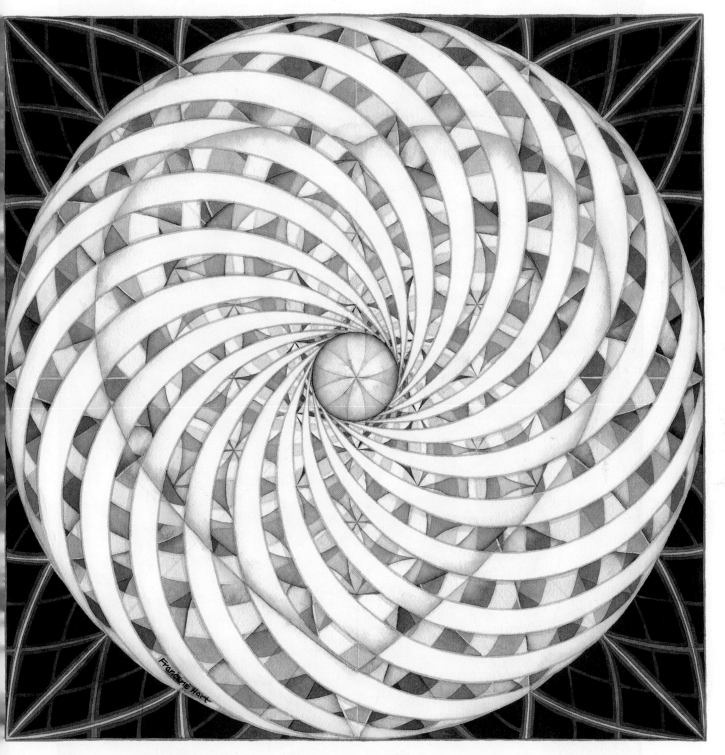

HEART TORUS, 1998

The torus is the primary shape in existence and the shape of
Earth's magnetic field. The dynamic spin of the torus, coupled
with heart energy, creates an energetic portal through which to
connect with the intelligence of your heart.

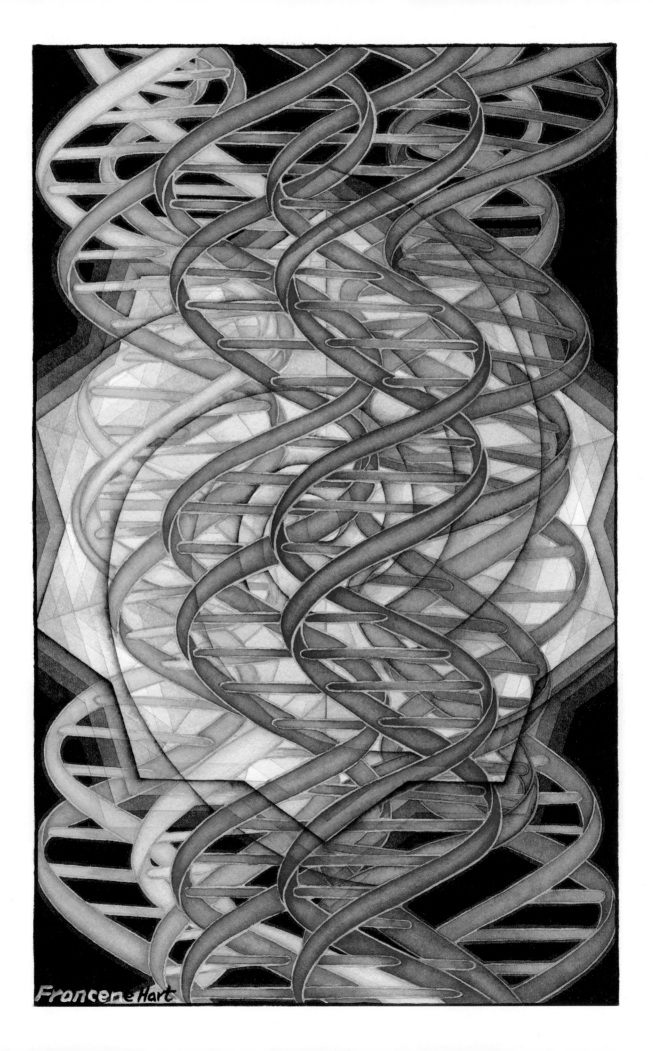

Francene Hart

The Freedom of Love is an exploration of love, both the earthly kind and that known as unity, or "Christ consciousness." The stellated dodecahedron is a polyhedron composed of twelve pentagons extended at each vertex. Also called a double star tetrahedron, it is considered a cosmic gateway. Associated with unity consciousness, it creates a matrix through which to experience the true freedom that comes with living in integrity and heart energy. Intersecting circles and hearts are given the freedom of wings, and heart spirals suggest an infinite love, whether earthly or more exalted.

Before we can truly love another, it is vital to have self-love and find balance and wholeness within ourselves. Not allowing cultural or religious prejudices to dictate the life essence flowing through us allows our own personal truth, which includes self-appreciation, to be revealed. Taking stock of the development of the soul's purpose and expressing gratitude for the ups and downs of this life's passage will help balance and offer validation to the way we see ourselves and others. It takes honest self-awareness to reach a place of emotional maturity and healthy self-respect. Courageously living our truth and walking our walk with humility and grace will support us in following a visionary path.

Every life includes times of conflict and confusion. Each person must work through difficult events and discover how to move beyond heartache, confusion, sorrow, or remorse. Discovering ways to support physical health and spiritual growth that can transcend trying times is an essential part of a healthy human life path.

There are times in life when everything seems about to blow apart. Seeking a way to survive within this energy and transmute it

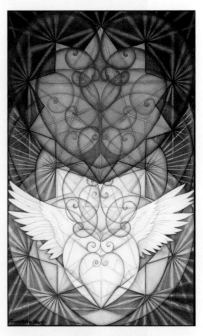

THE FREEDOM OF LOVE, 2003

DODECAHEDRON

RAINBOW DNA, 2001

Human DNA uses the phi ratio to form the wave that spins our genetic codes. Decoding and activating the full spectrum of insight and understanding creates a rainbow of possibilities.

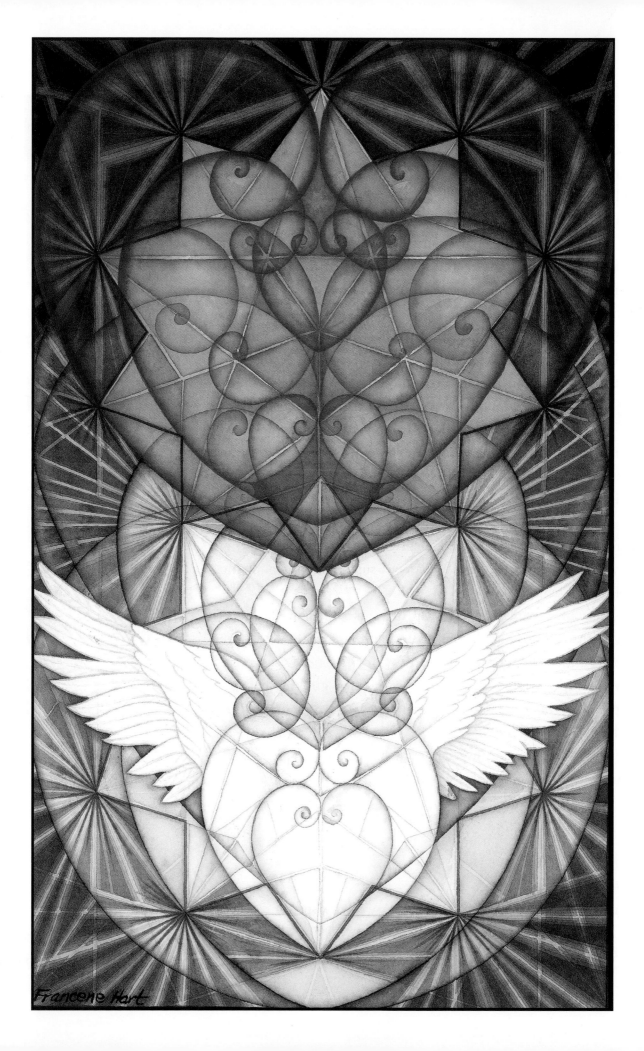

into something positive was the purpose of *Tornado Dancing*. The figure dances calmly within the vortex of a powerful tornado. She is the eye of the storm . . . she is a force of nature. She is able to withstand the vagaries of existence while maintaining her sacred center.

Maintaining that center is the work of a lifetime. From 2014, *Eve's Evolution* speaks to the passing of time and the evolution of this feminine icon. Eve and her apple have represented many aspects of the feminine. Often maligned, she is here symbolized as a seeker of wisdom. The dark Eve, holding a red apple embodying passion and youth, is mirrored by the white-haired wise-woman Eve, who has earned the golden apple of knowledge and understanding. Their hair and lives are intertwined through time and experience. They are powerfully yielding and very comfortable with life's passages.

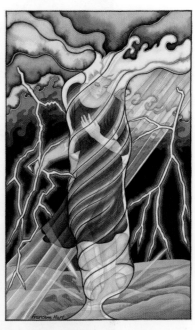

Tornado Dancing, 1996

Intentional Balance . . .
Power *To,* Not Power *Over*

It is human nature to seek intimacy with another. The coming together of whole individuals in mutual understanding creates common ground from which love may become shared vision. As each of us evolves and is better able to create balance within her or his own nature, we have the opportunity to be present and balanced within loving union.

Many believe that if they can only find a mate, life and love will be fulfilled and they will become the beloved, part of a couple inseparable in love. In the everyday reality of life, matters unrelated to ideal love sometimes come into play. Relationships may be hindered by ego, selfishness, disrespect, or even boredom. Hormones and sexual dissatisfaction are common stumbling blocks to experiencing deep love, yet also are part of the human experience.

Eve's Evolution, 2014

The Freedom of Love, 2003
The stellated dodecahedron is associated with unity consciousness and creates an amazing matrix for experiencing true freedom.

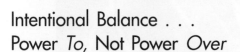

Unearthing the Source of Inspiration

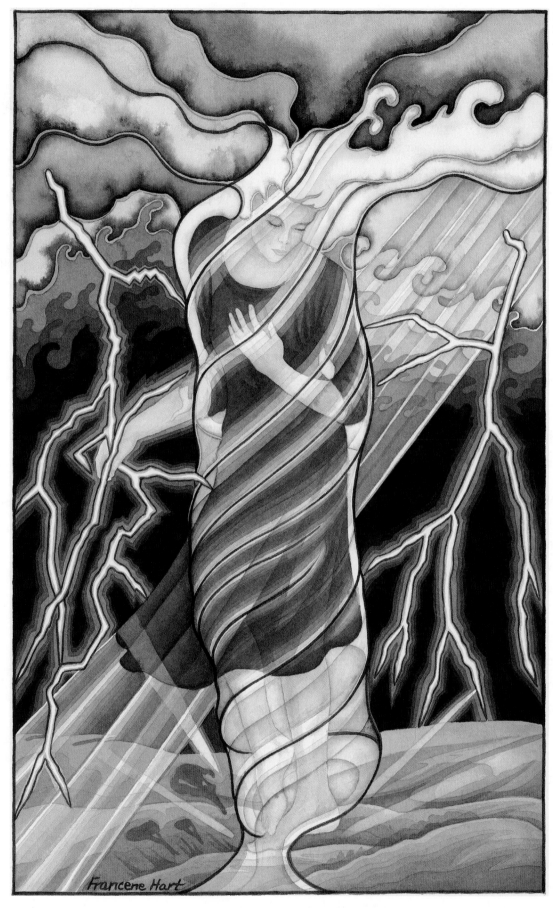

TORNADO DANCING, 1996

The figure in this painting dances calmly within the vortex of a powerful tornado,
able to withstand the vagaries of existence while maintaining her sacred center.

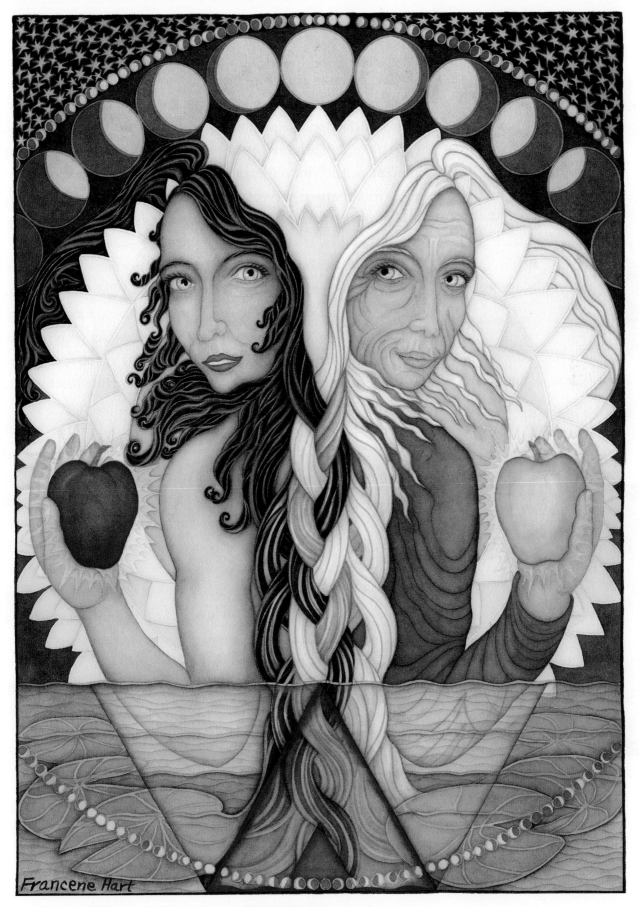

EVE'S EVOLUTION, 2014

The dark Eve, holding a red apple embodying passion and youth, is mirrored by the older,
white-haired Eve, who has earned the golden apple of knowledge and understanding.

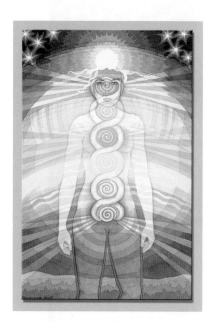

CHAKRAS, WHEELS OF LIGHT

The seeming need for control or power over another person is one unmistakable reason many relationships dissolve or linger in dissatisfaction. Being able to communicate with clarity and respect is a skill achieved by sincerely opening ourselves to hearing another perspective on reality. Respectful communication offers us a vision beyond everyday reality to realms through which we may more clearly experience our connection with another and to the "All that Is."

Spiral Communion celebrates the manner in which we connect with another, honoring the possibility of creating a positive long-term relationship. One of the most valuable ways to maintain the love and respect that sparks original attraction is to dedicate ourselves to communicating holistically. Do you speak from your heart with respect and sincerity? Do you truly listen to the person who is speaking?

Inspired by the magic of the golden spiral—similar to the Fibonacci spiral, but based on a series of identically proportioned golden rectangles with unique mathematical properties—this painting incorporates elemental forces, the chakra system, and human communication. Amidst many colorful symbols, the sacred couple holds true to their intention by looking into each other's eyes while sharing breath and heartfelt conversation. All is sacred spiraling communion.

Love and Power is meant to honor the possibility of creating a new kind of love and power, based on power *to* rather than power *over* . . . power to create a new kind of sharing . . . power to discover a new paradigm for living . . . and power to birth into being new possibilities for the coming age of peace and enlightenment.

LOVE AND POWER, 1999

SPIRAL COMMUNION, 2010

Inspired by the magic of the golden spiral—similar to the Fibonacci spiral, but based on a series of identically proportioned golden rectangles—this painting incorporates elemental forces, the chakra system, and human communication.

Unearthing the Source
of Inspiration

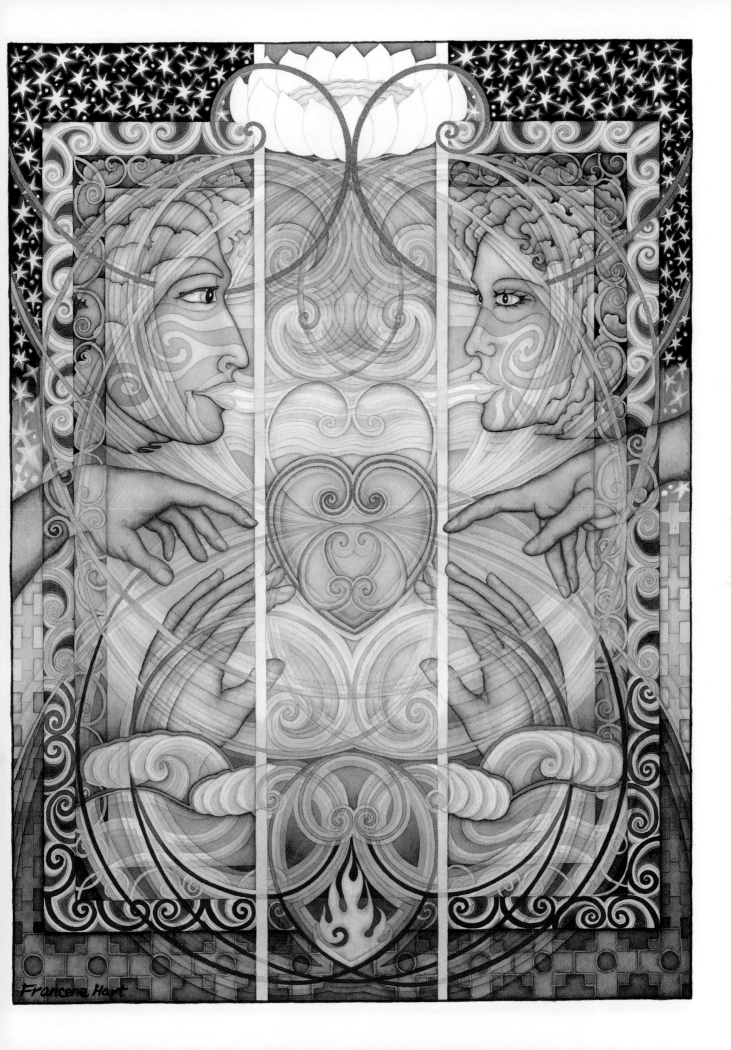

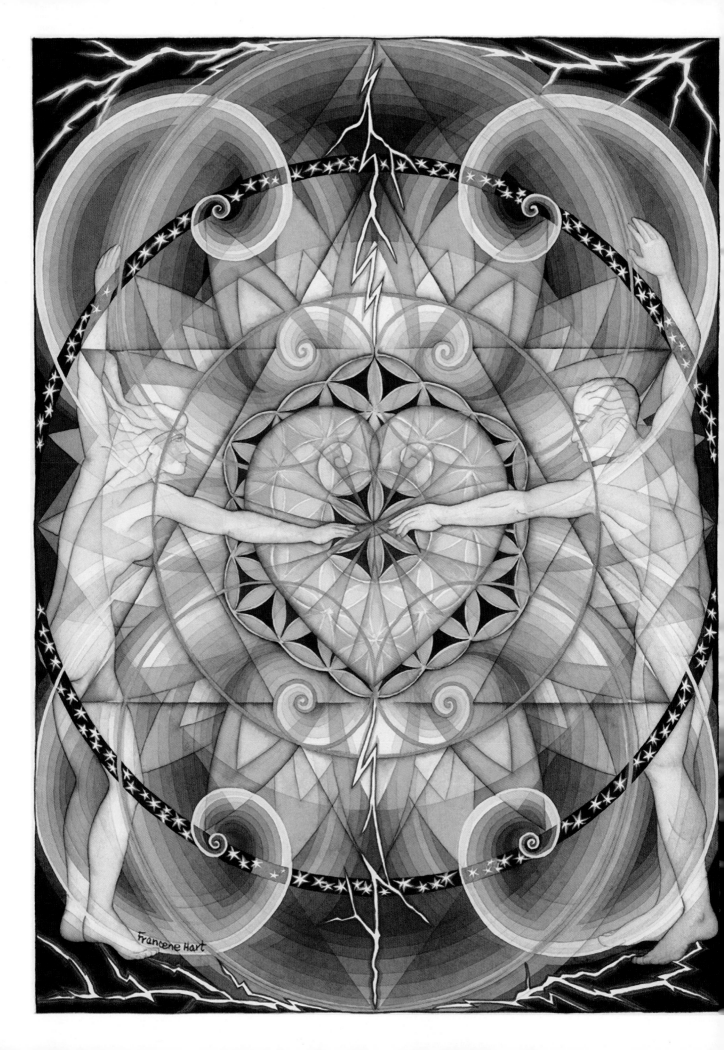

Francene Hart

It is filled with symbols from sacred geometry—spirals, encompassing circles, triangles, and the flower of life within the central heart—all found in nature. The intention of this painting is to celebrate the joining of love and power.

The Kiss blesses a moment of tender affection. Beauty and love surround the sweetness of their kiss. Two golden rings create a form known as the *vesica piscis* in sacred geometry—two overlapping spheres with the same radius, intersecting in such a way that the center of each sphere lies on the perimeter of the other, symbolizing a shared space in which the kiss becomes a union of souls. There are two other rings—one a rainbow, another filled with stars—which help complete the elemental connection. This union of earthly energies represents the marriage of heaven and Earth, of light and dark, and the conviction that we have the ability to create sacred union in our lives.

The Kiss, 2006

Universal Love for All Our Relations and Respect for Mother Earth

I've long been an advocate of respect and protection for this precious planet we call home and have been moved many times to create paintings that celebrate Mother Earth and the beauty and diversity of our human brothers and sisters who share this precious blue-green sphere.

Vesica Piscis

Tetrahedral patterns and a vesica piscis form a protective divine matrix around the planet in *Earth Prayers*. In the center our home, Mother Earth, shines in beauty and grace. Multicolored hands surround and reside within these patterns, symbolizing human participation in stewardship and sustainability. Stewardship expresses an understanding that there is spirit

Love and Power, 1999

This painting celebrates the joining of love and power through myriad symbols from sacred geometry. It honors new possibilities in relationships for the coming age of peace and enlightenment.

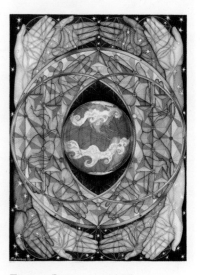

Earth Prayers, 2007

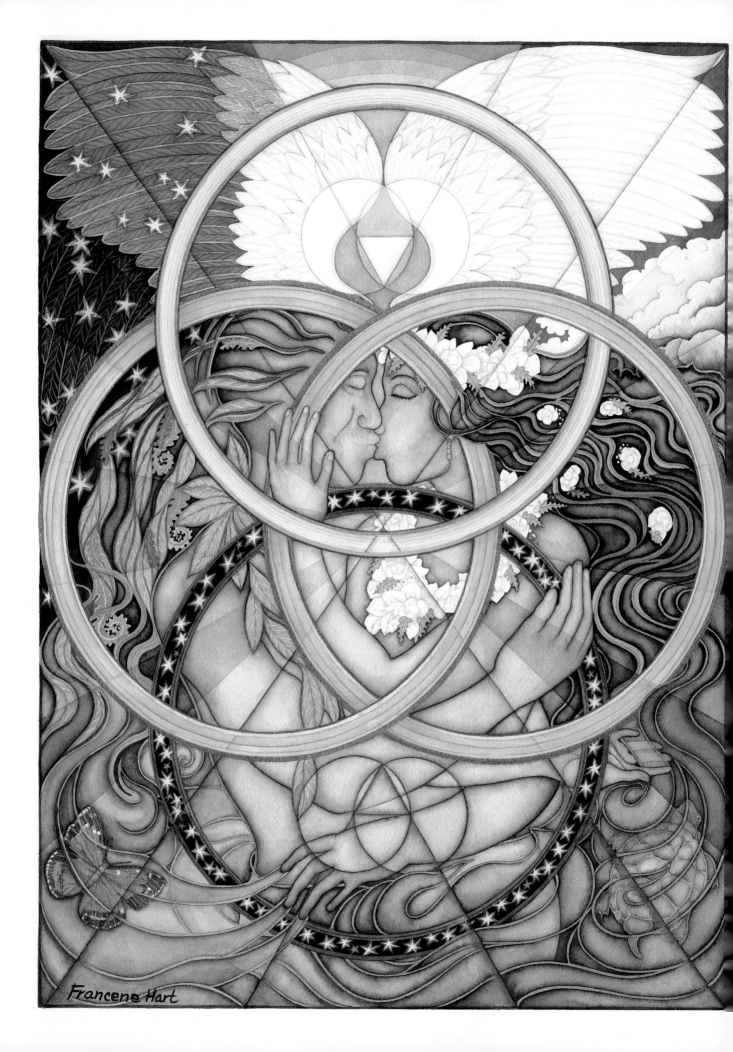

Francene Hart

in everything and that all is connected. It implies awareness that each of our actions, from growing a vegetable or using natural resources to a single thought, affects the whole. It requires living with a sense of connectedness and relationship with all beings, and respect for the Earth.

I was moved to create *Love Thy Neighbor* in response to seemingly constant news of division and hatred. Its purpose was to offer, instead, the energy of love for all our planetary neighbors. This piece contains symbols from multiple spiritual traditions, sacred geometry, peace, science, and more. It is by our intentions that we will discover ways to shift attitudes and love our neighbors.

Six Möbius loops, or infinity symbols, wrap around the heart center activating the aspiration to wholly honor world traditions, living in harmony, with compassion. The golden egg radiates the abundance we create in accepting and understanding the many facets of our humanity. Love and respect for the diverse ecosystems and peoples that populate this incredible planet are essential if humans are to continue their tenure on Earth. It is nearly incomprehensible and certainly reprehensible to witness the damage we have caused to this fragile planet and to the diverse human, plant, and animal populations living here. The practices of tolerance, loving kindness, compassion, and respect for all people, regardless of differences in culture, ethnicity, and religion, are the most nourishing rituals we can offer ourselves and all our relations. Open your heart to knowing that we are all in this together and that each part is as important as the other.

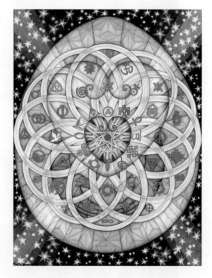

Love Thy Neighbor, 2011

Möbius, or Infinity Symbol

The Kiss, 2006

Two golden rings create a *vesica piscis*—two overlapping spheres with the same radius, intersecting in such a way that the center of each sphere lies on the perimeter of the other— symbolizing a shared space in which the kiss becomes a union of souls.

Unearthing the Source of Inspiration

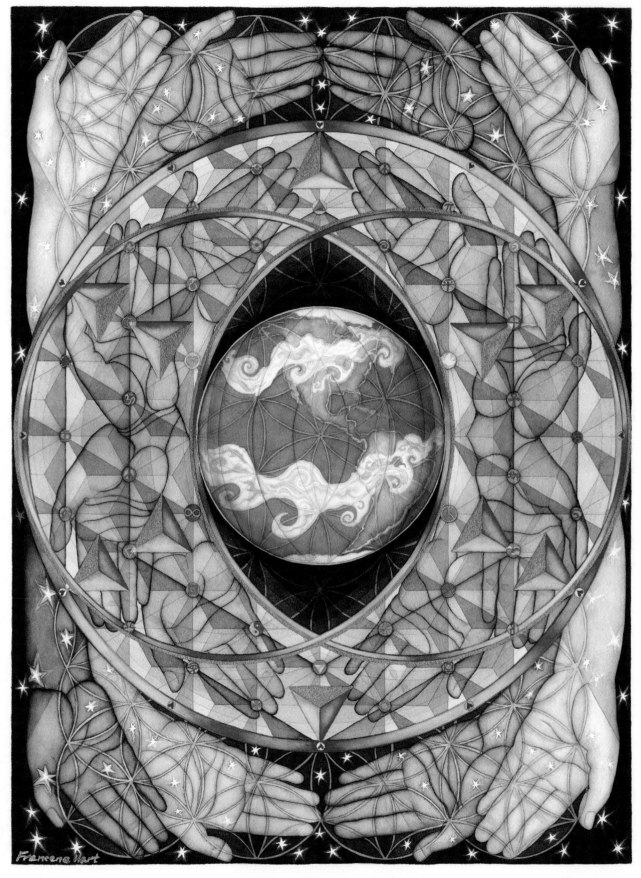

EARTH PRAYERS, 2007

Tetrahedral patterns and a vesica piscis form a protective divine matrix around the planet. Multicolored hands surround and reside within these patterns, symbolizing human participation in stewardship and sustainability.

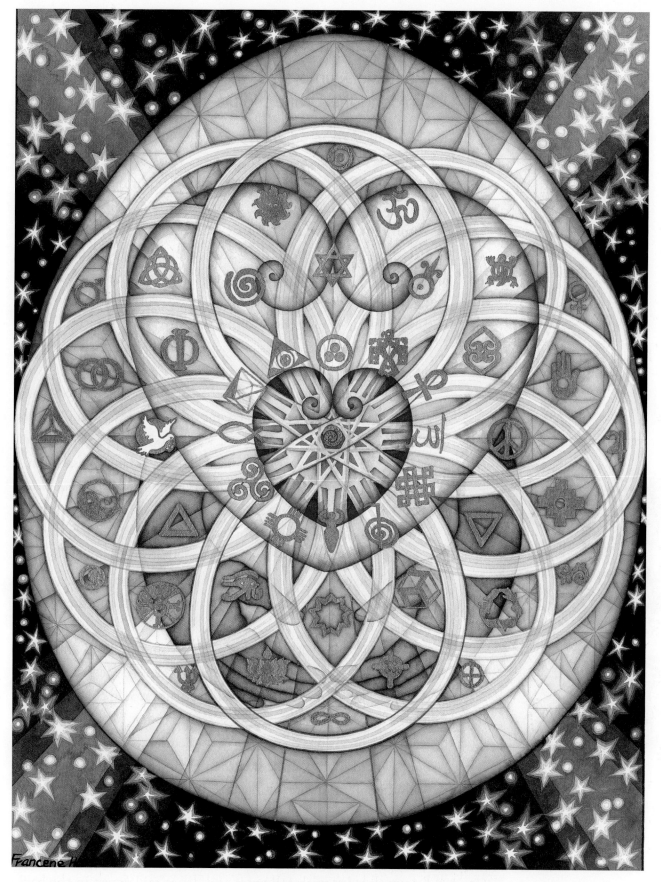

Love Thy Neighbor, 2011

This piece contains symbols from multiple spiritual traditions, sacred geometry, peace, science, and more. Six Möbius loops, or infinity symbols, wrap around the heart center, activating the aspiration to wholly honor world traditions while living in harmony with compassion.

Shamanic Journeys . . .
Exploring the Divine Nature of Reality

The word *shaman* originated with the nomadic Tungus people of Siberia and means "one who knows or knows the spirits." The term is used to describe a wide range of traditional and modern practitioners who enter altered states of consciousness in order to communicate with the spirit world for a variety of purposes, including healing themselves and others. I have encountered a number of individuals I consider to be shamans, not all of whom would call themselves shamans, using a variety of resources to connect with soul essence. Respecting diversity in spiritual traditions allows a range of visionaries to add to the wisdom of our human community.

When I lived in the forest, I had a friend who shared books and teachings that introduced me to new ideas. One day she handed me a book she was sure I would like. It was *Spiritwalker: Messages from the Future,* by anthropologist Hank Wesselman. I thoroughly enjoyed the author's storytelling, and as I put down the book and picked up a brochure for a metaphysical conference I planned to attend, something serendipitous occurred. I noticed that the event schedule included an introductory experiential workshop on the classic method of shamanic journeywork. I signed up and began a journey into shamanism and the modern mystical movement.

During this workshop, through drumming and intention, Hank helped guide us into three spiritual levels. He instructed us that after some time the sound of the drum would change and we were to return our consciousness to the room. I experienced several amazing visions during this experiential workshop series. The one I would like to share was the journey to our "sacred garden" with the intention of finding a spirit guide. This journey inspired *The Secret Garden.*

The moment the drumming began I slipped into a trance and was transported to a round, crystal clear pool surrounded by a rock ledge with tall grass and dense rain forest in the background. When engaged in shamanic visioning, I always seem to

GARDEN OF DELIGHTS

Unearthing the Source
of Inspiration

56

enter through water, and here I was floating in a pool that felt like a birthing place. This was particularly comforting since at the time I considered myself a non-swimmer. After first basking in contentment in this pool, I pulled myself up onto the ledge and lay down to rest. I listened to birds and unknown animal sounds, smelled the jungle, and felt the warmth of the sun on my skin. Something rustled in the tall grass, and as I turned to look, I saw first the flick of a long tail, then a very large golden jaguar emerging from his camouflage. It had been suggested that if an animal appeared, we might want to ask if it was our spirit guide. The answer was affirmative. I watched quietly as the elegant jaguar strolled over and stretched out on the edge of the pool beside me. I felt a sense of reassurance and protection in that moment that I had not previously understood in this lifetime. This giant cat approached close enough to touch, and I felt comfortable snuggling into the animal's silky fur and looking deep into the eyes of this great being. I then experienced a period of intimate communication that has no words, yet will dwell in my soul for eternity. When the drumming changed, signaling it was time to return to present reality, I expressed my gratitude for the revelations of this experience and slowly returned my consciousness to the room.

During shamanic journeying I came to know jaguar as a principal spirit guide. Jaguar is said to have the ability to cross between worlds. I appreciate his guidance (in my experience this guide is male) and honor our continuing journey together, which started even before this incident. After the experience I remembered several earlier instances when jaguar had made an appearance when I was not yet ready to receive him as a guide.

My sister, a student of rock art and its possible interpretations, including shamanism, facilitated a trance experiment with my brother and me. We shared a meditation utilizing one of Michael Harner's drumming CDs, while seated in a position found in archaeological relics. She was reading Felicitas D. Goodman's book from Indiana University Press, *Where the Spirits Ride the Wind: Trance Journeys and Other Ecstatic Experiences,* and wanted to explore the theories. She

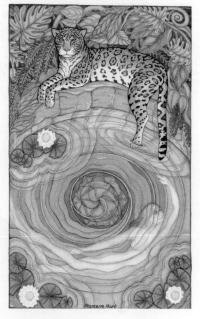

THE SECRET GARDEN, 1997

Unearthing the Source
of Inspiration

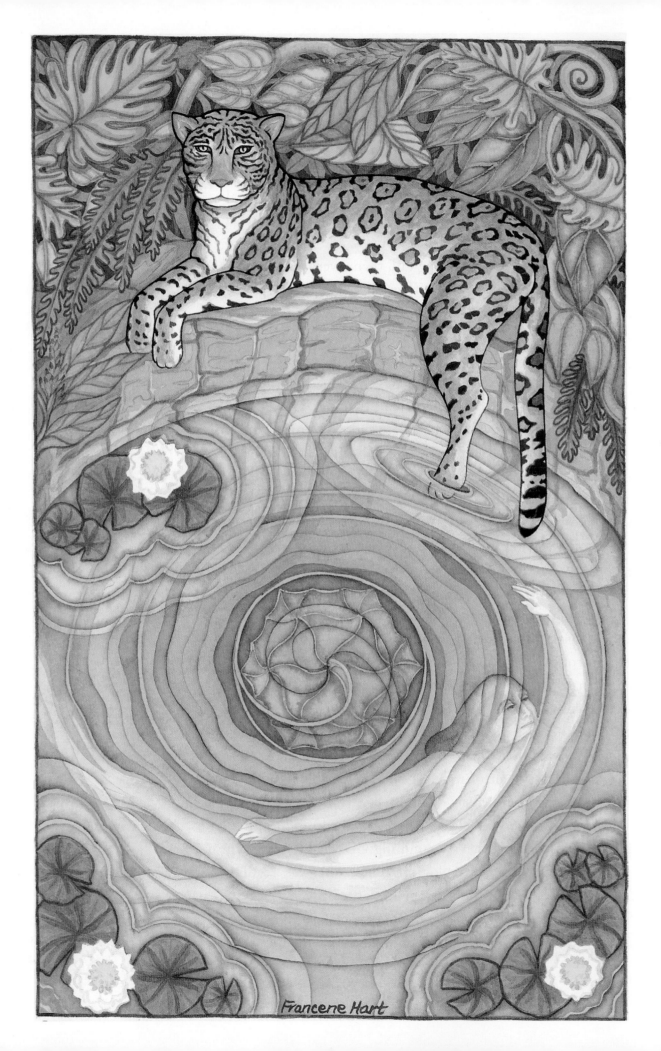

Francene Hart

demonstrated one of the seated positions but did not tell us its name or origin. I had an intense trance experience melding consciousness with a jaguar and went hunting for food to feed a starving village. When the trance ended, she told us the position was modeled after an Olmec artifact from the La Venta archaeological site, called the Tattooed Jaguar.

I had several earlier experiences with jaguar energy when I was studying the ancient Maya. At the time I assumed they were related solely to those studies. I did not imagine I would have a cat-being as my guide as I had always been "a dog person." This all feels amusing now, as my jaguar guide has shown himself both in visions and in physical reality several times.

Spirit Guides and Jaguar

Virtually every traditional culture incorporates spirit guides as part of our personal retinue of helpers. They might be saints or other enlightened individuals, guardian angels, animals, or nature spirits assigned to us before we are born. When requested, spirit guides offer comfort and guidance throughout our lives. For some the guide remains constant, but others discover guides through shamanic journeying or when help is needed most.

Jaguar has been my companion, guide, and protector for quite some time. Now that I know him well, I am able to call him into awareness and receive guidance or comfort whenever needed. In a later chapter I share a magical tale of seeing a living jaguar during a jungle tour deep in the wilderness of Bolivia as well as a second sighting in Belize.

The inspiration for *Spirit Kin* was ignited during a high-spirited Beltane campfire celebration. The shaman danced and drummed around a fire and called in the power of his spirit kin.

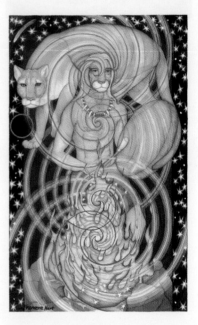

SPIRIT KIN, 2000

THE SECRET GARDEN, 1997

Something rustled in the tall grass, and as I turned to look, a very large golden jaguar emerged. The giant cat approached close enough to touch, and I then experienced a period of intimate communication that will dwell in my soul for eternity.

Unearthing the Source of Inspiration

I was transformed as I watched him morph and shape-shift before my very eyes. In this painting the shaman drums and merges with a different kind of big cat, a mountain lion (or puma or cougar), representing strength, courage, and transformation. Golden spirals set alight their fiery, dynamic energy.

In an encounter with another type of spirit guide, inspiration for *Piercing the Veil* followed an experience that seemed to connect me with a man who had recently passed. I was sleeping at the house of a friend who was mourning the loss of his brother. When I awoke in the morning, I looked up at a nearby shelf and saw a photograph of the departed holding a bundle of arrows. I had been unaware that the brother had been studying shamanism. I experienced a very strong jolt of energy as I viewed this photograph and knew it was a message to honor this passing and the path he had followed.

There are passages and veils that shamans and visionaries transcend by purity of intention and their ability to pierce through personal limitations and rational thoughtforms. The journey of this painting represents a passage beyond three-dimensional reality, penetrating the veil between life and death. The shaman holds a bundle of arrows representing the intentions of the peaceful warrior. He is surrounded by blue fire, which burns away ego, and stands amidst powerful golden phi spirals that facilitate his interdimensional journey.

Another remarkable encounter occurred during an experiential workshop facilitated by Bradford Keeney, who shares shamanic methods for ecstatic healing. I was among a number of people assembled in a circle on a beautiful meadow. Bradford went into trance and charged up the group one person at a time, then left us to interact in a lightly altered state of grace. Many joyful and tender moments occurred during the next two hours, yet the one I share here was significant as it seemed to allow me to reconnect with a participant I hadn't recognized.

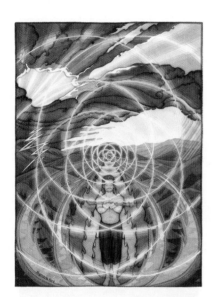

Piercing the Veil, 2000

Spirit Kin, 2000

The shaman danced and drummed around a fire, and called in the power of his spirit kin. Golden spirals set alight their fiery energy.

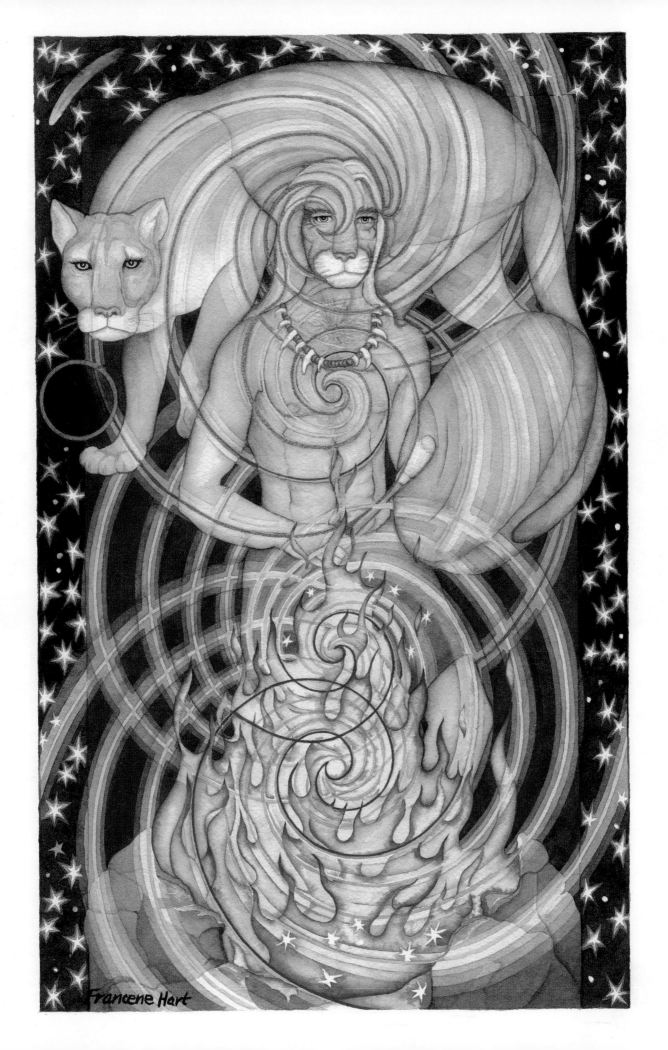

Francene Hart

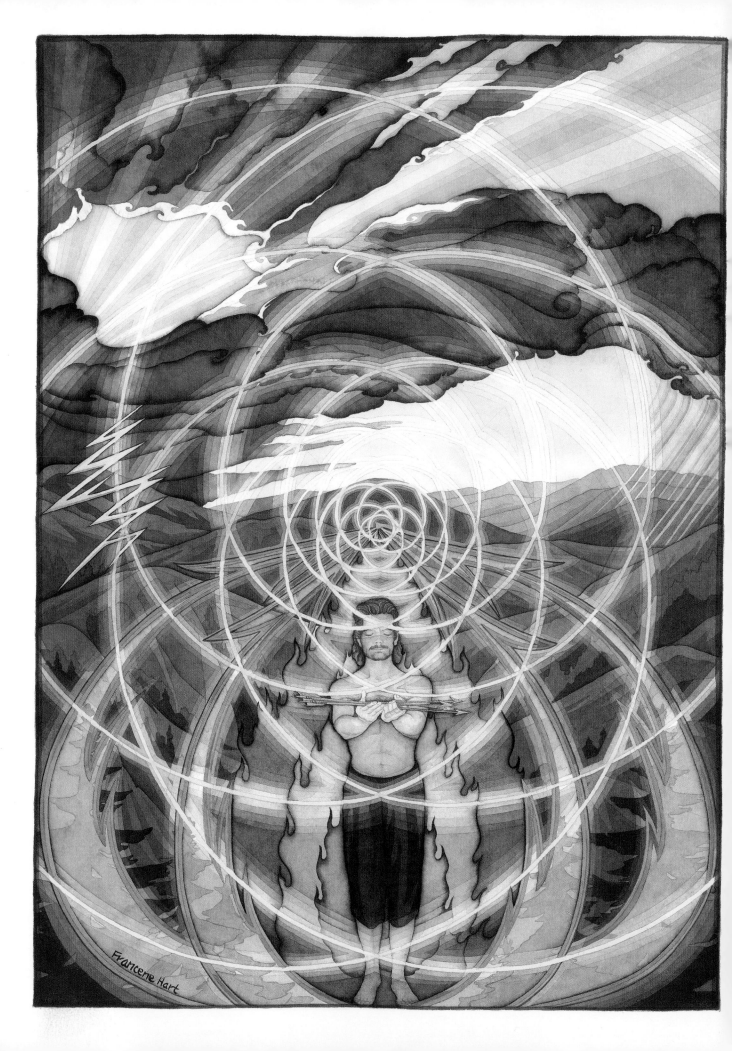

Francene Hart

At some previous time I had had a past-life memory surface in which I was wed to a native warrior who went off to battle and never returned. There was a child and a feeling of loss associated with this memory. At one moment during Bradford's ecstatic healing workshop, a man approached and gently stated, "I am sorry I did not return." It was a shocking moment and without a doubt connected us. We spoke after the session and confirmed that we shared a memory and sadness that came from being separated long ago in another lifetime. This experience became inspiration for the painting titled *Farewell to the Warrior*. It represents the moment of parting and the love shared. My companion in this experience later made a pilgrimage to the Great Plains and found for himself some soul recovery. We had no long-term association; however both of us felt that a shamanic healing had occurred.

FAREWELL TO THE WARRIOR, 1995

PIERCING THE VEIL, 2000

The shaman holds a bundle of arrows representing the intentions of the peaceful warrior. He is surrounded by blue fire, which burns away ego, and stands amidst powerful golden phi spirals that facilitate his interdimensional journey.

Unearthing the Source of Inspiration

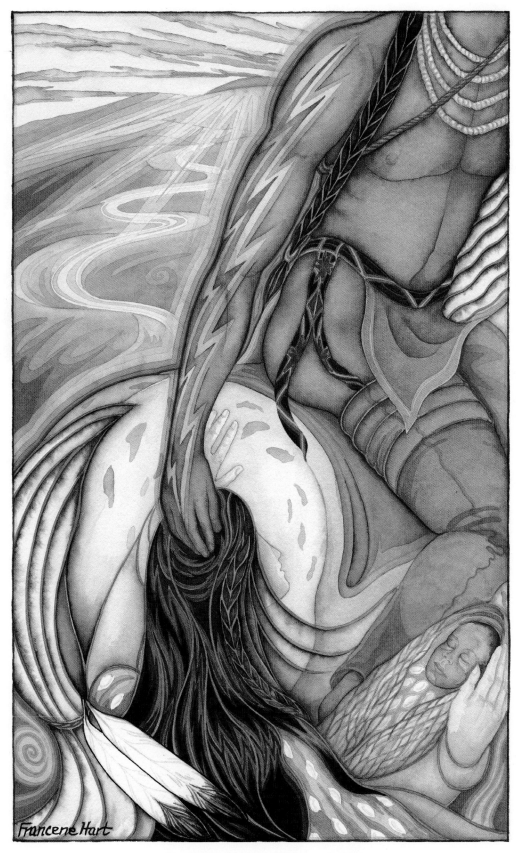

FAREWELL TO THE WARRIOR, 1995

I had had a past-life memory in which I was wed to a Native warrior who went
off to battle and never returned. At one moment during an ecstatic healing
workshop, a stranger approached and gently stated, "I am sorry I did not return."
This painting represents the moment of parting and the love shared.

SACRED GEOMETRY
The Hidden Order of Nature

Sacred geometry is a contemporary philosophical and symbolic study as well as an ancient science, a sacred language, and a key to understanding the way the universe is constructed. It is the architecture and natural design of creation. Sacred geometry, in one form or another, has been studied throughout the world since curious humans began to see relationships. Sometimes called the language of light, sacred geometry is the new science of compassion.

In the physical world we are immersed in sacred geometry. When we admire a giant spider's web glistening in the morning dew, it is not just the miracle of nature, but the beauty of the spiral webbing that attracts our attention. The intricate shapes of a honeycomb fascinate us with their story of industrious bees and strong communities, but the many remarkable hexagonal wax cells, perfectly horizontally aligned, are a marvel in and of themselves. Sacred geometry, abundant in our universe, can inspire and bring new dimension to artistic endeavors.

Divine Introduction

For many years, nature and spirit were the primary themes for my paintings. One day in the period when we were living in the woods, my son noted that I mostly worked with curves and circular imagery and suggested I try adding other shapes. Since childhood he has been my best critic, so exploring his advice I began

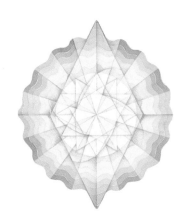

incorporating some simple geometry into one of the paintings.

Sparks flew as I layered diamond geometry into a rather simple painting. Something unique and extraordinary was happening, and although I had initiated it, I could not explain exactly what was occurring. Nonetheless it felt refreshing to be playing with expanded influences. I wanted to learn more. Curiosity and an almost childlike sense of excitement became companions during this period of study.

Geometry had not been my best subject in school, yet it felt important to be able to access this information by means of a hands-on experiential method, particularly as I was seeking to utilize the information in my paintings. I'd always been an artist, not a mathematician, so I was excited to discover that these geometric configurations could be drawn with very simple tools: a compass, straightedge, and a pencil.

I began with simple, basic forms. The diamond—which in nature is formed deep in the darkness of the earth but amplifies light when brought to the surface—is formed by two triangles. One triangle points upward, which can be seen as representing masculine, visible energy; the other points downward, which seemed to represent subtle feminine energy. Together they unite the masculine and feminine, where I was striving to find balance.

In *Diamond Mandala*, elongated diamonds, like rays of sunlight, intersect the central diamond, making it three-dimensional. I didn't quite realize it at the time, but in this way the central diamond has become an octahedron, which is considered to be an energy tool that can assist in maintaining balance in the face of challenges. The rays of light extend out to encompass spirals in each corner—the light continuing in ongoing exploration. A comet enters the scene suggesting the potential for new information entering consciousness.

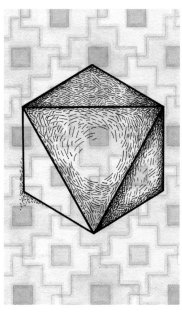

OCTAHEDRON

DIAMOND MANDALA, 1997

Elongated diamonds, like intense rays of sunlight, intersect the central diamond, making it three-dimensional. In this way the central diamond has become an octahedron, which is an energy tool that can assist in maintaining balance in the face of challenges.

Sacred Geometry

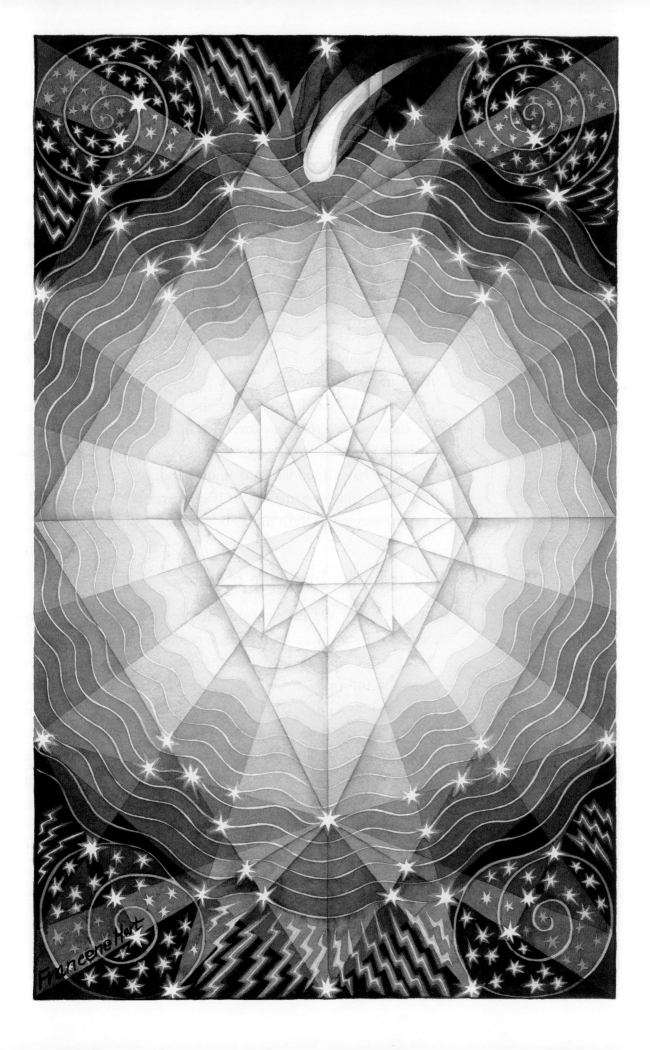

These were patterns I was finding in the forest. As I walked among the trees, powerful rays of sun shone down like flashes of inspiration, and just as leaves unfurl on young plants, I felt that my mind was opening to a new way of painting and a new way of being. It was as if the patterns in nature were reflecting my spiritual search.

When I acquired a computer and connected to the Internet, the first thing I searched was "sacred geometry." I am not sure I had even heard that term, yet somehow it directed my search. At that time I could find only three websites and a handful of books on the subject, all of which I investigated. As I write this today, there are more than 2,110,000 references on the Internet, and the field continues to grow.

I was delighted to discover the book, *A Beginner's Guide to Constructing the Universe: The Mathematical Archetypes of Nature, Art, and Science,* by Michael S. Schneider. This wonderful tome has helped with my understanding of many geometric principles and constructions. It is the first book I recommend to anyone seeking to learn more about sacred geometry.

Learning the Language of Light

As I incorporated various configurations into the paintings and watched their effect on my art, I realized I wanted to learn as much as possible about the mechanics and meaning of this fascinating information. At first I did not understand that I was tapping into a universal language of light. For a while I thought this study was simply an engrossing personal tangent. Studying and experimenting with these fascinating symbols brought me to the realization that sacred geometry is one way information is entering consciousness. Layering this wisdom into art already filled with nature and spirit felt like downloading information from the universe. Through the act of integrating these beautiful patterns into paintings, it became obvious that the information could be translated into a creative tool as a means of conveying esoteric material.

The painting process sometimes felt like turning the pages of

a book or following an obscure path in the forest, because mysteries were revealed to me as the work unfolded. Much of this discovery felt not wholly definable, yet undeniably genuine.

An Ancient Language

Like much seemingly obscure knowledge, sacred geometry was studied in ancient times, then later suppressed, forgotten, or hidden. Its resurgence in our time is a renaissance of sorts, as we are learning to expand conventional wisdom to include intuitive interpretations of this sacred language. My sense is that I simply tapped into information that was poised to become part of consciousness.

Sacred geometry is a universal language that is being remembered in our time to aid in our shift from duality to unity. I am heartened that it is becoming so widely accessible. As its popularity continues to gain momentum, all manner of people are finding ways to employ the information as creative portals. Seekers in many fields are applying this intelligence to help unlock the mysteries of the universe. There is a thriving subculture of artists and scientists studying patterns as a key to understanding everything from nuclear physics to human biology.

I am also grateful that I came to this study on my own. The awe and wonder I experienced as the work evolved was powerfully moving. In the process I discovered something new every day.

Marrying Art and Geometry

Paintings born of these studies are interwoven throughout this book. Rather than trying to explain each configuration, I will share just a few experiences that illustrate the manner in which sacred geometry has become significant to my artmaking.

In the piece titled *The Lesson,* an angelic figure invites us to explore one of the primary patterns from sacred geometry, known as the flower of life. This configuration is composed of nineteen interlocking circles, or spheres, and thirty-six partial circular arcs, enclosed by a large circle. A sphere is the ultimate expression of

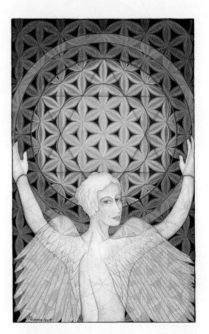

THE LESSON, 1998

Sacred Geometry

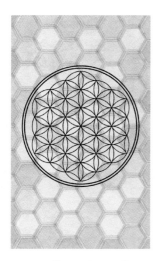

FLOWER OF LIFE

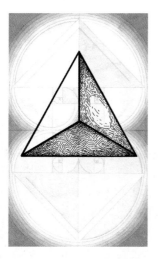

TETRAHEDRON

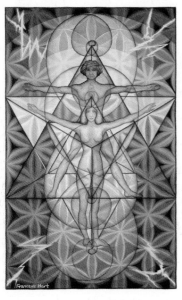

TOGETHER, 1999

all-inclusive unity and completeness, and some believe the flower of life formation holds all the patterns of creation.

The angelic being in the painting appeared to me during a shamanic meditation in which I set an intention to connect with upper realms and return with wisdom of the future. In the vision she was working on a large circular hoop, embroidering many colored threads into a magnificent tapestry. At one point in the vision she looked at me, then turned back to her weaving and demonstrated a technique in which a needle of light is used to pierce the flower of life matrix. It seemed she was demonstrating a way to weave our intentions into the future. We are all weavers of the future.

The star tetrahedron is a three-dimensional shape that joins an upward-facing tetrahedron, representing male, fire, and blade, with a downward pointing tetrahedron, representing female, water, and chalice. Together they are interlocking, interpenetrating dynamic balance and expanded awareness. The three-dimensional version of the star tetrahedron is one of the primary geometries contained in the energy fields surrounding our bodies. When activated, it forms a time-space vehicle of ascension.

Standing together within a star tetrahedron in an electrified field alive with bolts of lightning, yet grounded in the flower of life, the couple in *Together* joins in balance and co-creation. A series of golden spirals unites them, and the male and female triangles intersect, defining one another. Wanting to demonstrate these principles yet move beyond the geometric shapes used by Leonardo da Vinci in his famous drawing, *Vitruvian Man,* I took a more inclusive approach to this information. The painting also represents a balancing meditation about sacred relationship.

Another important figure in sacred geometry is the golden spiral, the cosmic representation of ideal balance, universal

THE LESSON, 1998

One of the primary patterns from sacred geometry is the flower of life. This configuration is made up of nineteen interlocking circles, or spheres, and some believe it holds all the patterns of creation.

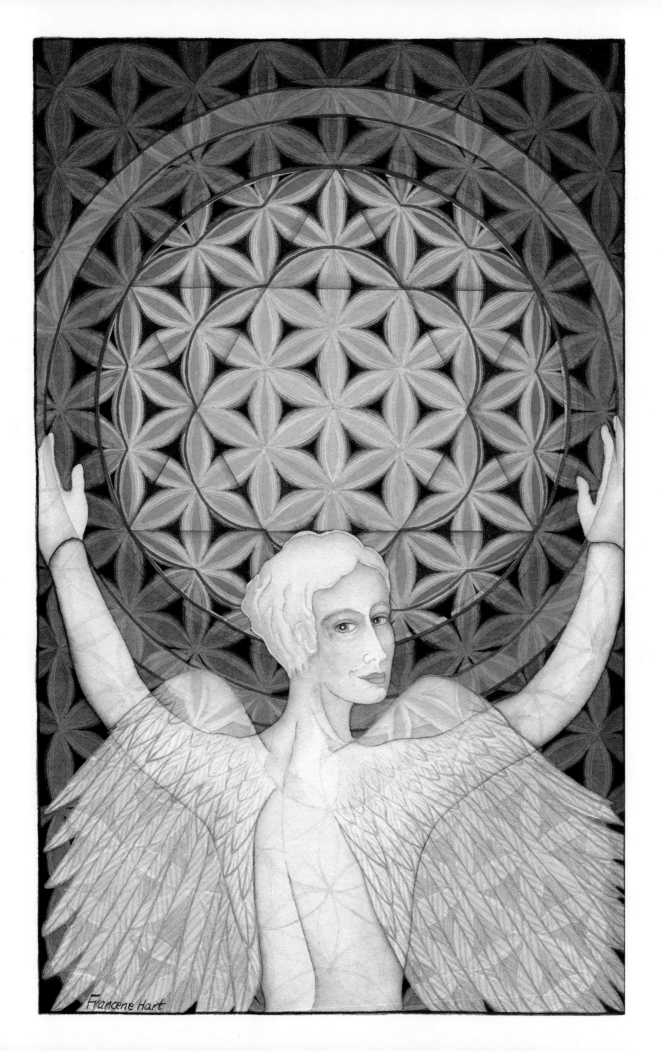

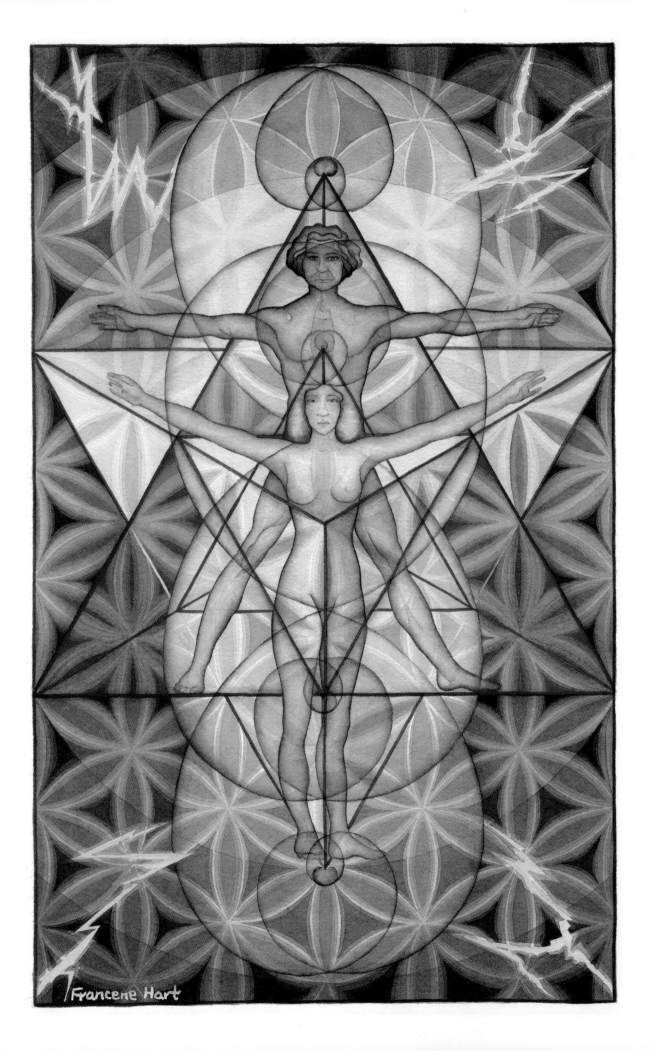

Francene Hart

harmony, and spiritual transformation. It is considered intrinsically beautiful and perfect. In ancient times, gold was seen as a perfect and beautiful metal and became associated with objects of perfection such as the golden spiral and golden ratio, also called the divine proportion. The golden spiral is a logarithmic spiral whose growth factor is the golden ratio. This spiral is the blueprint of nature and our humanness. From the spiral shape of our DNA to the spiraling motion of galaxies, this piece of sacred geometry is both container and accelerator of consciousness. Discovering that mirrored golden spirals form something very close to a heart shape has made them a highly useful element in many paintings.

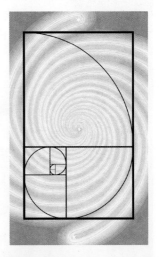

GOLDEN SPIRAL

Honoring new beginnings and emerging life force, *New Beginnings* celebrates the mother goddess as she passes on the breath of life, the vital life-sustaining force of living prana, to her child being birthed into this plane of existence. The mother goddess breathes life into all new beginnings. Hearts formed of golden spirals set in motion the energy of deep love and new beginnings.

The torus, as noted earlier, is the primal shape of the universe and is dynamic energy in constant motion. It is the shape of Earth's magnetic field. It is the nature of the torus to move energy.

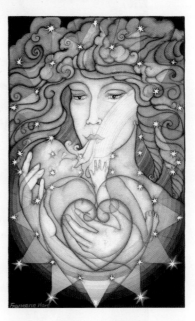

NEW BEGINNINGS, 2000

Studying this dynamic geometry gave rise to a vision of rainbow light moving with toroidal capabilities. It was a truly poignant experience translating this spin-filled energy into rainbow form. *Ka—Life Force* employs a tube torus, or rotating light, to convey spirit, or life force. Water lilies, which are intended to represent our potential for enlightenment, surround and are contained within this dynamic, spiraling, rainbow-colored torus.

TOGETHER, 1999

Standing together within a star tetrahedron in an electrified field alive with bolts of lightning, yet grounded in the flower of life, this couple joins in balance and co-creation. The male and female triangles intersect, defining one another.

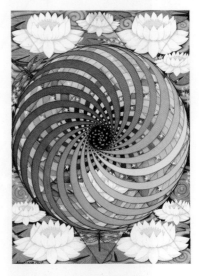

KA—LIFE FORCE, 1998

73

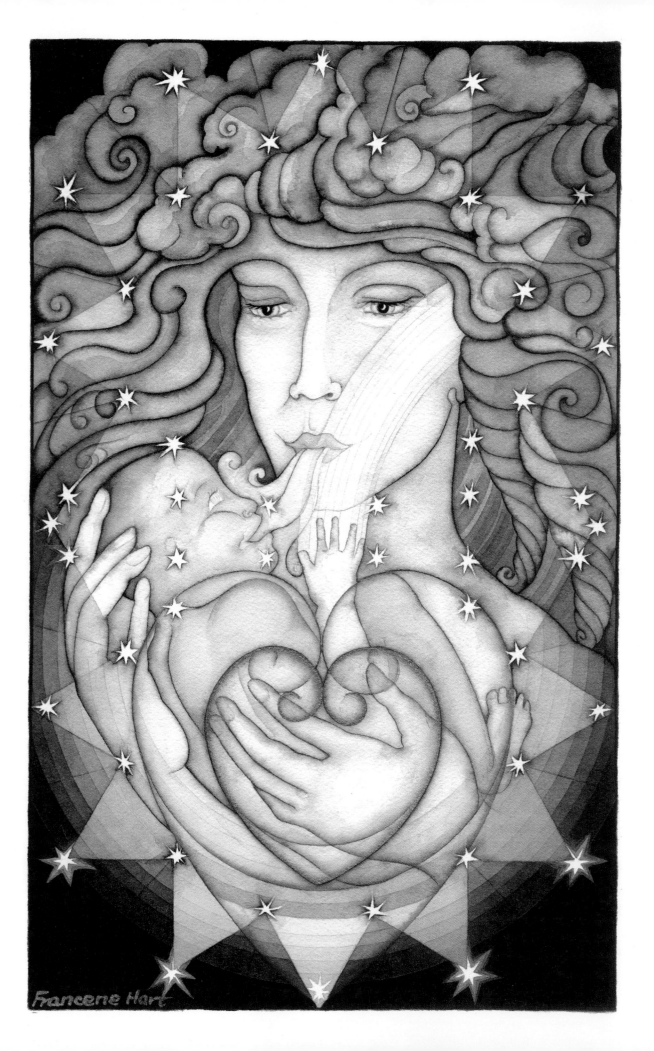

Francene Hart

Its name, Ka, comes from the *ka* (spirit) of the *merkaba* (or mer-ka-ba, light-spirit-body), which carries the body from one world to another. The merkaba is the divine light vehicle the ascended masters use to connect with those attuned to the higher realms, or conversely to descend to the lower realms. In ancient times it was believed that the merkaba could be activated by certain types of breath in meditation. At a certain point an activated merkaba puts forth a magnetic burst.

The merkaba is mentioned in the Bible as the vehicle used by Ezekiel to ascend into heaven. And in the Torah there is a reference to the *merkavah* (Hebrew spelling), meaning both "chariot" and "throne of God."

Merkaba

Sacred Geometry Oracle Deck

For a number of years I incorporated sacred geometry into works of art. Receiving messages from spirit to take this work into the world brought up many personal doubts. Living in the woods, and quite comfortable in my reclusive lifestyle, I was reticent about sharing my work with a wider audience. Finally succumbing to spirit's directive, I began exhibiting the paintings at various venues. I was amazed and somewhat surprised that people recognized and appreciated the paintings, particularly the sacred geometry aspects of my work. These studies and art had been happening in my small private world. I did not think I had discovered anything new, but recognized that I was tapping into information that was quite remarkable on many levels.

Evolution of the Concept

It had often been suggested that I create a tarot deck from my paintings. There are already many beautiful tarot decks, so

New Beginnings, 2000
The golden spiral is the blueprint of nature and our humanness. From the spiral shape of our DNA to the spiraling motion of galaxies, this piece of sacred geometry is both container and accelerator of consciousness.

Sacred Geometry

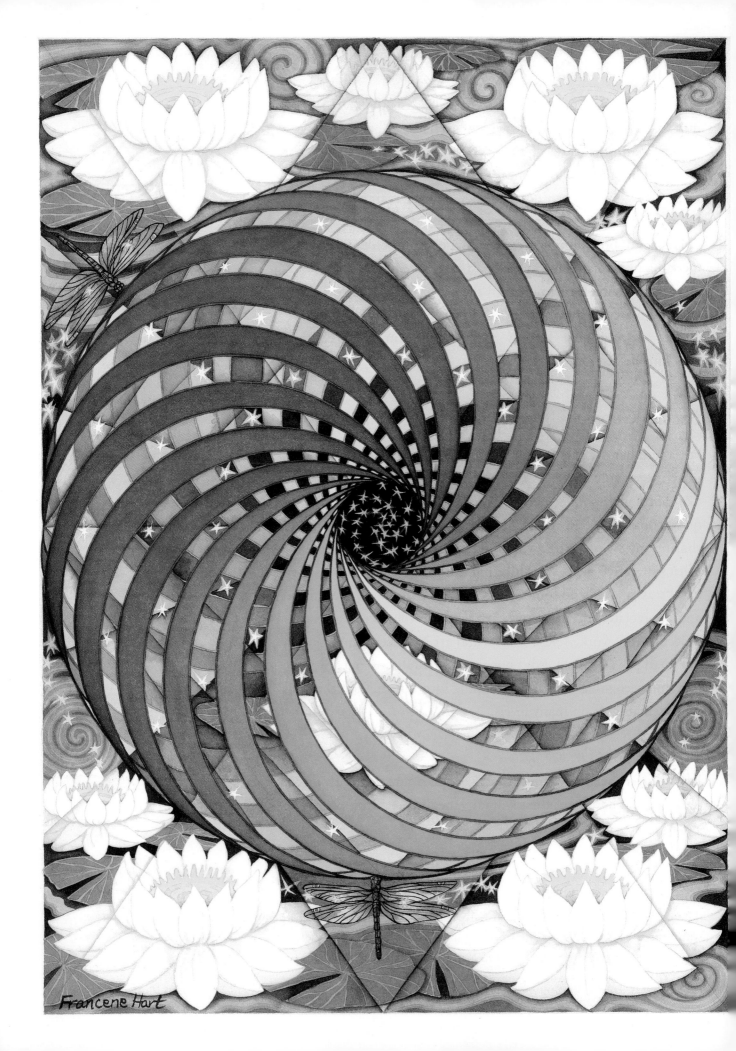

Francene Hart

when my brother suggested a sacred geometry deck, it felt wholly appropriate. Having done so much research and realizing how overwhelming the information can be when you are learning the basics, I felt it was correct to include diagrams as some of the cards. The objective was that the deck would function partially as a teaching tool about sacred geometry.

Another thing that fascinated me was that sacred geometry has existed around the planet throughout time, often having similar meanings in different cultures. This may be because it embodies both art and science, right brain and left converging, giving it universal appeal. And of course it is so prevalent in nature, our common denominator.

When I asked spirit how many cards were needed for my deck, the number 64 kept emerging. That seemed a large number for a card deck; however it also felt right, as there are many places 64 shows itself. There are 64 known codons (nucleotide triplets in amino acids) in human DNA, 64 hexagrams in the I Ching Chinese divination text, 64 sexual positions described in the ancient Hindu Kama Sutra, and there are 64 squares on a chessboard. $4 \times 4 \times 4 = 64$, and as a product of 8×8, it is the expression of a realized totality and therefore perfect. Further, the number 8 is a Fibonacci number. Fibonacci numbers, in which each number in the Fibonacci series equals the sum of the two preceding numbers, appear not just in mathematics but also in nature, for example in the arrangement of leaves on a plant stem (phyllotaxis) or an uncurling fern. So this intersects perfectly with the art that sprang from sacred geometry at a time when I was being so inspired by nature.

As the project progressed I realized that other than creating diagrams for some of the patterns, the art was already complete. I did no paintings specifically for decks, neither the initial deck nor the subsequent *Sacred Geometry Cards for the Visionary*

KA—LIFE FORCE, 1998
This piece employs a tube torus, or rotating light, to convey spirit or life force. Water lilies, which are intended to represent our potential for enlightenment, surround and are contained within this dynamic, spiraling, rainbow-colored torus.

Sacred Geometry

Path, but chose from paintings that had come through during self-education.

Next came writing the text, which was intimidating at first, as I did not consider myself a writer. Asking spirit for assistance, I stated my intention to include the research I was conducting into sacred geometry, references to cultures around the planet, and whatever guidance I needed in order to bring this project to fruition. Thus the *Sacred Geometry Oracle Deck* was born.

Sharing the Work

I was certain this deck was not meant to be self-published. A few of my paintings had been used as book covers for Inner Traditions • Bear & Company, so I submitted my idea to the Vermont-based publishing company. I am honored that they had the faith to publish the *Sacred Geometry Oracle Deck*.

Around the time the first deck was published, my life changed radically. I was led to take a monumental leap of faith and move quite spontaneously from northern woodlands to the Big Island of Hawaii. There are more details about that later in this text.

After living in Hawaii for several years, I realized there needed to be a second deck. This was not just because the first deck did not include any paintings of Hawaii, my new place of heart, but also because the concepts and art had undergone additional evolution. This time I wanted all 64 cards to be represented by art.

Destiny Books (a division of Inner Traditions • Bear & Company) graciously published the second deck, *Sacred Geometry Cards for the Visionary Path,* which reflects the increasing fascination with sacred geometry. For a growing number of individuals, its relevance has much to do with our awareness of, and participation in, conscious evolution. As we become ever-more awake to the effects we have on our reality and that of the Earth, *Sacred Geometry Cards for the Visionary Path* provides encouragement and support.

As we move toward an awareness of how these shapes and configurations affect us on levels from microcosm to macrocosm, we will develop an appreciation of a divine plan that includes the language of light called sacred geometry. Integrating ancient

Integrating ancient and modern wisdom teachings with full-color images portraying the sacred geometrical proportions in the natural forms of animals, oceans, and celestial bodies, the Sacred Geometry Cards for the Visionary Path *both steps beyond and is designed to work in conjunction with the* Sacred Geometry Oracle Deck.

and modern wisdom teachings with full-color images portraying the sacred geometrical proportions in the natural forms of animals, oceans, and celestial bodies, *Sacred Geometry Cards for the Visionary Path* both steps beyond and is designed to work in conjunction with *Sacred Geometry Oracle Deck.*

It is extremely gratifying that both decks have been well received and warmly appreciated.

Ongoing Fascination

Though I do not plan to create another deck in this series, I continue to work with sacred geometry creating paintings of spirit and vision. The information that continues to flow through the paintings feeds me and those who encounter my work in ever-evolving ways, including this book. I am humbled by this sacred life path.

Sacred Geometry

This section seems an appropriate place to include a description of the painting titled *Renewal,* which nicely represents the subtitle of this book, chronicling my "Journey on the Path of the Divine." I include it in this chapter as an inspired demonstration of the manner in which a complex combination of geometric elements can be layered in order to inform and create a greater whole. This meditative piece from 2014 superimposes the multicircular geometry of the flower of life with the complex tetrahedral geometry of vector equilibriums. A vector equilibrium includes the underlying structure of the torus and is possibly the most primary geometric energy array in the cosmos—the blueprint by which nature forms energy into matter.

Hexagons, triangles, stars, and star-tetrahedral elements all merge in a synthesis of information with the intention of bringing balance, wholeness, and a sense of renewal. Clouds, rain, and water are all symbols of renewal. The purple lotus and *om* symbol add to the meditative quality. Dragonflies, a symbol of transformation, complete the scene. Dragonflies are also thought to be messengers between the elemental world and the world of spirit.

RENEWAL, 2014

This meditative piece superimposes the multicircular geometry of the flower of life with the complex tetrahedral geometry of vector equilibriums. A vector equilibrium includes the underlying structure of the torus and is possibly the most primary geometric energy array in the cosmos—the blueprint by which nature forms energy into matter.

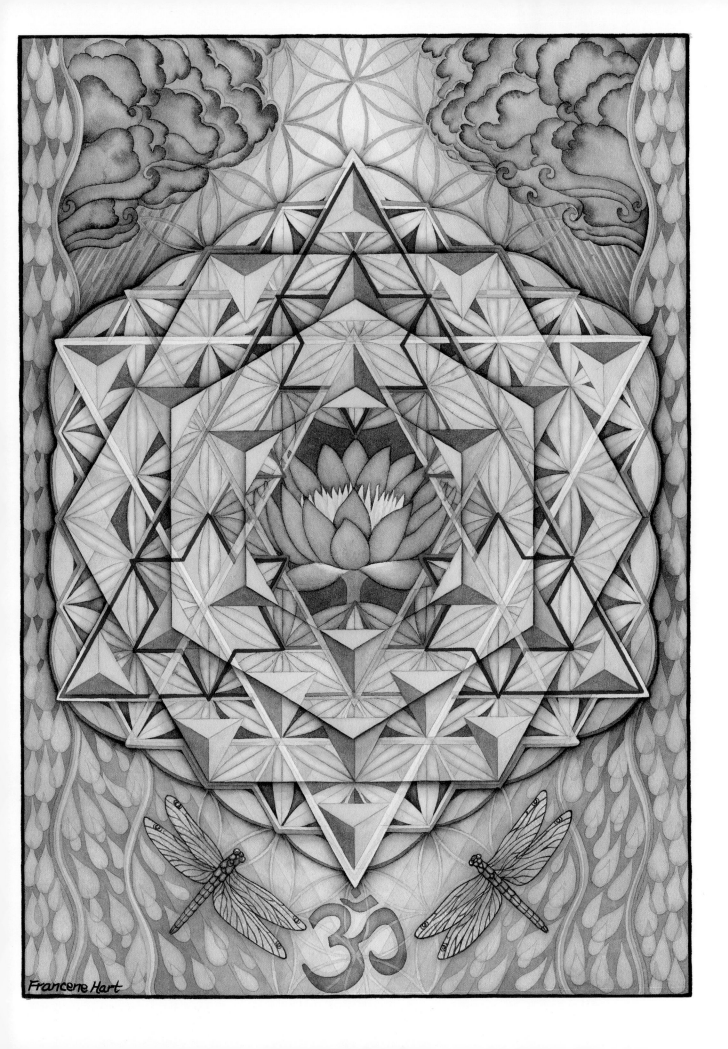

Francene Hart

EXPANDING ARTISTIC VISION
Travel Adventures and Spiritual Journeys

After many comfortable years homesteading, travel sparked an innate curiosity and yearning to experience other places and cultures. A couple of visits to New Orleans, a road trip to the Northeast and Canada, and a brief visit to Jamaica were enjoyable and initiated emergence from my woodland cocoon. These trips also helped with the recognition that it was not going to be enough to go on vacation and bask on the beach. The excitement of exotic places, peoples, and ancient sacred sites beckoned me to step out of life's comfort zone into the magic of spiritual adventure.

Along the way I was always passionately seeking inspiration for paintings. *Traveler's Prayer* was inspired simply by watching my partner offer morning prayers to the rising sun; he is the perfect embodiment of the openness it takes to fearlessly step into the world and experience whatever countless wonders may come. The geometry embedded in the image was borrowed from Mayan temple walls at Uxmal in the Mexican Yucatan. The figure raises his arms in prayer and salutation as he begins another day of adventure.

As you travel this wide world, a prayer flies with you: a prayer for safety and loving encounters, for beauty and the expansion of your world view, and for adventures that occur only when your heart is open to embrace magic.

Travel Counsels

All of the adventures shared here have been independent travel with friends. I have been blessed with some of the finest traveling companions imaginable. There is value and challenge to independent travel verses organized tours, and for some, tours are the only comfortable option. Whatever your mode . . . go explore wherever you are called, in whatever way you are able.

There are a few simple counsels regarding spiritual travel:

- Open your heart and all your senses. Allow curiosity to unlock the doors of perception and reveal the magic your soul seeks.
- Keep fed and hydrated. Tired and hungry makes for tension. Stuff comes up when traveling.
- Both supportive and difficult traveling companions offer invaluable lessons. Do not allow a crabby companion to ruin your experience.
- Powerful sacred sites may bring with them strong, even contrary energies. Observe your energy. Make a point to honor and make peace with the "spirits of place."
- When there are too many visitors, being first in the gates at archaeological sites will offer more privacy and better viewing. Look for the space between crowds and remember to breathe deeply.
- Expand your awareness to include everything around you. Problematic situations most often occur when you are not paying attention. Stay in the moment as much as possible.
- Allow self-awareness and contemplation to dispel dis-ease.
- Go with the flow. When something extraordinary happens, allow itinerary changes to help you experience mystery.

How We View the World

We live in a world filled with beauty and incredible diversity. The open-minded traveler knows that exploring even a small part of the planet may alter perspective on everything. Experiencing other cultures, both ancient and modern, meeting different

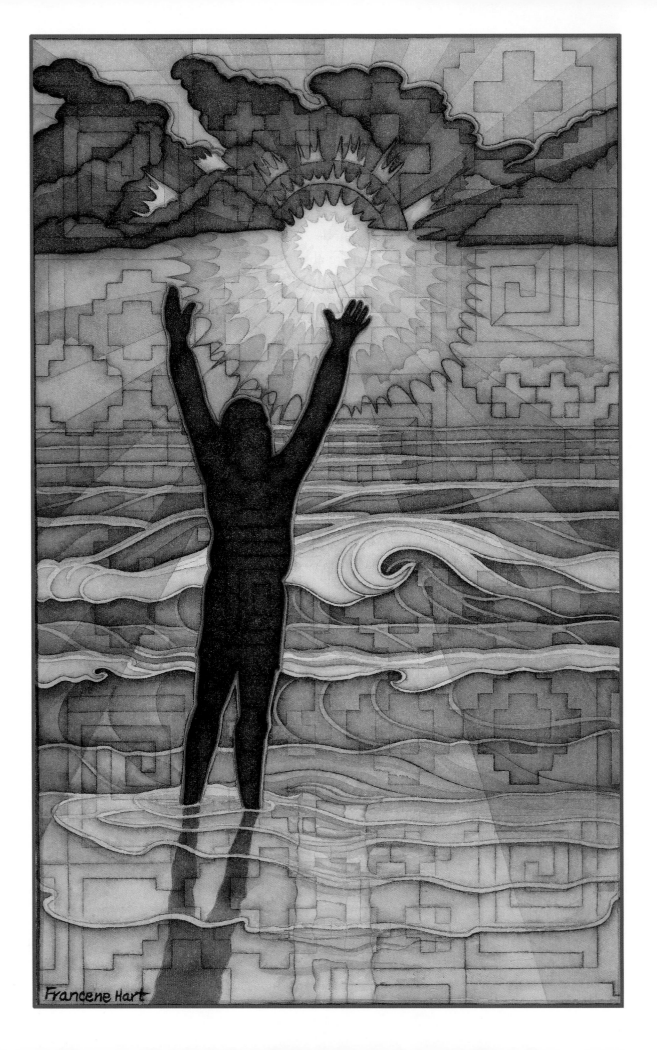

Francene Hart

peoples, and exploring unfamiliar places will undeniably reshape the way the traveler views the world.

Our worldview is the overall perspective from which we experience and interpret all aspects of life on our planet. An appreciation of diversity both relaxes and expands that worldview.

A life confined by location or choice may foster limitations that constrain the ability to understand and appreciate the amazing variety and richness that other cultures offer. Exploring fresh ideas and a variety of traditions has the potential to pop us out of the rigidity of conventional thought and strengthen our awareness that we are all human beings inhabiting a living Earth. We are all one!

Sacred Sites and Archaeology

The sacred is that which is worthy of veneration and awe. A person, object, or place may be designated sacred and regarded as extraordinary or unique. It is our intention and respect that confers this designation.

Sacred sites are places defined as having great spiritual significance, and often have religious, mythological, or historical importance. When surrounded by ancient remains, centuries-old structures, and remnants of mysterious cultures, our priorities tend to shift. It's one thing to read historical accounts or look at photographs and films of sacred places, but seeing and feeling these places, walking streets that were walked hundreds or thousands of years ago, offers an unparalleled understanding of the past and insight into possible directions for our future.

Honor the Spirits of Place
Each location holds an energetic echo of events that have occurred there. Some feel peaceful, others are filled with

TRAVELER'S PRAYER, 1995
The figure is the perfect embodiment of the openness it takes to fearlessly step into the world and experience whatever countless wonders may come your way. The geometry embedded in the image was borrowed from Mayan temple walls at Uxmal in the Mexican Yucatan.

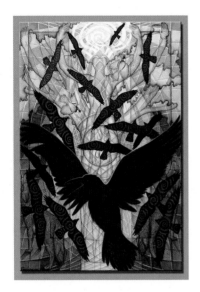

SHADOW AND GRACE

discord and a sense of risk, either physical or psychic. Many of the great sacred sites and archaeological destinations around the planet were, at some point in their antiquity, places of conflict and strife. Residues of that energy are recorded in the stones and in the land. Sometimes the shadows whisper tales of those who lived before. Traveling to these places can bring thrilling adventures or a series of misfortunes, sometimes both. Feeling the spirit of place is a real and often palpable experience. Entering these places casually or unconsciously may attract occurrences you might rather not encounter. You may fall, become lost, or have difficult communications with your travel companions.

Respect and appreciation for natural wonders and world heritage sites is extremely valuable if you wish to have a positive experience. Tuning in and openly listening to the voices of the ancestors will expand your experience. Making offerings representing your respect and peaceful intentions to the spirits of place can shift challenging energy, creating opportunities to better experience the magic of the site. You might want to show your appreciation by leaving a gift if the site permits it. An offering can be as simple as a bit of food, pure water, candle, coin, incense, a crystal, or simply an intention. In many cultures there is a protocol or custom for offerings. Often it is flowers, alcohol, or tobacco. Sometimes prayers are wrapped in leaves and left at a particular place. The cultural traditions of the place you are visiting will dictate what is an appropriate gift. Make it your practice to be aware of park policies and continually act in consideration of the local cultures, both ancient and contemporary, when you are traveling. In all regards it is primarily about your intentions. Walk in peace with respect for the spirits of place.

The stories that follow have necessarily been condensed and many details omitted due to the large number of intimate experiences around the planet that have helped make my travels so rich and rewarding. I will share highlights and offer a feel for these places while focusing on the creative inspirations that matured along the way.

Maya Dream, Central America

Fascinated as I've been since childhood by the mystery of the ancient Maya, it's no surprise that my travels have taken me to many Mayan cities and temples. When I was introduced to Central America in 1993 on a visit to the *ruinas* of the ancient Maya, I was immediately enamored of the countryside and the colorful people. The Ruta Maya travel route is one of vibrant ethnicity and sacred archaeology.

On this first journey I was naive about the history of the ancient sites and new to seeing with more than tourist eyes. It was an arduous journey of backpacking, camping, and "chicken buses"—the elaborately decorated buses that transport people, goods, and often, chickens between communities, yet my heart filled with visions that seemed to be memories from another lifetime. There was an awareness of finding a place on the planet that offered soul nourishment. The vivid colored clothing, or *traje,* of local villagers combined with their warmth and connection to the land stimulated my desire to dive further into cultural discovery. After the first visit to Mayan temples, I was hooked on discovering more and translating these experiences into art.

Tikal, Guatemala

My traveling companions were oppositional, at times bickering with each other, feeling a need to control the flow of the adventure. When we arrived at the sacred city of Tikal in the sultry Petén lowlands of interior Guatemala, conflicts escalated and it became necessary to follow separate routes. Disagreements arose again on two future visits to Tikal. Curiously, each time upon leaving this sacred place the energy shifted and harmony returned.

Tikal is a national park and a UNESCO World Heritage Site. The city was a Mayan center of great power, the largest Mayan city during the classical era more than a thousand years ago. It is a breathtaking site, filled with impressive pyramids. Some have been restored and many more lie collapsed in ruins, enveloped by jungle. The sight of temples poking through the forest canopy is astounding.

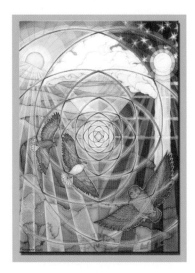

Night into Day

Because it is a park, the land and animals are protected. Dawn and dusk are greeted with the roar of howler monkeys and an incredible cacophony of bird song. Countless species of mammals, insects, snakes, and amphibians abound. Tropical heat and humidity add to the mystical feel of this astonishing jungle site.

One day I had been quarreling with one of my traveling companions, and as we reached the base of Temple IV, he stomped off, leaving me in an emotional shambles. Needing to shift the energy, I decided to get myself to the top of the great temple. A series of steep steps and wobbly ladders upward through dense vegetation, with glimpses here and there of finely built pyramid walls, led to the summit shrine of Temple IV. At 212 feet high, Temple IV is the tallest pre-Columbian structure still standing in the New World. It was a precarious climb and a personal passage that allowed me to distance myself from conflict while expanding my view both visually and emotionally. I was rewarded with mystical visions and panoramic vistas from above the rain forest canopy depicted in *Ladders*.

I came to know with certainty that the power of this great city filled with incredible temples and pyramids holds an intensity that should never be taken lightly. The energetic resonance is potent here. I've journeyed to Tikal four times and would go there again in a heartbeat. I've been tossed and tested and shown the importance of entering sacred locations with reverence. Learning to ask permission from the spirits of place to enter and respectfully explore was an important lesson.

Spiral into Palenque

Leaving Tikal, the journey took some of us through rough backcountry Guatemala by way of a picturesque river trip on the Rio Negro. Crossing into Mexico through a remote back door, we

Ladders, 1993

A series of steep steps and wobbly ladders led upward through dense vegetation. It was a precarious climb and a personal passage that allowed me to distance myself from conflict while expanding my view both visually and emotionally.

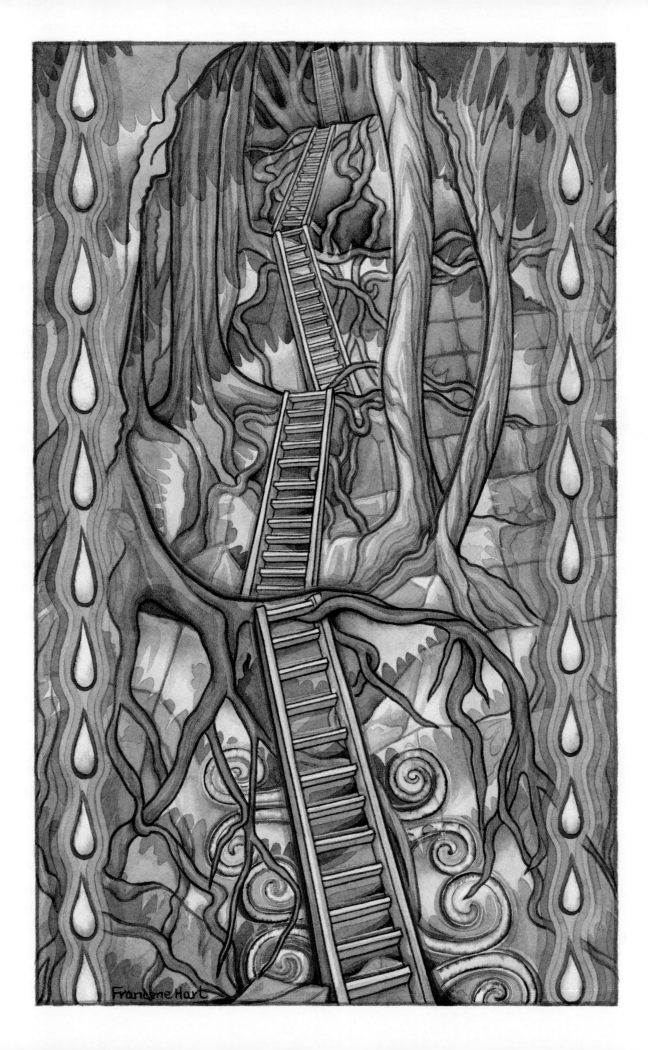

packed into an already-filled old station wagon and arrived in the middle of the night at another incredible archaeological park, Palenque, in the Mexican state of Chiapas.

There was a greater sense of comfort in this place. A feeling of familiarity took hold of my being. Every pyramid and tumbled pile of stones seemed to declare, "There is something hidden here . . . there is more to learn." I realized I needed to research the peoples who lived their lives in these places so that when I returned, as was destined, I would be better able to receive the communications of the rocks and spirits.

Mayan Dream, a watercolor from 1993, includes both dream and archaeological symbology from Palenque, a seventh-century Mayan city-state in what is now Chiapas, Mexico. It contains curved and angular spirals. Spirals represent the purest form of moving energy and ideal balance. In the background is the Temple of the Inscriptions, which was built as a funerary monument to K'inich Janaab' Pakal, ruler of Palenque from 615–683 CE. It is one of the most famous structures of the ancient Mayan world. Deep within the heart of the stepped pyramid on which the temple sits, down a steep, slippery, spiraling stairway, lies Pakal's sarcophagus, its lid nearly filling the tomb and covered with amazing glyphs. This place has become an icon of Mayan art and is famous throughout the world.

Return to Maya

In 1994, journeying with a family back to Mayan country became a play-filled journey of sharing observations with a ten-year-old traveling companion about everything we encountered. Each colorful butterfly and lizard was a source of delight and amusement. Every giggling discovery was extra special when seen through a child's eyes.

Mayan Dream, 1993

This watercolor includes both dream and archaeological symbology from Palenque, in Chiapas, Mexico. It contains curved and angular spirals. Spirals represent the purest form of moving energy and ideal balance. In the background is the Temple of the Inscriptions.

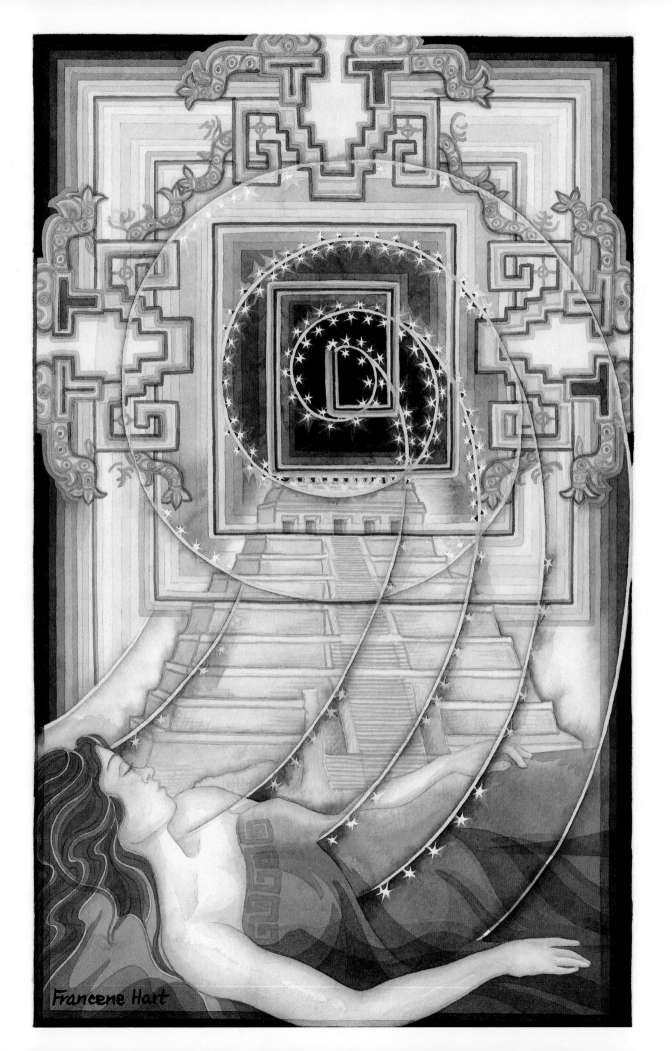

Francene Hart

This was also the year of the Zapatista uprising in Chiapas. The situation made for a thought-provoking trip, since most travelers opted to avoid this possible-conflict zone. We were safe throughout the journey, although once again experienced unusual tension when visiting Tikal.

Leaving Guatemala, we encountered a unique situation in the beautiful colonial city of San Cristobal de Las Casas in southern Mexico. The city was curiously empty, yet we wanted to show the children the *zocalo,* or plaza central, a park in the middle of town. We were unaware that peace talks between the Zapatista rebels and the government were taking place inside the cathedral in the plaza. Local police had laid down their weapons and joined the national and international Red Cross in forming three rings of protection around the church during the negotiations. It was a powerful vibration and we felt privileged to bear witness to it.

Back to the Sacred City

Again we visited Palenque. Likely because of the political disputes, this stunning ancient site was nearly deserted. I had the great privilege of spending an entire afternoon at this exquisite location with no other visitors and only one guard on site. My luxurious time alone at this incredible sacred location brought forth many images of life that felt fully real, despite a lack of archaeological proof.

The city is spectacular, filled with gorgeous temples and powerful energy. I was drawn into the jungle to a place where turquoise waterfalls cascade into a series of pools, a place known as the Queen's Bath, or Baño de la Reina. I felt a humble familiarity with this environment as I listened to the howler monkeys and sensed a jaguar stalking softly through these ancient grounds.

Queen's Bath Palenque was painted after this journey to the sacred city. The symbol in the lower right corner is a Palenque emblem glyph.

QUEEN'S BATH PALENQUE, 1996
Turquoise waterfalls cascade into a series of pools at the Queen's Bath. The glyph in the lower right corner of the painting is the emblem glyph for the city of Palenque.

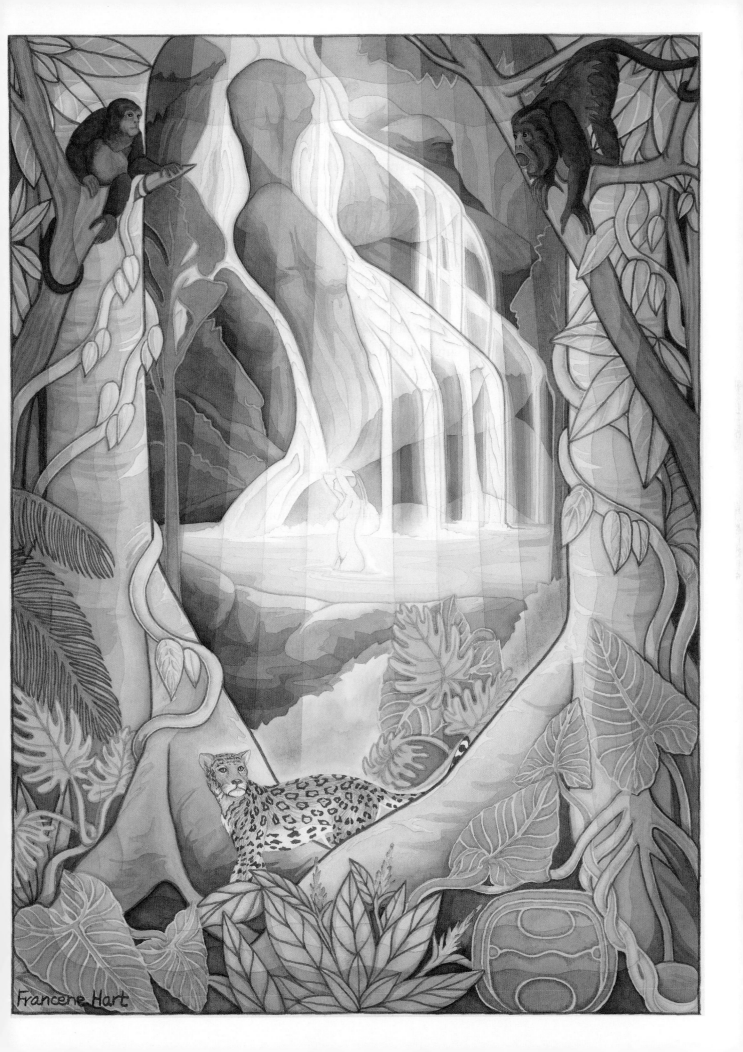

Francene Hart

Dive into History

I headed home, determined to understand more about the ancient Maya. Knowing there is depth I had missed, I intended to return with greater understanding, both archaeological and spiritual. I read several books, including *Maya Cosmos: Three Thousand Years on the Shaman's Path,* by David Freidel, Linda Schele, and Joy Parker and *A Forest of Kings: The Untold Story of the Ancient Maya,* by David Freidel and Linda Schele (William Morrow Paperbacks). In particular, Schele's life and work added greatly to the body of modern research available about the Maya. I also investigated several hypotheses about the intentions of these people known as the sacred timekeepers and the shifts in consciousness and predictions associated with the end of one period of the Sacred Round (tzolkin) calendar in 2012. Developing a greater understanding of the Maya transformed the way I view many sacred places. It was almost like seeing with new eyes. It became easier to decipher significance in the ruined structures. Beautiful glyphs and paint became more visible . . . meaning began to reveal itself.

SACRED ROUND, OR TZOLKIN

A Return to Tikal

In 1996, once again the energy of Tikal offered mind-altering, enigmatic encounters. Walking the avenues of the former capital city transported me in a fresh way and offered fascinating experiences. The temples always amaze, yet on one particular day, nature was performing her own magic. A tree next to one of the larger temples was resonating with a loud buzzing that turned out to be a huge swarm of bees. The swarm had a physical presence that looked like a spirit being, perhaps a royal one from the classical period. Or maybe the bees were simply moving their home.

There was a very noisy ruckus occurring near another temple that I felt must be investigated. Following the sound of the uproar into the jungle, I found myself beneath trees filled with two large families of howler monkeys vying for a bounty of

fruit. There was a lot of posturing among the dominant males, with bellowing roars and aggressive advances. Meanwhile mothers and babies ran every which way, scrambling to stay out of the fray. At first it was entertaining; however after a while the volume (they have been described as the loudest animals in the world) and aggressive bravado drove me to flee this din for a quieter part of the park.

Finding myself at the base of Temple IV, I was again called to climb the crazy ladders to the top. It was humid and airless climbing the walls of the great temple. Upon reaching the summit, with its splendid view above the canopy, I took time to rest and meditate. What occurred there must be described as transcendent. Looking out across the jungle canopy at several temple crests and green-mantled hills, I slipped into an altered state of consciousness and witnessed a vortex of energy opening before me. It felt like a doorway to another dimension, conceivably a means of slipping through a fold in the space-time continuum. Powerfully drawn to the position of this turbulence, I took note of its location. I was offered a vision of a ritual taking place involving a priest cloaked in a jaguar skin. Not knowing the meaning of this encounter, I nevertheless felt there was something significant to decipher.

HIDDEN IN THE JUNGLE, 1998

Later, looking at a park map of the city, I realized there was a huge, unexcavated (at that time) flat-topped pyramid at that location. I am uncertain of the pyramid's name; however this account feels correct: there is an image on one of the walls that may record a dream a person had during a ritual . . . and another carving that combines the traits of a jaguar and a frog.

Jaguars are symbols of power, and frogs are symbols of fertility and life. Was this a past-life recollection, or perhaps simply my sensitivity to this extraordinary place? Jaguars began populating my visions from this time forward.

The awe-inspiring vision from atop Temple IV became my muse for *Hidden in the Jungle.* The hidden pyramid emerged through a vision. The jaguar–water lily image was borrowed from temple walls. Truth was revealed that cannot be explained.

Expanding
Artistic Vision

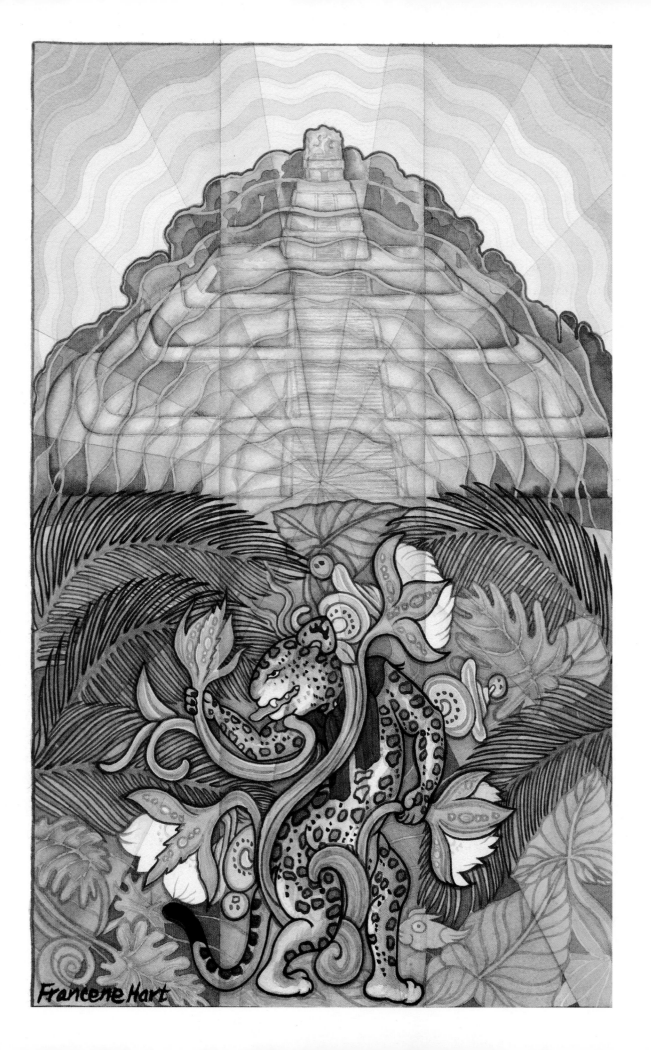

Francene Hart

Lake Atitlan, Guatemala

In 2001, shortly before I was called to move to Hawaii, I returned to Guatemala to facilitate a sacred geometry retreat. We stayed and studied at a village on gorgeous Lake Atitlan, which is surrounded by several volcanoes.

Volcanoes are considered sacred by every culture living near them. One of those at Lake Atitlan, Volcan San Pedro, was the inspiration for *Luna and the Volcano*. Quiet waters reflect geometric seeds of light from the golden orb of the full moon. A triangle of fire accents the pyramidal form of the volcanic core and speaks to its dormant energetic potential. The larger circle surrounding the pyramid suggests the eternity of the circle enclosing the power of the triangle, which represents the harmonic trinity of earth, sky, and humans. The mood suggests reflection during quiet moments, recommending that you find awe and wonder in the unexpected occurrences each day provides, and view them as pieces of your personal heroic journey.

As part of our studies we also visited Tikal. Through ritual and intentions, I was optimistic that I might finally have made peace with the energy of that powerful sacred city.

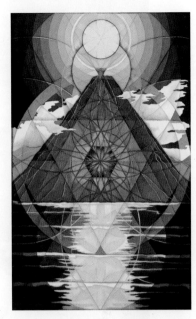

LUNA AND THE VOLCANO, 1998

Himalayan Passage

One of my most epic travel adventures, one that changed my life forever, was a journey to Nepal. I did not know my traveling companion well. We met at a metaphysical conference and felt an instantaneous soul connection that continues to this day. Laurie had previously asked me twice to journey with her to Peru, but I was living a homesteader's frugal lifestyle and thought I could not afford what seemed like an extravagant trip. This time I thought to myself, *I'd better find a way or she may stop asking*. I requested

HIDDEN IN THE JUNGLE, 1998

I slipped into an altered state of consciousness and witnessed a vortex of energy opening before me. It felt like a doorway to another dimension, conceivably a means of slipping through a fold in the space-time continuum.

Expanding
Artistic Vision

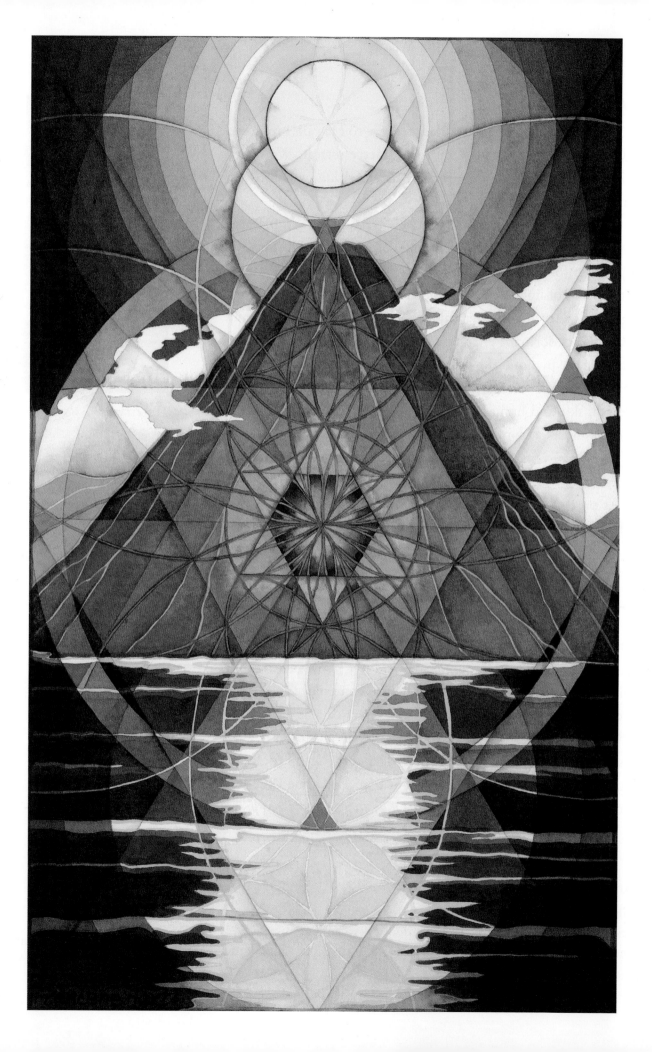

support from the universe, and funds from the sale of a painting arrived one month before our departure.

After a stop in Bangkok, we took a short flight to Kathmandu in Nepal. I was stunned by the exotic markets, the many Buddhist and Hindu temples, and the friendliness of the people. At this time Nepal was considered a very safe place to travel, even for single women. One day I took a solo walk in the city near our hotel and became temporarily disoriented. As I looked around I was filled with a sense of exotic wonder, realizing that everything I was observing was different from anything previously experienced. It seemed as if I had stepped into another time, and it felt splendid. The moment passed, and kind locals helped me find my way.

We visited several temple complexes around Kathmandu, including Durbar Square, where the city's kings were once crowned (*durbar* means "palace"), and the Swayambhunath stupa, the most ancient of all the holy shrines in the Kathmandu valley, possibly dating back to the first century. Buddhist legend holds that the valley was formerly filled with a great lake, in the center of which grew a miraculous lotus that radiated a brilliant light. When the Bodhisattva drained the lake with a stroke of his sword to allow more access by pilgrims, the lotus transformed into a hill and its light transformed into the stupa. The name Swayambhunath means "self-created."

There is immense beauty in the people of Nepal. The two beautiful children in this photo, members of one of the lower social castes, are street cleaners in Kathmandu. They use small, handheld brooms to sweep dust and tiny pieces of debris from the brick streets. The temples in the background are located in Durbar Square.

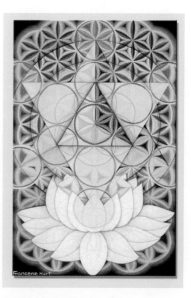

LOTUS, FRUIT OF LIFE

These two beautiful children are street sweepers in Durbar Square.

LUNA AND THE VOLCANO, 1998
Quiet waters reflect geometric seeds of light from the golden orb of the full moon. A triangle of fire accents the pyramidal form of the volcanic core and speaks to its dormant energetic potential.

Expanding
Artistic Vision

99

Trekking the Annapurna Circuit

Before we departed from the United States, Laurie suggested we plan a trek as part of our trip. Having backpacked several times, including once at 10,000 feet in Montana, I agreed. At her suggestion I consulted a trekking guide, and surmising what our time and altitude might allow, I decide I could handle it. I then spent a good deal of effort physically preparing for this adventure.

Once we arrived in Nepal, our plans changed. My friend had a dream of seeing Mount Dhaulagiri, the seventh-highest mountain in the world, the peak of which is visible when summiting the highest pass on the Annapurna Circuit. When we found an Annapurna map at our guesthouse, it seemed certain the universe was guiding us.

We caught a bus from Kathmandu early on a very foggy morning. Seeing busses pass within inches of each other on an extremely narrow rugged road, and many more that had fallen over the mountain, was unnerving to say the least. However, our bus managed to make it. When we stopped for lunch, I was quite hungry so I joined our porter guide in a bowl of *dahl bat,* a traditional dish of rice and lentils. I assumed since it was cooked it would be safe to eat. I was mistaken and it wasn't long before my stomach was in revolt. Apparently cooked food and even dust contain tiny parasite eggs. Laurie, far wiser in this instance, opted to snack on dried fruit and nuts we'd brought with us.

The old school bus continued upward through picturesque villages and beautifully terraced fields, then up a steep ascent. As the light faded it began raining and the bus got stuck in deep mud. Amazingly, the men on board somehow managed to get us moving again. Meanwhile my gut was cramping. We decided to spend the night and begin the trek early the next morning. In retrospect I know how foolish this was on my part. However at the time I did not want to be a bother or hinder my traveling companion, so I simply forged ahead.

The next morning we hiked through terraced fields, past stubbly cut-over woodlands, on through richly forested mountains, then above the tree line. Every day was a gift and a challenge. My muscles and hiking abilities were fine . . . my intestines were not. I had brought along antibiotics a doctor friend had given me,

which helped considerably for a while. Since that incident I've added grapefruit seed extract to my travel supplies. I learned the hard way the importance of protecting intestinal health.

There are difficulties and plenty of opportunities for growth when trekking. I experienced fear regarding several issues and was presented with the opportunity to face them all, one at a time. At the start of our hike a narrow, broken part of the trail frightened me until our porter guide cut me a walking stick, which helped with my sense of stability. I thought I might be afraid of the swinging foot bridges and there was one narrow crossing near our start that rattled me. However most of the bridges are wide with hefty handholds and netting, so that even if you slip there is no danger of falling into the river. Realizing this, I decide to enjoy them, even bouncing in the middle.

One of the most frightening incidents was when the trail forced us to cross a recent avalanche-scree chute. The loose rock debris and shifting shards along a trail snaking precariously above a many thousands of feet drop truly worried me. It took a great deal of effort to compose myself in order to traverse this particularly dangerous crossing, with Laurie offering energetic and verbal support.

Having made it across, I needed a moment to integrate what had just happened. My process was to be quiet, observe what had happened, and then release the charge. Laurie, who is a metaphysical teacher, exuberantly cried, "Francene, that was fantastic! You did it. That was an initiation!" I rudely told her to shut up, a comment quite unlike me that deeply hurt my friend's feelings. I felt bad for my reactive response, and it took some time to appreciate that she was not trying to preach to me; rather it is her manner to enthusiastically encourage others. Our conflict transpired largely as a consequence of not knowing each other well. Fortunately we managed to work through this damage. Laurie will forever be my inspirational, supportive soul sister.

Most of the trail was easy enough to trek. It was a very old route that has been traveled for centuries. There were gorgeous sections that looked like well-worn stone stairways spiraling around precipitous outcroppings. Much of the trail was wide and safe for foot and donkey traffic.

Villagers wished us a sincere "Namaste" as we passed on the trail.

One thing I will be eternally grateful for is that early on in the trek I made a conscious decision to turn on the perceptual cameras and record every moment. I did not want to miss the beauty and magic all around me or spend time complaining. I have been on many extraordinary adventures, yet I recall this Himalayan passage in greater visual detail than any other.

As I review this writing my heart goes out to the people of Nepal who, in April of 2015, experienced a devastating 7.8 earthquake and multiple strong aftershocks, with a huge loss of lives and livelihoods and of many sacred temples and villages. It is heartbreaking to know that many of the places in this story may no longer exist, or at least not in the same form. Although we took many gorgeous photographs, they can never do justice to the magnificence of the Himalayan environment. These are a few of my visual memories of Nepal:

- The beauty and diversity of the villagers, and their sincere *"Namaste"* as we passed on the trail (see photo above).
- Deep shadows, lush fragrant forests, and incomprehensibly magnificent mountain vistas.

- Diminutive men with calves of iron carrying several cases of beer or soda on their backs up extremely steep trails.
- Crazy swinging footbridges over wild rivers, and donkey trains hung with bells that rang out a warning to move off the trail.
- Long rows of prayer wheels and piles of exquisitely carved Mani stones covered with prayers. I whirled every wheel in continual prayer for myself and for all beings.
- Stunningly clear starry nights that I appreciated after leaving the warmth of my sleeping bag for the outhouse in the wee hours.
- Traversing the treacherous edge of an ancient glacier and being astounded by the primeval energy surrounding us.

We had rain for our first few days of the hike, which indicated there would be snow farther up the mountain. We met hikers trudging down the trail, frustrated and disappointed. Some had tried to wait out the storm. However at this juncture the Thorong La pass, which is where we were headed, was closed due to deep snow and high winds. We decided that if the next morning dawned bright, we would proceed. As fortune had it, the next day was gorgeous. The trail to the pass opened again just a day before we arrived. This lifted my spirits, as I would not have wanted to turn back having come so far.

After thirteen days of trekking we reached the village of Manang at 11,000 feet, and were advised to stay an extra day or more to acclimate to the altitude. At this point my body rebelled and I was in bed and very weak. Unable to eat much and in pain most of the time, I knew it was essential to stay nourished and hydrated. I added Emergen-C to every bottle of water. I was also able to down a hot protein drink most mornings and sometimes a small bowl of boiled potatoes later in the day, which is the only thing on teahouse menus not cooked in generous amounts of yak butter. Watching the people and village from the tea house window, I saw that even the children had leathered skin, yet bright abundant smiles. I watched men playing cards on a porch at about 15°F, and a woman washed dishes amidst encircling clouds of steam. Life in this environment is harsh and demanding.

The next morning we were to begin again and I felt I could not move. My friend returned with the news that she had found me a horse to ride for the day. I am not a horse person, yet here was my rescue. I was apprehensive; however after a short time I realized this sturdy little equine was strong and sure-footed, and not going to toss me over the cliff. For a time I felt like a queen riding in the great sacred mountains. I watched several large ptarmigans, peccaries, a couple of giant birds that look like griffins spiraling along the precipices, and many long-haired yaks. It was a luxury to enjoy the magnificent mountain vistas without the need to watch every step. Alas, when we reached deep snow my sweet savior horse could take me no farther.

The horse's owner led me to a tiny hut where I had a remarkable experience. Several men were huddled around a small central stove where a woman was cooking *tsampa,* a traditional Tibetan roasted barley-flour dish, which she topped with greasy bits of yak meat. I could not understand a word of the stories being shared, nor could I have joined them to eat even if I had not been ill. However, sitting in the warmth of the moment, the richness of the experience allowed me to feel blessed that I could be here as an almost invisible witness to an everyday life I could barely have imagined before this adventure.

That night the water bottles froze solid in our room. The following day we made it to Annapurna Base Camp. The few trekkers ready to climb to the nearly 18,000-foot Thorong La pass left mostly before dawn. We were slower getting started. As we began the climb we could see a ribbon of tiny headlamps moving steeply upward ahead of us.

That day was perhaps the most demanding of my life. I had no idea how I was going to make it in my physical state, yet began with a prayer, holding the vision of standing at the crest of the Thorong La pass. As the day progressed the snow-covered trail appeared to extend to the heavens. Each time we rounded a corner I envisioned seeing the summit. Around noon the winds picked up and the trail of footprints before us began to disappear. At a critical juncture, even though I knew there was no other choice, I felt I could not go on. My friend took hold of me and said, "You have to ask for

help!" Drawing from inner reserves, I silently asked my guardians and guides for any help they might offer to help get me over the top. A sense of peace came over me, and Laurie and I held each other for a few moments before moving forward again. Though it did not make the path easy, there were three specific times during the remainder of that climb when I sensed tall presences on either side, holding me under my arms, helping to lift me up. There was no doubt they were my angels. The painting *Not Alone* honors the support of those divine helpers who offered spiritual assistance during an incredibly challenging trek. These tall angelic figures undeniably provided a much-needed boost of endurance as I climbed through deep snow on this high mountain pass.

From that moment on I began a mantra. . . . There is no up, there is no down, just one foot in front of the other. After many difficult hours of hiking we reached the summit, and though I had hoped to feel triumphant, I was merely humbly satisfied that the ascent had been accomplished. We were at the top of the world and the view was absolutely spectacular. The sacred aspect of this day was profound.

It was another 5,000-foot descent in elevation before we reached the village of Muktinath at dark. I wholeheartedly praise our sweet porter guide, Rauda, who assisted me greatly throughout the trek and especially descending the mountain that evening. We were the last to arrive and some thought we might have been lost. After sixteen days with dysentery, I was in an exceptionally altered state, perhaps very close to being lost.

A ten-day Hindu celebration was taking place in Muktinath. The village was filled with colorful pilgrims, some of whom had walked hundreds of miles from India. Following a day of rest, we planned to trek the following morning to Jomsom. I awoke in intense pain. After the stress and relief of making it through the past few days, my gut felt like it had turned into a painful rock. We began the decent very slowly . . . exceedingly slowly. It was an incredibly surreal experience.

The trail was dusty and the scene had a desolate beauty highlighted by a stream of pilgrims in multicolored *saris* heading for Muktinath. Even the most elderly seemed to flow around

Not Alone, 1999

I love the weathered face of this gorgeous elder we photographed in Muktinath.

**Expanding
Artistic Vision**

105

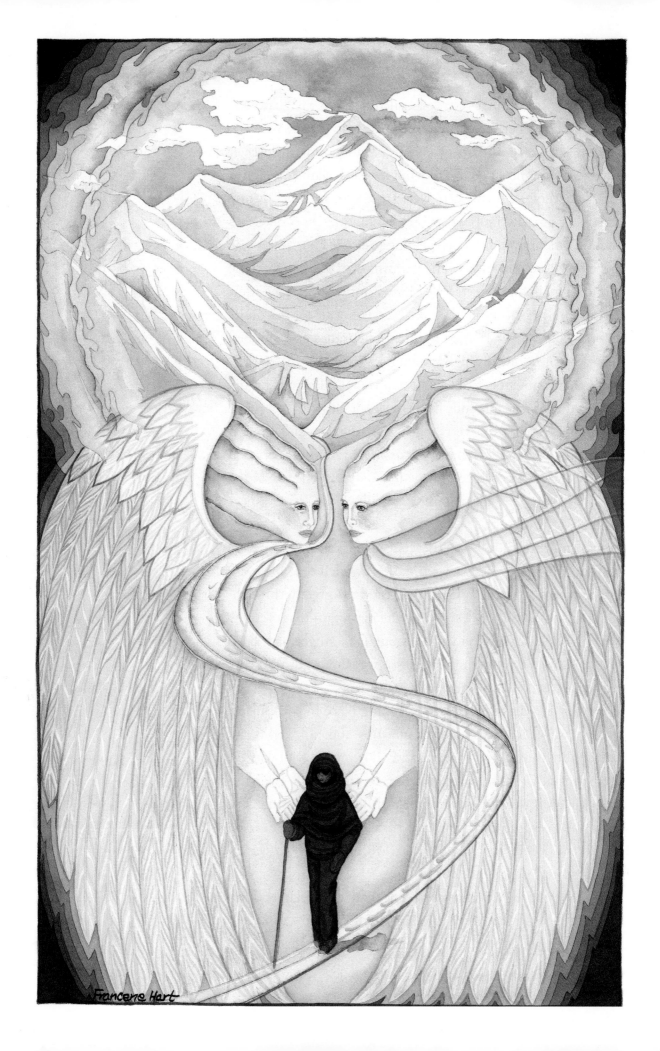

Francene Hart

me quickly as I continued the mantra, "One foot in front of the other." By this time my steps were baby steps. As the afternoon light lengthened it became clear I would not be able to walk the final few miles to Jomsom. My friend again found a small horse to carry me. This one galloped down the rocky riverbed trail and I was definitely not in control.

We were now trekking in a part of Nepal adjacent to Tibet in the "snow shadow" of the Annapurna Range. *Forbidden Land* was inspired by the stark beauty and otherworldly experience, looking from the trail into the remote Mustang District of Nepal. Mustang straddles the Himalayas and extends northward onto the Tibetan plateau. This region was called the "forbidden land" because it was, until recently, closed to Westerners. Lightning bolts crisscross the circle of infinity in this painting. The lightning bolts' fragmented geometric shape is found in nature and thus in sacred geometry, and it has figured prominently in many cultures since ancient times, when it represented the wrath of the gods.

This was as far as my feet were going to take me. Jomsom is the only place to fly out of in this region so Laurie booked us a flight. Arriving the following morning at the mountaintop airstrip, we spotted our ride. It was a Russian jet helicopter owned by Nepal Airways, and we sat military style with packs in the center.

Before the start of our trek I had read accounts of forests of blooming rhododendrons along the trail. We had seen only a few on our trek, yet each filled the valleys with fragrance. On the helicopter ride out, the attendant offered me her seat with a tiny window, and as we went whooshing down the mountain, I was able to see huge forests splashed red and pink. This fulfilled a missing piece of my journey and gave me cause to smile through the pain.

Back in Kathmandu we went directly to the Nepal International Clinic. I was twenty-five pounds lighter than when the trek began. I learned I had contracted three kinds of dysentery,

Forbidden Land, 1995

Not Alone, 1999

The painting *Not Alone* honors the support of those divine helpers who offered spiritual assistance during an incredibly challenging trek up and over the Thorong La pass on the Annapurna Circuit.

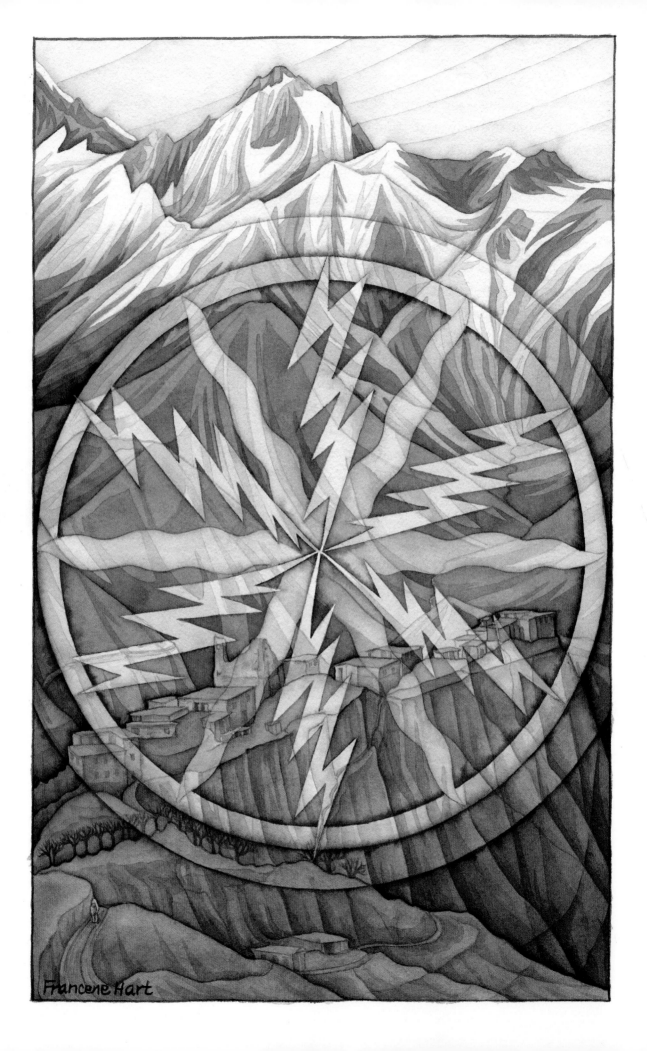

Francene Hart

including amoebas, which I was told eat holes in your intestines, and three doctors told me it was a miracle I survived.

I'd known during most of the trek that I was in peril; however I never thought I might die, just that I had to keep moving forward. That attitude, the help of our porter guide, my friend, and angels are likely reasons why I am here today. Though I hope never again to hike at extreme altitudes or have a similar parasitic experience, it was an incredibly important opening and created a kind of rebirth in my life and art.

Back home, Laurie had a reading from her friend, Kate, who channeled the Wise Ones and was told she had been my spiritual midwife. I live in gratitude and appreciation for the transformation she helped me to birth.

Himalayan Passage honors this transformational journey to Nepal. The symbolism appeared as one of the first places I recognized sacred geometry entering the work. There are three triangles representing not only the magnificent mountains, but also the passage I experienced, body, mind, and spirit. The immensity of the lessons learned and gifts received trekking the Annapurna Circuit over an 18,000-foot pass are still being revealed many years later. Namaste.

TRANSMUTATION

Peru and Bolivia

Again traveling with my dear metaphysical friend Laurie in 2000, I knew there would be magic in the mix. We landed in Lima and spent a couple of days enjoying the garden district, then flew to Cuzco. The altitude jumps from sea level to over 11,000 feet at Cuzco, so it's essential to take time to adjust. The first day we took a taxi to one of the temple ruins. Struggling to catch my breath, I watched a group of children running and laughing, playing soccer. It is amazing how adaptable human beings are! From there we

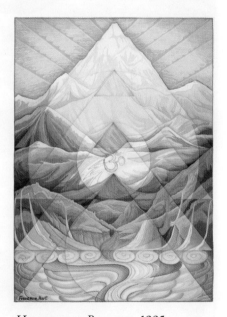

HIMALAYAN PASSAGE, 1995

FORBIDDEN LAND, 1995

This lightning-crossed painting was inspired by the stark beauty we could see from the trail into the remote Mustang District of Nepal, formerly forbidden to Westerners.

Expanding
Artistic Vision

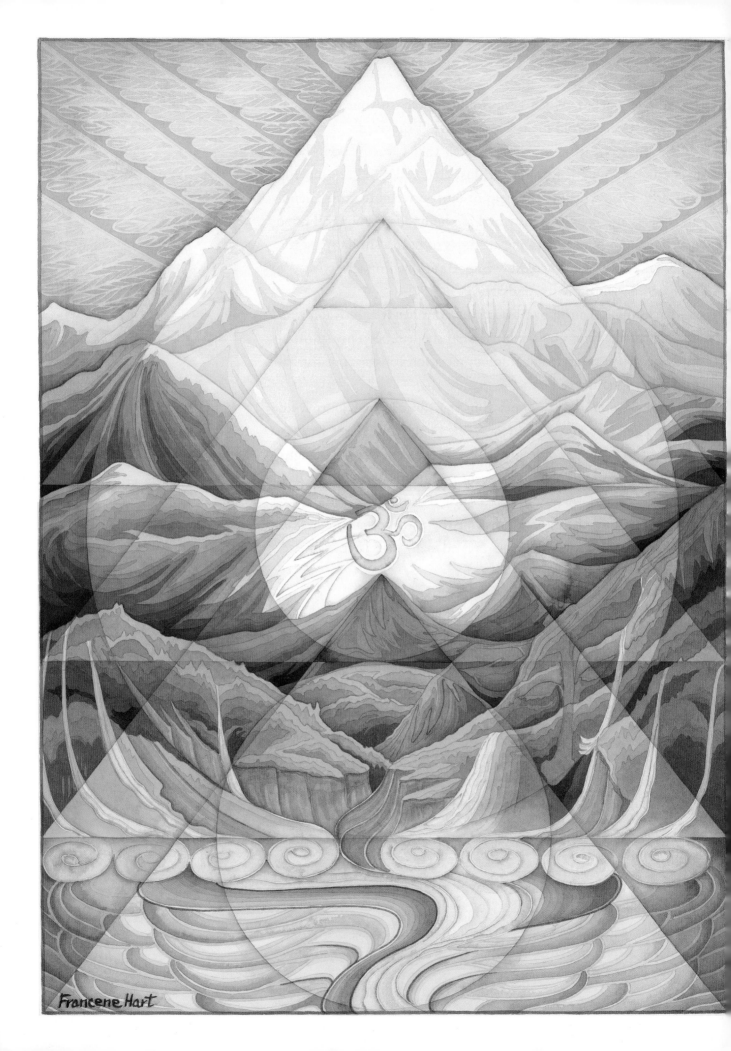

Francene Hart

walked down the mountain through fields of potatoes and flowering lupine, arriving at the archaeological sacred site of Sacsayhuaman, the historic capital of the Incan Empire, as the light was fading.

The city of Cuzco's layout was designed in the shape of a jaguar. Located high above the city streets, Sacsayhuaman is the jaguar's head. The turbulent history of this place and massive interlocking walls create an imposing presence. Because of several of its qualities, it is considered to be one of the greatest monuments that mankind has built. We would return to investigate the magnificent stone walls and sacred spaces, yet before the light completely faded Laurie wanted to take me to a place she called the "magnetic circle." It is said to be the remaining base of a tower, part of a reservoir system. This would have been the eye of the jaguar. It consists of three concentric, circular stone walls connected by a series of radial walls. The tower this base supported was long ago dismantled for use as building material in the city.

We were tired from our long day, yet there was no doubt this place held immense power; its resonance was tangible. I was watching my friend offering her prayers in the center of the circle when I stepped off a stone ledge, fell, and put a hole in my hand. As I watched blood appear in my palm, it occurred to me that I had forgotten to greet the spirits of this great place. Remembering that in many cultures a blood offering is required in homage, I humbly entered the circle and closed my eyes, offering blood and blessings. When I opened them, a huge full moon was coming up over the mountains, flooding the site with a dreamlike luminescence. Auspiciously, it was the night of a full lunar eclipse, which we would witness later.

It was time for us to leave the site, as Laurie wanted me to

PHASES OF THE MOON

HIMALAYAN PASSAGE, 1995

The symbolism in this painting was one of the first places I recognized sacred geometry entering the work. Three triangles represent not only the magnificent mountains, but also the passage I experienced, body, mind, and spirit.

Expanding
Artistic Vision

111

CHAKANA

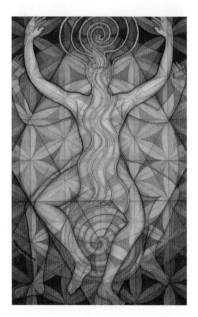

DANCING PRAYER

meet Mauro, a local shaman, before it became too late, so we walked down the long stone stairway back to Cuzco. As we entered the antiquities shop he owns with his family, without introduction Mauro's face lit up and he and I embraced, then laughed, embraced, and laughed again for several minutes. We spoke no mutual language yet the warmth of our communication was unquestionable. We would meet Mauro again later in our adventure.

The figure in *Andean Shaman,* painted later that year, expresses the essence of Mauro's welcoming energy. He greets visitors in salutation, extending hand and heart energy, inviting them to embrace the joy of feeling truly welcomed. He is a vessel of spirit, consciously able to receive energy from Source and move it through his being, transmitting it energetically into the world.

The stepped geometry in the painting refers to the Andean symbol called the *chakana,* or Inca cross, which symbolizes spirit moving through the lives of the people. Similar symbols are found in cultures throughout the world. Traditionally the chakana also represents the Southern Cross constellation, visible only in the southern hemisphere. According to ancient Andean legend, it was the center of the universe.

The following day we planned to book a train to Lake Titicaca, yet were uncertain of the timing. As we stepped out of our favorite breakfast spot, a driver Laurie had met years before was waiting at the curb. In short order, divine timing had us on the road in an old, mostly reliable car. The mountain vistas were amazing, and as it was a saint's day (I don't recall which), the villages were filled with colorful parades. There was even a parade of four elaborately costumed dancers marching along a remote stretch of highway. As the day faded it began to rain hard and it became evident that the windshield wipers were not functioning. The last hour of this drive was worrisome, since as far as I could determine we had zero visibility, yet again we made it safely to our destination.

Our stay for the night was in the village of Puno at the west end of the Great Lake. That night in our tiny room, Laurie and I spent hours in deep connection with spirit. What occurred for

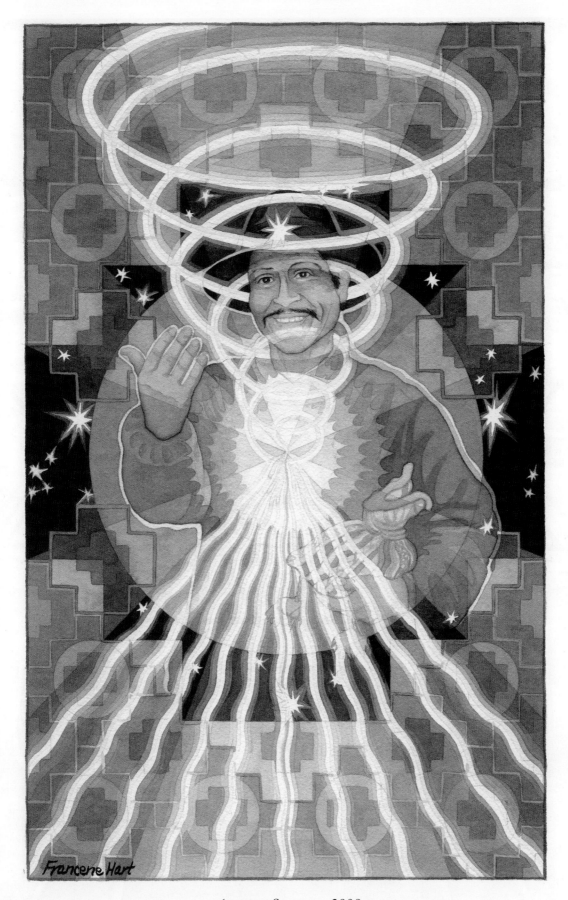

ANDEAN SHAMAN, 2000

The shaman is a vessel of spirit, consciously able to receive energy and move it through his being, transmitting it into the world. The stepped geometry refers to the Andean symbol called the *chakana,* which symbolizes spirit moving through the lives of the people.

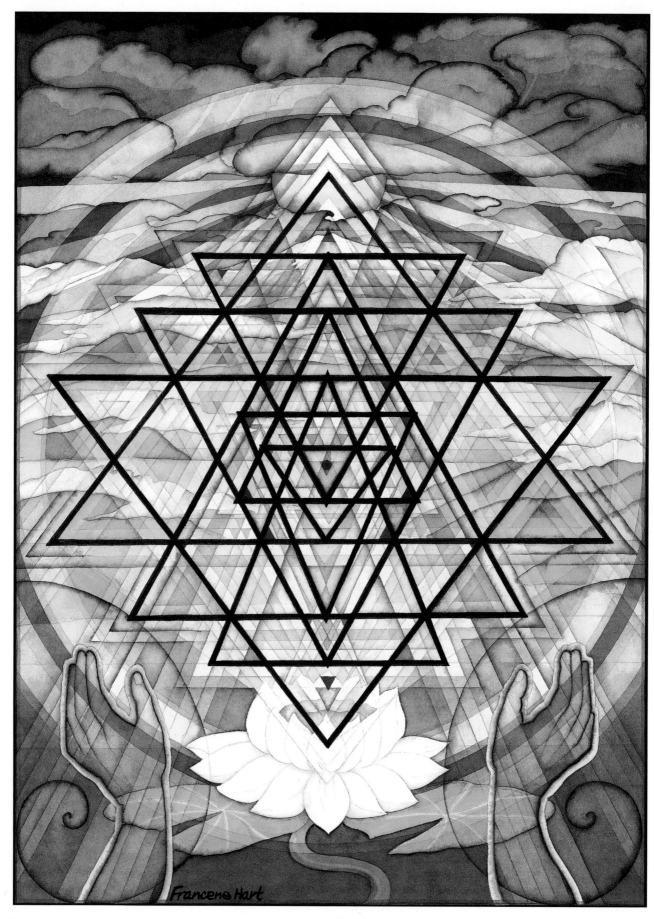

EXPANDED SRI YANTRA, 2000

The Sri Yantra is considered to be the source of all yantras. Its forty-three triangles
are said to map the totality of the human experience.

me with storytelling and coaching from my friend was the recognition and conscious acceptance of the sacred responsibility that is developing in my life and art. I had been enjoying a quiet, reclusive life hiding in the woods. The universe had repeatedly advised me to take the art into the world, yet I had resisted for several years. That evening it became evident that it was time for me to step up and make a covenant with creation to share my gifts and truly become the visionary who was emerging. This was my "call to vision."

My studies led me to explore the *yantras,* which are tools for consciousness that are similar to Buddhist mandalas. The Sri Yantra is considered to be the source of all yantras. Its nine interlocking isosceles triangles centered around a *bindu* are drawn by superimposing four upward pointing triangles, representing Shiva, or the male principle, and five downward pointing triangles, symbolizing Shakti, the female principle. The triangles are interlaced to form a total of forty-three triangles that map the totality of the human experience, from physical matter reality to ultimate enlightenment.

Expanded Sri Yantra, a painting that depicts the sacred geometry of the Sri Yantra, moves beyond the boundaries created by this ancient Tantric meditation symbol. Moving like a spacecraft over open waters, the symbol becomes one of freedom and liberation. As with other sacred geometry configurations, meditating on the Sri Yantra offers a way to access information. The background in this painting is Lake Titicaca in Peru, the highest body of navigable water in the world.

We moved on to Bolivia and capital city La Paz, and visited the colorful witches market where we did ceremony with a wise old *curandera* (shamanic healer). She blessed Laurie, who was seeking—and soon after found—her future husband and me in my quest for verification of the mission I had accepted that night on Lake Titicaca. The next day we visited the mysterious ruins of ancient Tiwanaku on the cold, dusty Altiplano, believed to have been a pilgrimage site many thousands of years before the Inca. The chakana pictured on page 116 are found carved in stones at Tiwanaku. The equal-armed cross with a superimposed square

SRI YANTRA

Expanding
Artistic Vision

115

The chakana pictured here are stepped-cross symbols found carved in stones at Tiwanaku.

ABOVE THE STORM

signifies the levels of spiritual evolution we must pass through as we walk through life.

We traveled back to Cuzco, and the next morning I mentioned to my friend that I would love to do some visioning with Mauro. Without our having initiated any action, we found him waiting outside the door when we stepped out of our hotel. We spent the morning with him exploring the walled complex of Sacsayhuaman, famed for the precise, mortar-free fit of the large stones of its walls, some as heavy as two hundred tons. We meditated at specific locations he deemed important. Some were cave-like and mysterious, all felt powerful. At lunchtime we met up with his wife and children and began a long, unexpected hike up the mountain through muddy fields strewn with wildflowers and countless Incan potsherds.

Mauro planned to show us a specific place, but plans changed as thick rain clouds and cold approached. Often the journey is more important than the destination. This day, ancient details and time spent with this beautiful Peruvian family were our gifts. When the light started to fade, Mauro flagged down an old station wagon and we seven packed like sardines into the back of an already-full vehicle and headed back to Cuzco. It was much farther than I had expected, and when I unwound my body from

the back of the car, my legs could barely carry me. My physical being was exhausted, yet my soul was completely filled.

Machu Picchu

The following day we traveled to Machu Picchu. This ancient city is one of the world's best-known and most beloved archaeological sacred sites. The ruins lie on a high mountain ridge above the Sacred Valley of the Incas. It was abandoned at the beginning of the Spanish conquest and remained unknown to the outside world until 1911. Part of the attraction is the enigmatic nature of this incredible emerald city. Many of Machu Picchu's mysteries remain unsolved, including the exact role it may have played in the Incas' sophisticated understanding of astronomy and the domestication of wild plant species. I was honored to be able to visit Machu Picchu at this time, and again eight years later, but I realize that the pressure of tourism is damaging this fragile environment.

I was inspired by Machu Picchu to paint *Mountain Apus,* which is not the typical view but honors the beautiful green-domed mountains that surround the city in all directions. They are locally called *apus,* which means "mountain spirits." In Inca mythology, every important mountain has its own apu. I felt a special attraction to these green mountain beings. The stepped geometry of the chakana is embedded in the painting. On the train back to Cuzco, we experienced a rare sighting of an Andean condor, shown here passing over a rainbow circle, which felt like an affirmation.

Return to Central America, 2004–2005

I met James in Hawaii and, as he is a lifelong traveler, we began a relationship that has included many splendid journeys. Newly in love and wanting to share the wonders of Central America, my beloved and I decided to explore the mysteries of the ancient Maya. I flew alone to meet him for the first of several romantic airport rendezvous. We reunited amidst the bustling humanity and colorful chaos of Mexico City at Christmastime. He soon became my sacred travel best friend.

This was a cool perch out of the direct sun with an excellent view of the Sacred Valley.

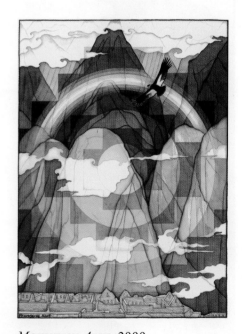

MOUNTAIN APUS, 2000

Expanding
Artistic Vision

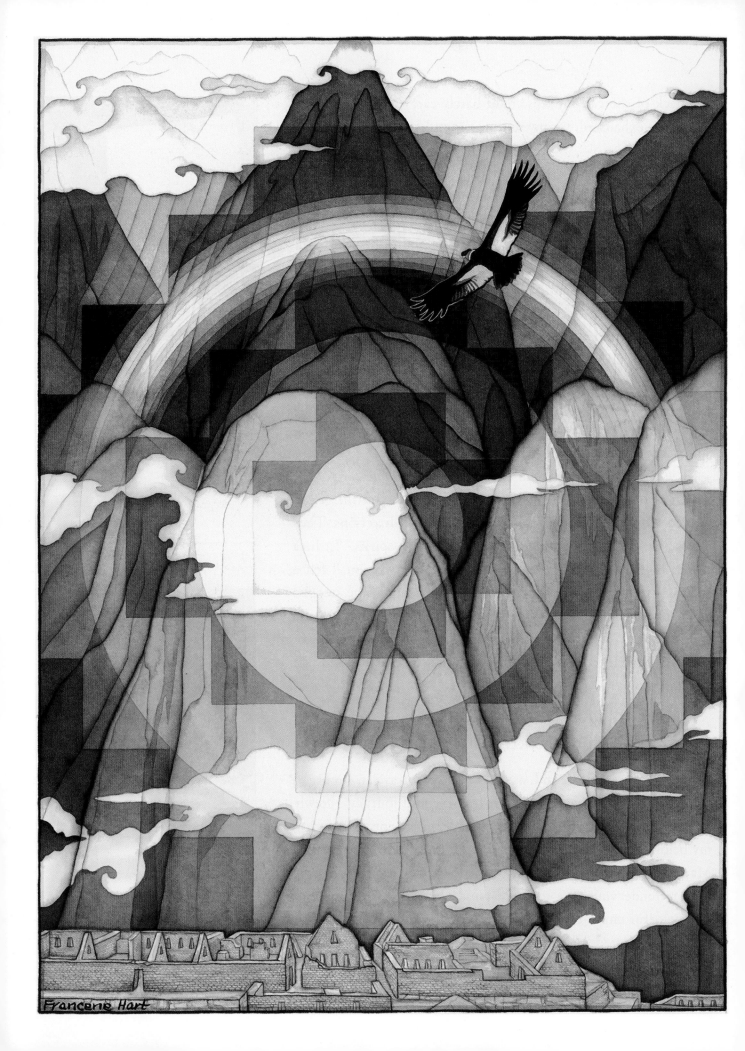

Francene Hart

The incredible National Museum of Anthropology is one of the highlights of the city on all levels. Having studied the Maya for several years, I found it of specific interest to view Mayan artifacts, particularly what is known as the "Madrid Codex." The Maya created an extensive written record containing hundreds of folded books called *codices*. This exquisite book is one of only three or four authenticated codices believed to have survived the destruction and flames of the Spanish conquest. Examining this important artifact was truly a spiritual experience.

Around the planet invaders and conquerors continue to destroy art and artifacts, books and libraries in an effort to almost literally erase preceding cultures.

We traveled by bus throughout Mexico, discovering mind-altering Mayan chocolate in Oaxaca at Christmas and visiting many archaeological and historic sites, including Monte Alban, San Cristobal de Las Casas, Palenque, Chichen Itza, Tulum,

The pyramid known as El Castillo dominates Chichen Itza. The architecture of the pyramid contains precise information regarding the Mayan calendar.

OPPOSITE: *MOUNTAIN APUS,* 2000

Apus are powerful mountain spirits in Inca mythology. I felt a special attraction to these green mountain beings. The stepped geometry of the chakana is embedded in the painting.

Expanding
Artistic Vision

119

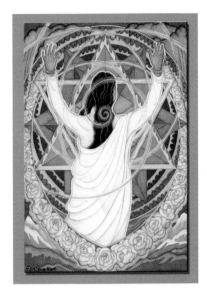

DIVINE MOTHER

Alfombras are stunning living carpets created for Easter Week holy processions.

Coba, Uxmal, and Mérida. From Mérida I flew home to Hawaii, leaving James to continue exploring the land of the Maya.

A few months later in 2005 we met again, this time in Antigua, Guatemala. James had booked a romantic room during a spectacular celebration of Easter Week, or Semana Santa. It is a grandiose homage to Jesus, who is portrayed in elaborate daily processions of sculptures of Jesus and Mary made by Guatemalan artists, carried on floats by men or women dressed ceremonially for the occasion.

An extraordinary part of this tradition, here and in other parts of Central America, is the daily creation of stunning *alfombras,* which literally means "carpets" (see photo below). These temporary works of art are created on the city's cobble-stone streets, which are covered with sand to provide a smooth

base. Then, using wooden stencils, Antiguans create living carpets with colored sawdust and many varieties of beautiful flowers and vegetables. The holy processions trample their creations daily in what is perceived as a sacrificial act, reflecting the sacrifice of their Christ for mankind. The remains are quickly swept away, and the artistry starts anew the following day. Clouds of traditional copal incense fill the air as intensity builds among crowds of the faithful and ritual intensifies throughout the week.

From Antigua we bussed to Lake Atitlan, then Quetzaltenango and San Marcos in Guatemala, exiting into Mexico through Tapachula. We traveled up the west coast through numerous simmering beach towns and on through mountainous pine-scented Tarahumara Indian country to lovely Creel. Riding what was supposed to be an eight-hour train through gorgeous canyon country, we arrived fourteen hours later at 4 a.m. in the coastal city of Los Mochis, where we boarded the Baja ferry. We enjoyed time to rest and a boat excursion to Isla Coronado, complete with a gorgeous display of dolphins, seals, and gulls all feeding together in the cold waters of the Sea of Cortez. Onward again we continued through many villages in Baja and finally walked across the border to San Diego, where I made my departure back to beloved Hawaii. Our journey had involved many miles and bus hours, and would become our customary mode of travel as we planned further adventures.

Cambodia and Angkor Wat

In 2006 I visited friends who were living and working in Phnom Penh, Cambodia. The city was stimulating and frenzied with lots of traffic, mostly motorbikes, moving in every direction with virtually no traffic signals. I wondered how all this could possibly work.

It was also filled with many spectacular Buddhist and Hindu temples, as well as the National Museum, which houses treasures from prehistoric times through the highly sophisticated ancient Khmer Kingdom. Walking around the city or sitting in our favorite cafe, I enjoyed the peaceful constraint of the many ubiquitous

saffron-robed monks. I remember Cambodia as a beautiful country filled with kind, resilient people.

The following week we traveled up the Tonlé Sap River on the fast boat to Siem Reap, which would be our base for a week of exploring a spectacular ancient temple complex and World Heritage site. Angkor is thought to have been the world's largest preindustrial urban center. Photos of Angkor Wat, the most famous temple, do not reveal the sprawling complex that expands across 150 square miles and includes a huge number of temples and waterways. Each day we were met at our hotel in Siem Reap by our local guide and transported via *tuk tuk,* or three-wheeled taxi, to one, then another, then another spectacular temple. I was in awe for the entire week we spent in this spectacular, tourist-filled ancient city. Busy as it was, by going early or to lesser temple sites we often found space to meditate and feel the spirit of place. For instance, we found that by climbing what is known as the "sunset temple" at dawn, we were able to enjoy a more serene and equally beautiful experience.

Splendid to behold, Angkor Wat temple is one of the largest religious monuments ever constructed. It was originally built as a Hindu temple dedicated to the god Vishnu, and converted into a Buddhist temple in the fourteenth century, when statues of Buddha were added to its already rich artwork. Like many other temples at Angkor it is surrounded by waterways called *barays,* which regulate water levels and protect the temples. I was charmed and inspired by countless numbers of dancing Apsara sculptures and reliefs found throughout this ancient city (see photo at left). An Apsara is an elegant supernatural female spirit of the clouds and waters, superb in the art of dancing. As depicted in *Apsara Hands,* most of them have exaggerated hand mudras representing sacred dance.

Some other favorite Cambodian temples were Ta Prohm,

Countless numbers of dancing Apsara sculptures and reliefs are found throughout this ancient city.

Apsara Hands, 2006

An Apsara, the female spirit of the clouds and waters, uses hand mudras in sacred dance. There is also a fabulous pond in front of the temple filled with pink lotus blossoms. All provided inspiration for this painting.

Expanding
Artistic Vision

Francorie Hart

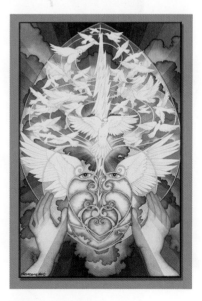

PEACE OFFERING

where huge trees have grown up through and around the temple walls; Banteay Srei, a small exquisite temple complex; and the Bayon, with its many smiling Buddha heads. I was captivated by this temple. Some thirty-seven of the original fifty-four towers are still standing, and the serenity of the massive stone faces carved upon them is striking. The peaceful feeling and superb golden afternoon light combined with the gentle receptivity of two young Buddhist monks inspired *Bayon Faces.* The saffron-robed monks are mostly young men who, in many cultures, would be spending time in the military. This sort of compassionate service resonates in my heart as peaceful service.

There were also white-robed nuns, mostly elders finding time

BAYON FACES, 2006
The serenity of the massive carved stone faces coupled with the gentleness of the peaceful young monks resonated in my heart.

Expanding
Artistic Vision

125

for spiritual service after their families had grown. A most touching experience with these women occurred near the Terrace of the Elephants at Angkor. I noticed a group of nuns standing together and used hand gestures to ask if I might take their photo (page 125). Afterward, they all gathered around to look at the photos on my camera, before putting their arms around me and sweetly stroking my head and arms. An upwelling of love energy surrounded this encounter. It was an especially tender moment that still brings tears to my eyes.

Ecuador, Peru, and Bolivia, 2007

The lengthiest of my travel adventures occurred in 2007. It felt like a lifetime of adventure packed into a few months. Arriving alone was always both exciting and a bit nerve-racking, but I learned that my partner would be waiting at the destination (in this case Quito, Ecuador), and that magic and divine inspiration would follow. After a couple of days exploring museums, art collections, the historic district, and splendid cathedrals, it was time to leave the city.

We took a bus toward Mindo and enjoyed this lovely rural area known for its wildlife, including numerous species of hummingbirds and butterflies. In a cloud forest nearby, and in the rain forests of South America, it seemed we were followed by the delightful winged vibration of blue morpho butterflies. Their sweet presence is depicted in *Winged Vibration*.

We talked about going to the Galápagos Islands. However because we were traveling on a budget, we chose instead to experience two jungle trips and an excursion to Isla de la Plata off the coast of Ecuador for the same cost as a few days in the Galápagos. Those islands remain on the list, yet our decision became inspiring in countless ways.

Winged Vibration, 2008
A blue morpho butterfly takes center stage surrounded by hosts of butterflies and hummingbirds. Golden spiral hearts represent the sweetness that deeply touched us.

Francene Hart

*We enjoyed watching
the courtship of the
blue-footed boobies.*

Isla de la Plata, sometimes called the poor man's Galápagos, was a treat. On the hour-long boat ride to the island we encountered a spectacular late-season humpback whale display beyond anything I have ever experienced in Hawaii. It seemed to be the culmination of a heat run, which is a frantic mating ritual involving a number of amorous males and a desired mate. She was straining to move her massive body up into the air, out of the struggle, while several of her suitors attempted to pull her to them. With no apparent proximity regulations for the boat, we probably were a bit too close for the safety of both boat and whales in those roiling waters. After a time of wild whale antics, other people on the trip (most of whom were birdwatchers) urged that we head for the island.

We hiked a long trail around Isla de la Plata, enjoying beautiful island scenery and large populations of blue-footed boobies. They seem unconcerned about our presence as we walked past the nests they had constructed in the middle of the trail and enjoyed the humor and tenderness of their courtship.

There was also a large colony of magnificent frigate birds—large seabirds with black plumage, long pointed wings, and deeply forked tails—nesting in scrubby trees overlooking the ocean. Frigate bird males have a red chest pouch that they inflate like a balloon to attract females. There were many other birds as well, so the birders were happy.

Following this trip we bussed back to Quito, then on to Baños de Agua Santa (Spanish for "holy water baths"). We relished a rest and healing soaks for a couple of days in Baños's famous thermal baths heated by the constantly active Tungurahua volcano, which towers over the village.

Amazonian Jungle Adventures

From early childhood I had longed to travel to the Amazon. Most of my friends dreamed of going to Europe; however I yearned to experience a rich and mysterious jungle environment that was ever-present in my dreams. Perhaps each of us has similar yearnings . . . each individual, yet with a definite call to experience. It may be something in our bones or genes that calls us to find a particular environment that fills our soul. If you have a longing for a certain place, my advice is follow your dreams . . . find your bliss.

Most of the Amazon River is more a wide highway than the intimate jungle experience I had imagined. In some places it is ten miles wide. You can't see the banks, let alone the creatures that live there. As I began to research possible adventures, I realized that what I desired was to travel in a dugout canoe up a tributary of the great river to a place where I could deeply feel the tropical wilderness.

Jungle Encounter in Ecuador

It was finally time to seek out that jungle encounter. In Ecuador we met locals who recommended indigenous-owned lodging. The journey began with a flight from Quito to Coca, then four hours up a small river by dugout canoe. As soon as we began the canoe ride, my entire being filled with a familiarity that felt like a comforting memory. This was why I had come, and I was ecstatic. The rustic, indigenous-owned lodge was surrounded by a maze of lagoons, and we hiked with our local guide into the deep, verdant jungle. After living for years in the northern forest, I had no inherent fear of this wilderness. Having an indigenous guide allowed us to totally relax into the experience, fulfilling my long-held dream. Giant buttressed trees, several types of monkeys, spiders, birds,

STEAM CAVE

Expanding
Artistic Vision

129

and butterflies were our companions every step of the way.

Perhaps the most stunning experience of this jungle trip was when James and I took a canoe out on our own to explore the lagoons. We watched all manner of wildlife watching us. Then I noticed activity on the lagoon ahead and asked him to stop paddling. Our forward movement gently propelled us into an open lagoon where we spotted a family of five giant river otters depicted in *Giant River Otters*. The adults and three young otters were fishing, but when they spotted us, they began an incredible display, propelling their large, sleek, powerful bodies halfway out of the water and barking loudly. We were in their fishing spot and clearly were not welcome. They were partially submerged but male giant river otters can be six feet long, so we kept a respectful distance. After a few minutes of wild exhibition, they disappeared into the depths of the green waters. We were left stunned, thrilled by their beauty and the power of the moment. After this first jungle adventure I definitely wanted more.

Onward to Peru

Our journey continued through Ecuador into Peru, taking us to innumerable sacred places and phenomenal landscapes. On the way south we enjoyed a visit to the scenic village of Vilcabamba, often called the Valley of Longevity as its inhabitants reportedly live to a venerable old age.

From there we headed out the southern back door of Ecuador into northern Peru. Nine-and-a-half hours, four bus changes, and many villages later, the bus was stalled for several hours due to road construction. I was beginning to think we lived on the bus. My rear end felt flattened. However the views of local people and the countryside were infinitely rewarding at this pace. When the bus finally got moving again the road we traversed was

Giant River Otters, 2008

An encounter with five giant river otters left us stunned, thrilled, and eager for more jungle adventures. The circles surrounding the otter family create a tube torus above and beneath the waters.

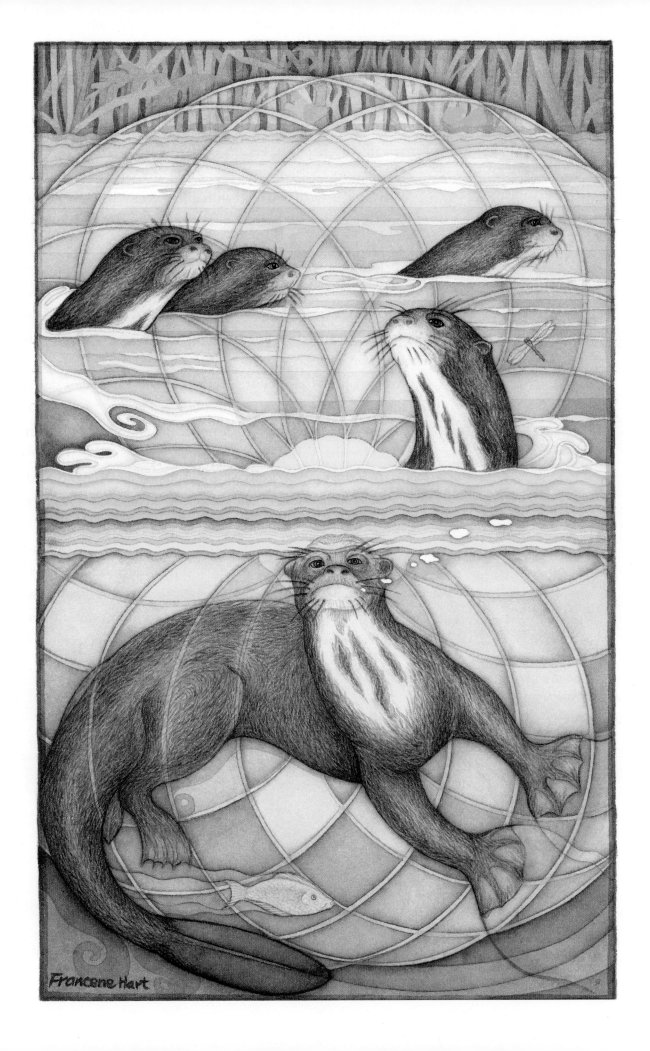

Francene Hart

otherworldly, roughly snaking through newly cut rock overhangs only inches taller than the bus. In the dusty evening we finally arrived in Chachapoyas, Peru.

Situated in the mountains far from the coast, Chachapoyas remains fairly isolated and more difficult to get to than other regions of Peru. It is, however, packed with ruins of the Chachapoyas culture, a pre-Incan civilization translated as "warriors of the clouds." Road closures dictated our route so we caught a *combi* (a minivan or minibus) at 3:30 a.m. and arrived at first light in the town of Lamud, wondering what would happen next. As is the way of magical travel, a taxi arrived and took us to the home of a local guide who became our escort and angel for the day.

Jose led us to burial cliffs known as the Sarcofagos de Aya-Chaqui. We viewed numerous mummies encased in clay sculptures that were positioned in cavelike niches looking out across the Utcubamba Valley. Most are inaccessible and can only be seen across the canyon; however Jose took us up a steep trail that passed very near a few of these ancient sarcophagi. The energy was intense and felt protective.

After a good night's sleep and back in Chachapoyas, we ventured to the tiny village of Maria and proceeded up a steep road to the monumental citadel of Kuelap, situated on a ridge overlooking the Utcubamba Valley. Positioned atop a mountain at 10,000 feet, Kuelap is sometimes called the Machu Picchu of the

Inaccessible mummies encased in clay sculptures are positioned in cavelike niches.

north. It sits 2,000 feet higher than Machu Picchu and predates the Incan Empire. Originally containing 450 round stone houses protected by massive superbly constructed exterior stone walls more than sixty-four feet high, Kuelap is said to be the largest archaeological complex in South America. The site is extraordinarily beautiful and filled with the mysteries of the ancient ones. Probably due to the challenges of getting there, we encountered no other travelers and only a few archaeologists at this phenomenal site. It was fantastic to enjoy the spirit of this place in an unencumbered manner.

Leaving Kuelap involved a series of adventures, with ruins in view all along the way and magic in the day. We enjoyed a ride in a big truck filled with happy, singing teens, finally arriving in Leimebamba. No departing bus was scheduled for several days and we had been hoping to move on that night, so when a driver said he would take us on the eight-hour drive over the mountains, we decide to pay the price. One-and-a-half hours into the drive, on a high pass, in icy rain as the light was fading, his car broke down.

Imposing stone walls surround Kuelap's impressive archaeology. Notice the two llamas at the base of the wall for size perspective.

Expanding
Artistic Vision

Very shortly another travel angel arrived in the form of a truck driver (virtually the only other vehicle on the road), who kindly returned us to Leimebamba and retrieved us the next morning to travel with him over the mountains for the price of some gasoline. We were crammed into the cab with a cargo of cattle in the back. I happily enjoyed the truck's large windshield as this ten-hour journey took us through some of the most spectacular mountain scenery I had ever viewed. It was very slow going on a narrow dirt road that was little more than a rough track. Hugging each other as the truck switchbacked over the narrow 12,000-foot pass, we finally arrived in Celendín. It had been a visual and experiential adventure I will cherish always.

Long bus rides ascending to and descending from great elevations make for rough travel. Soon we would find just how wearing this could be, since our desire was to continue to experience sacred places located at radically different altitudes. Trying to pack as many wonders as possible into our time and energy, the adventure continued. Close to the coast we enjoyed Chan Chan, the largest adobe city in the world and capital of the prosperous Chimú civilization. The ancient structures of this impressive site have been threatened by substantial erosion due to changes in weather patterns, including El Niño year storms, which have left the adobe looking almost melted.

Another radical altitude change found us ascending the peaks of the Cordillera Blanca to above 10,000 feet and the gorgeous mountain-ringed city of Huaraz. We had come to this altitude to visit the mysterious pre-Incan ceremonial site of Chavín de Huantar, constructed some 3,000 years earlier. It encompasses a series of terraces and squares, and a complex system of underground galleries. In these dark corridors conch-shell trumpets known as *pututus* are used to generate unusual eerie acoustics, likely intended to enhance altered states of mind during ceremony.

Another nine hours on the bus through green rolling pastures and small towns led us back to sea level. We were traveling toward the lesser-known and recently opened sacred city of Caral-Supe. More than five thousand years old, Caral is a fabulous example of the Late Archaic period of pre-Columbian pyramid

architecture. Located on a dry desert terrace, Caral features complex and monumental architecture, including six very large pyramidal structures. This impressive site is the oldest known center of civilization in the Americas. Caral was a thriving metropolis at roughly the same time that Egypt's great pyramids were being built. It is conjectured to have been a highly developed, peaceful society, as no weapons artifacts have been found on the site. When we visited, it had only recently become a park and there were few visitors and no hotels. Since it is only sixty miles north of Lima, I imagine this has already changed.

One night in Lima, not ready to face another long bus ride, we booked a flight to Cuzco, one of my favorite cities in the world since I'd visited in 2000. One of the marvelous things about experiencing sacred architectural cities and temples is the energy they hold. Many sites have been lost, then rediscovered after having been unoccupied for long periods of time. Cuzco is significant in that it has been continuously occupied since pre-Columbian times, through the passage of the Incan Empire, the Spanish conquest, and into modern days. It is easy to feel the potency of this archaeologically layered city and appreciate how the longevity of the site has fueled that energy. I was excited to share this wonderful place with my partner, yet when I woke the next morning at more than 11,000-feet altitude, I couldn't seem to make myself get out of bed. Exhaustion had finally taken its toll and I was forced to spend the day sleeping while James explored. I hated to miss anything, but after some rest I was ready to share further adventures the following day. We spent a couple of days exploring Cuzco's many temples, cathedrals, and the citadel at Sacsayhuaman, and enjoyed some good food.

The following day we caught a combi to Ollantaytambo. When I had visited the area eight years prior, we'd ridden the train from Cuzco to Machu Picchu, which is the route most visitors take. When the coach had buzzed by Ollantaytambo, I'd gasped at the beauty I could see from the train and decided that one day I would return. The ruins of this Incan sacred city are imposing. Huge locked masses of finely crafted stones, ancient irrigation waterways, and stone terracing dominate the area. The

village has been continuously occupied since ancient times and the people there still use wells and canals built centuries ago. There was a sense of permanence in these stone structures. The spirit of place felt solid in Ollantaytambo.

The following morning we rode the train to Machu Picchu, arriving at Aguas Calientes at the base of the mountain where Machu Picchu stands. We stayed the night and rode the first bus up the zigzagging road in order to have the opportunity to be in the door of the park at 6:00 a.m. Thick mist shrouded the site. Upon entering we could see only shadows of this famous sacred place. Slowly the mist lifted and this archaeological jewel was revealed in all her glory. Incredible houses and temples surrounded by green-mantled apus, or mountain spirits, undeniably held great power, and I was moved to be back among them. One of the most famous sacred places on the planet, the magic here required reverence and respect. Despite large numbers of tourists who arrived throughout the day, the ambiance was quiet and peaceful.

This is a classic view of Machu Picchu taken from above the ancient emerald city where the Inca trail heads into the high mountains.

We returned to Cuzco and Sacsayhuaman, and spent many amazing hours exploring the incredible construction of massive walls and numerous sacred nooks and crannies.

Onward we traveled to Lake Titicaca on an amazingly comfortable bus, surrounded by spectacular scenery all along the route. We arrived in the village of Puno, considered Peru's folkloric capital, to find a great festival taking place. We had stumbled into the city's 360th anniversary celebration. Indigenous villagers had come from all over the region to celebrate this event. Every street was filled with colorful parades, fabulous bands, and dancers festooned in elaborate traditional costumes. This was my second visit to Puno and magic was again in abundance at this powerful location. The air at 12,540 feet was thin and incredibly pure. Lake Titicaca was the same deep turquoise. We visited a number of places in the Puno region on this great lake, including several sacred islands, then traveled into Bolivia. A bus delivered us to La Paz and we went directly to the travel agent I had been e-mailing to secure our second jungle trip.

Bolivian Jungle Adventure

In researching jungle tours, I'd found what looked like another perfect choice. This time we flew from La Paz over the gorgeous Cordilleras in a tiny plane on a windy bumpy ride that landed in an open field. Four hours by dugout canoe up two Amazonian tributaries brought us to a remote lodge in the heart of the Madidi National Park. We enjoyed a second indigenous-owned lodge and ideal local guide. On our way to the lodge, floating up the shallow river (it was dry season), we saw an astonishing variety of birds and mammals.

As we rounded a river bend, we spotted a large animal crossing the river. Awestruck, I realized it was a jaguar. The animal climbed out of the river up a gravel bank, stopped for perhaps twenty seconds (a long time for a wildlife encounter), turned, and intensely observed us, looking directly into my eyes for many moments. I had known for several years that I have a jaguar spirit guide. Face to face with a jaguar, I was speechless and immobilized. Neither aggressive nor shy, this magnificent animal was resplendently at ease in

the jungle, on home territory and fully in jaguar power. Finally our guide said, "You can take a picture," so I snapped out of my daze, reached for my camera, and caught this stunning feline turning and sauntering into the jungle. I will never be able to explain how magnificent this being was or how deeply he moved me. Our twenty-six-year-old guide said he had seen only three jaguars in his life. In the background of *Jaguar Guide*, the painting inspired by this magical moment, the flower of life beams through the rain forest, animating the richness and diversity of this astonishing ecosystem.

Our guide took us on long hikes and explained much about the local medicinal plants and wildlife we might otherwise have missed. Macaws and lots of other birds, otters, spider monkeys, black fox, peccaries, jaguar tracks, and a sweet hummingbird nest with two tiny eggs were but a few of the delights. Again the jungle nurtured a part of me that felt like it had come home.

Blissed out after the second Amazon jungle experience, we flew back to La Paz at 13,500 feet. We were both weary and full and again zapped by the altitude. Enough elevation! Moving across the arid Altiplano, or the Andean Plateau, we felt relieved to be heading down to Cochabamba.

Having read about dinosaur tracks in nearby Toro Toro National Park, we booked a tour. It was a rough six-hour, four-wheel-drive journey that crossed several small rivers through dusty desert. There was also a spectacular panoramic view of radically tilted tectonic topography. The beauty of the long afternoon light was utterly fantastic. We made it to Toro Toro by late afternoon and immediately went out to explore the tracks of dinosaurs that had walked into mud 145 million years ago. Mario, our knowledgeable, graceful local guide, looked and felt like an elf as he skipped across the rocks and showed us his special places. He took us to areas where we sat in, or placed our hands on, dinosaur tracks in

Jaguar Guide, 2008

I will never be able to explain how magnificent this being was or how deeply he moved me. In the background of the painting inspired by this magical moment, the flower of life beams through the rain forest, animating the richness and diversity of this astonishing ecosystem.

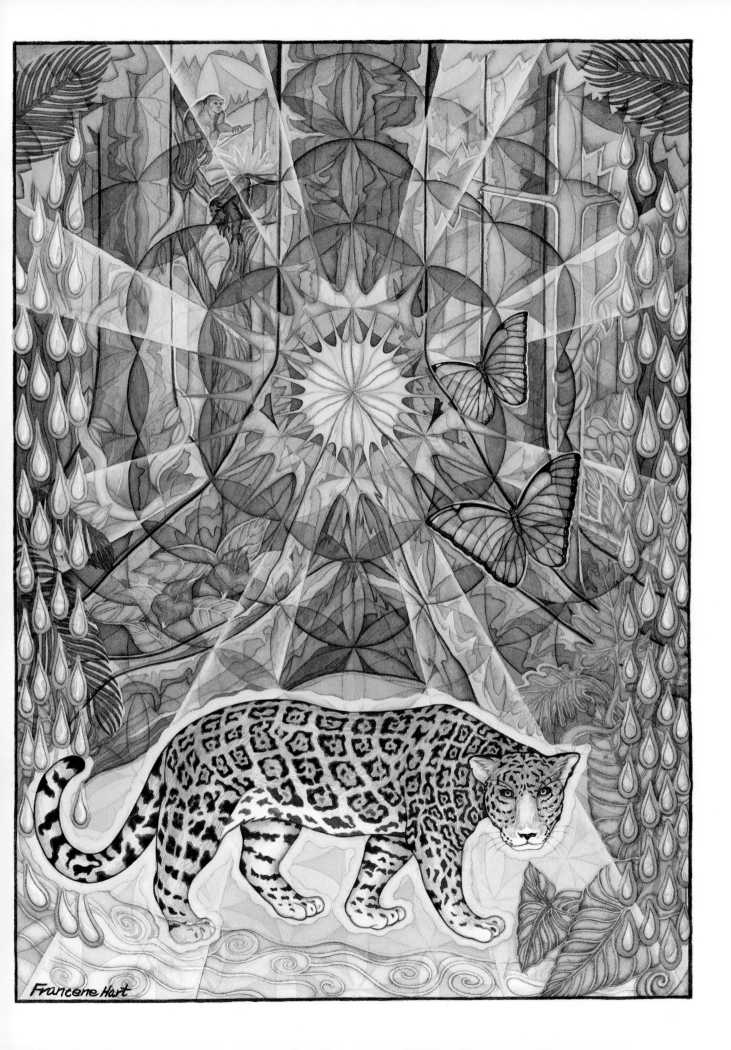

Francene Hart

the layered mudstone. We were far from ordinary civilization and the only visitors, yet it felt somehow strange to be touching prehistoric relics so casually. Mario said we shouldn't worry, that when these tracks erode there are many more layers beneath them.

The following day we hiked down eight hundred steep stone stairs into Toro Toro Canyon and the El Vergel Cascade. It was a long day, a beautiful hike, and I was weary. I said aloud, "If I make it to the top of these eight hundred stairs, there will be condors waiting." When we finished climbing the stone stairway, we were, indeed, rewarded by the sight of two Andean condors circling above.

The final day we awoke to rain. I was pleased, thinking it would soften the dust, yet as we walked through town the greasy mud stuck to our feet and we became taller. *Toro* in Quechua means "mud," so Toro Toro is double mud. This day we were to explore local caves. However the vehicle repeatedly became mired in mud on the road to the caves and we decided to forgo them, attending instead to the safety of all. This was a good call, as on our way out the slippery switchbacked roads and swollen rivers were nearly impassable. It was a great adventure!

Since I would be flying back to Hawaii from Santa Cruz in a couple of days, we decided to enjoy one last sacred place and traveled to Samaipata and the El Fuerte ruins. The day we visited the site was rainy with thick clouds and rapidly swirling mist, which added to the mystical feel of the place. This pre-Inca ceremonial site holds many secrets from the remote past, including unusual engravings and sculptures. Locals say they learned from their ancestors that Samaipata was the place from which the gods ascended into heaven, and the ancient carvings are said to have been there before people appeared in the area. Some claim that Samaipata was used by ancient astronauts to land their spaceships. Whatever your beliefs, this site held potent energy and was a wonderful conclusion to an epic journey.

Pharaonic Fusion, Egypt and Jordan

It took until 2008 for me to make the journey to the many sacred places in Egypt. I had not been greatly attracted there until my

studies of sacred geometry demanded a visit. I am grateful this visit was prior to the revolution of 2011 and the continued unrest that has plagued this historic part of the world.

We landed in Cairo, home to 20 million people, on a hot September evening. It was the feast of Ramadan and the streets were filled with crowds of stylish city dwellers. Coming from a very different culture, I found this to be an eye-opening experience. I consciously sought to travel with an attitude of openness and cultural respect. The teeming city was exciting and a bit overwhelming for this lifelong inhabitant of quiet rural places.

The first morning we visited Cairo's Museum of Egyptian Antiquities, which is phenomenal. It is filled with an awe-inspiring number of treasures, many of which are simply parked in the large entry hall. This is definitely not a modern museum, neither air conditioned nor well guarded, yet filled with the most incredible array of antiquities. It felt like stepping into another era. The King Tut exhibit was the most protected area. Its spectacular gold and exquisite detail was stunning.

The second day we set off to visit the Giza Plateau. Just as we were about to enter the Great Pyramid, a falcon, surely Horus (the falcon-headed god, son of Isis and Osiris) flew overhead . . . unquestionably a good omen. We checked our cameras with the guards and climbed the steep ramp to the king's chamber. It was quite hot and we were weary from jet lag and travel wonders, but the simplicity, fine granite walls, and architectural genius of its roof offered a powerful, calming experience. Entering this famous chamber I walked over and slumped down in the corner closest to the sarcophagus. Voicing a small sigh, I was startled to hear the tiny sound instantly amplified hugely throughout the space. How did I not know that this is a resonant sound chamber? We sat for a long time as visitors came and went. Some left quickly, saying, "Is this it?" Others were excited and joined in the soft, amplified toning meditation, which offered a profound pineal activation. We stayed for nearly two hours. I didn't want to leave. This was pure magic. When I stood up and looked back to where I had been sitting, there was a wing-shaped "sweat angel" soaking the wall. It made me smile. When I reclaimed my camera, the guard wanted a

big tip; apparently visitors do not ordinarily spend that much time in the king's chamber. We rested in an on-site restaurant directly in front of the sphinx with a view of all the pyramids, yet didn't feel like venturing into the noonday sun. It was very, very hot.

The following day we got an earlier, somewhat cooler start and enjoyed the vast, ancient burial ground of Saqqara, also on the Giza Plateau. It features numerous pyramids, including the world famous step pyramid of Djoser, considered to be the earliest large-scale pyramid construction.

Egypt is an ancient, impressive country. The enormity of its culture and symbolism stimulates the mind and boggles the imagination. Everywhere there is sculpture and painting, incredible architecture, and the power of the pyramids. *Pharaonic Fusion* is a synthesis of symbols encountered while traveling through this mystical land.

We decided to head south and enjoyed riding the overnight sleep train to Aswan. When we arrived, Aswan was hot like a blast furnace. We had a decent room with air-conditioning that shot icy air, but only a couple of feet into the room. We went in September to avoid the crowds, yet the intense heat definitely restricted our enjoyment. Walking through colorful markets, we were accosted by venders who aggressively pursued us. No other place I have traveled has such unrelenting merchants, and this is the case all over Egypt. It's too bad, as I love exotic markets but dislike being pressured.

Despite the heat we ferried to Elephantine Island in the center of the Nile and the Nubian Village. It was easy, there, to see the layers of humanity that have made their deposits over the long history of this ancient civilization. I booked a tour to Abu Simbel near the Sudan border on a small air-conditioned van leaving our hotel at 3:30 a.m. James decided to take the

PHARAONIC FUSION, 2008

The Great Pyramid, a work of architectural genius, offered a powerful, calming experience. With its multiple triangles and concentric circles enclosing clasped hands at the bottom, this painting incorporates symbols and sacred geometry that are ubiquitous in Egypt.

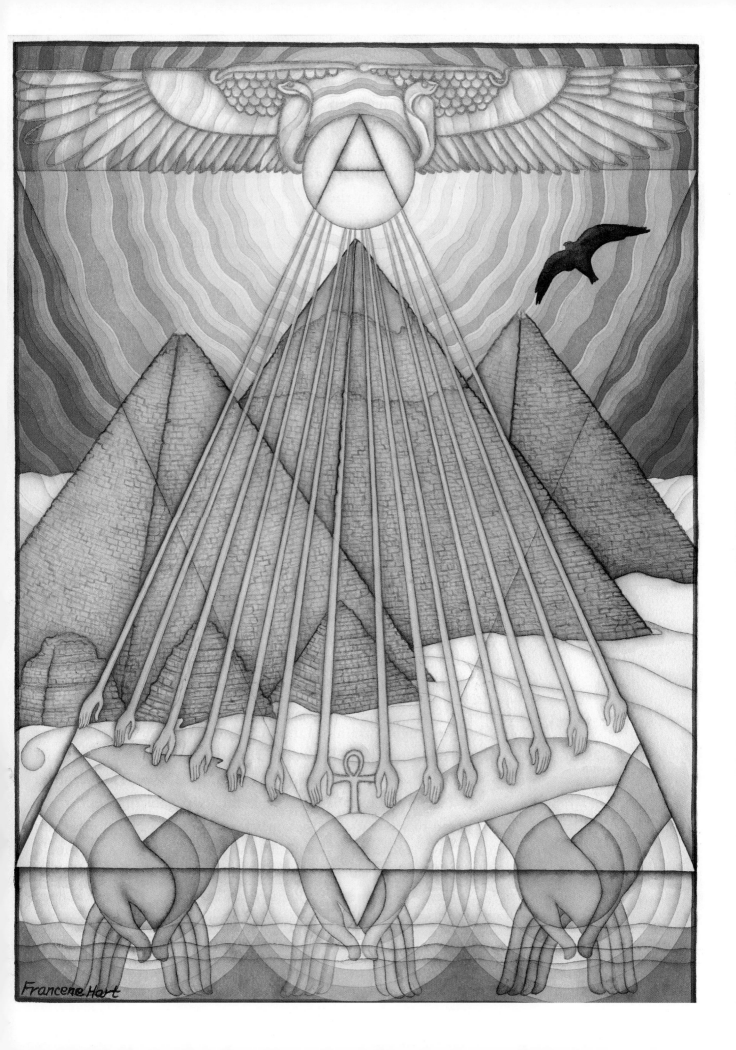

Francene Hart

local bus. Big windows in the van allowed the beautiful immensity of desert sand and rock vistas to be comfortably enjoyed. Sunrise was dusty and golden. The van stopped at the gate to Abu Simbel and the driver said he'd be back in two hours. Nearly first in the gate, I had an opportunity to explore this impressive monumental site before the heat and crowds became overwhelming. The scale alone here was astonishing, especially knowing Abu Simbel was originally cut from solid rock, then in modern times moved up the mountain as the Aswan High Dam devoured the countryside. The interior of the temple is also filled with huge statues and paintings.

This was the southern border of the empire. Ramses the Great, who reigned for sixty-seven years during the twelfth century BCE built this and many other monuments to his glory. He is known not only as one of Egypt's greatest warriors, but also as a peacemaker, having signed a first-ever peace treaty with his enemies, the Hittites. Egypt enjoyed an era of abundance and prosperity during his reign.

The rest of the day was one of deep rest for me back at Aswan. I spent the day painting, while sitting directly in front of the air conditioner. I was not comfortable walking the streets alone, as I was instantly accosted by *felucca* (sailboat) pilots hoping to secure a fare. James returned, and we went out to dinner and later felt the familiar unwelcome effects of food poisoning. The next morning we went to Philae and explored the Temple of Isis, which was full of artifacts and too many tourists. I was feeling weak and wanted to move on, so after twelve hours sleep we caught a train to Luxor. The museum here has an amazing collection of carefully displayed artifacts. How different from the disorganization of the Museum of Cairo! The beautiful temple at Luxor is remarkable for its architecture, but it was sad to see that exhaust fumes from the many Nile cruise ships have blackened its exquisite ancient temple walls. We would definitely not be taking a cruise. I was still not feeling well so James went out at 1 a.m. (it was Ramadan so stores were open all night) to the pharmacy and brought me the awful concoction that would end the poisoning. After what I had experi-

enced in Nepal, I wanted to attend to this sooner rather than later.

Feeling better we decided to travel to Karnack. The complex at Karnack is a huge open-air museum and the second-largest ancient religious site in the world, after Angkor Wat in Cambodia. Karnack is famous for the gigantic columns of the Great Hypostyle Hall area, which consists of 134 massive pillars arranged in sixteen rows. Of these columns, 122 are 32–70' tall with a diameter of almost ten feet. It is an awe-inspiring forest of artfully incised stones. Immense and built on a grand scale, Karnack engenders a sense of smallness.

We had thought to go back and explore the Valley of the Kings; however the intense heat helped with our decision to head across the Red Sea to Jordan and the ancient city of Petra. First we traveled to Hurghada through beautiful desert, only to find the ferry across the Red Sea had been canceled. We had a day of rest and swam among an amazing variety of sea creatures. Finally the ferry took us to Sharm El Sheikh where we caught a minibus to Dahab through the rough desert of the Sinai. This is a lovely coastal tourist town, so we relaxed into good food, a nicer hotel, and snorkeling.

Detour through Jordan

We took the fast (not so fast) ferry to Aqaba in Jordan, then another long ride to Wadi Musa. Jordan is much cleaner and more prosperous than Egypt, and we had no idea how beautiful it would be. It is also quite a bit cooler, as the altitude is higher. Our base was a tiny room in the Cleopatra Hotel. We excitedly chose a three-day pass and walked many hours each of these days exploring this huge historical and archaeologically rich city. Inhabited since prehistoric times, the Nabataean peoples' caravan crossroads was half built, half carved into banded rose-colored sandstone.

Petra was a trade and religious center where ancient Eastern traditions blended with Hellenistic architecture. Entering Petra, we walked a long, narrow natural gorge, the Siq, or "the shaft,"

I love details and my fascination with sacred geometry may be the reason I was attracted to this pile of similar stone spirals that archaeologists describe as a boneyard.

to find at its end Petra's best-known ruin, Al Khazneh, known as "The Treasury." Miles of trails and multiple eras of construction are represented in temples, tombs, colonnades, sculptures, a Roman amphitheater, and Byzantine mosaics.

Petra is a dazzlingly beautiful jewel. Sometimes it amazes me how challenging it is to fill oneself with magic and wonder, then contain it in the physical. Leaving Jordan, we returned to Dahab on the Red Sea for more rest, good food, and snorkeling. The reef seemed fairly healthy despite the fact that what I first thought were jellyfish turned out to be many floating plastic bags.

The ferry to Hurghada was down again, so we took a really long bus ride north up the Sinai Peninsula to Suez, thinking we would stay overnight. We found Suez to be a bleak industrial pit, so caught another long bus ride down the Egyptian side of the Gulf of Suez back to Hurghada. After a day of

Expanding
Artistic Vision

146

rest and a boat and snorkel to Giftun Islands, we said good-
bye to the Red Sea and bussed through dusty twilight back to
Luxor.

The heat had abated to bearable. Now it was time to explore
the Valley of the Kings. The valley is believed to contain sixty-
three tombs and chambers. Most are not accessible; however
the sites we visited were well worth the heat and crowds. We
explored several tombs and filled ourselves with the art of the
ancients.

Throughout the journey I was attracted to, then enamored
of, images of the sky goddess Nut. She was painted on walls,
ceilings, and arches inside sarcophagi. She was an important
part of the resurrection myth and believed by some to be the
"original mother." She is said to swallow the sun at the end
of the day and birth it again from her womb every morn-
ing. She arches over the sky and is always seen filled with
stars.

Nut and the Cosmic Dream takes us into a spiral dream of the
cosmos. Spirals are the purest form of moving energy. They exist
everywhere . . . from the most minuscule to the grand expanse of
the universe and to this cosmic dream.

I was excited as the next part of our adventure took us to
Abydos. My studies of sacred geometry often speak of this impor-
tant site. Three hours by convoy and guarded tourist bus is the
only way to visit the region. There are guns at every bridge and
countless checkpoints.

Our first reward was the stunning temple to Seti I. This
temple is densely ornamented with hieroglyphs and carvings,
and there is mystery about its dimly lit corridors. As we were
exiting through the back door into blinding sunlight, a guard
said, "Flower?" My heart skipped a beat, as I had arrived at
the venerated temple of the Osireion, which I had especially
come to see. This structure shows significant architectural dif-
ferences from the Seti I temple and is believed to be far older.
Exquisitely constructed of massive red granite blocks and pillars,
it reminded me more of Incan than Egyptian construction. The
guard said I had only one minute so I quickly found my way to

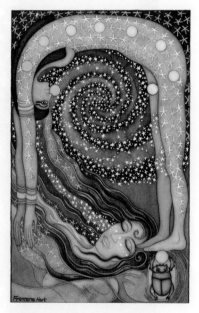

Nut and the Cosmic Dream,
2009

Expanding
Artistic Vision

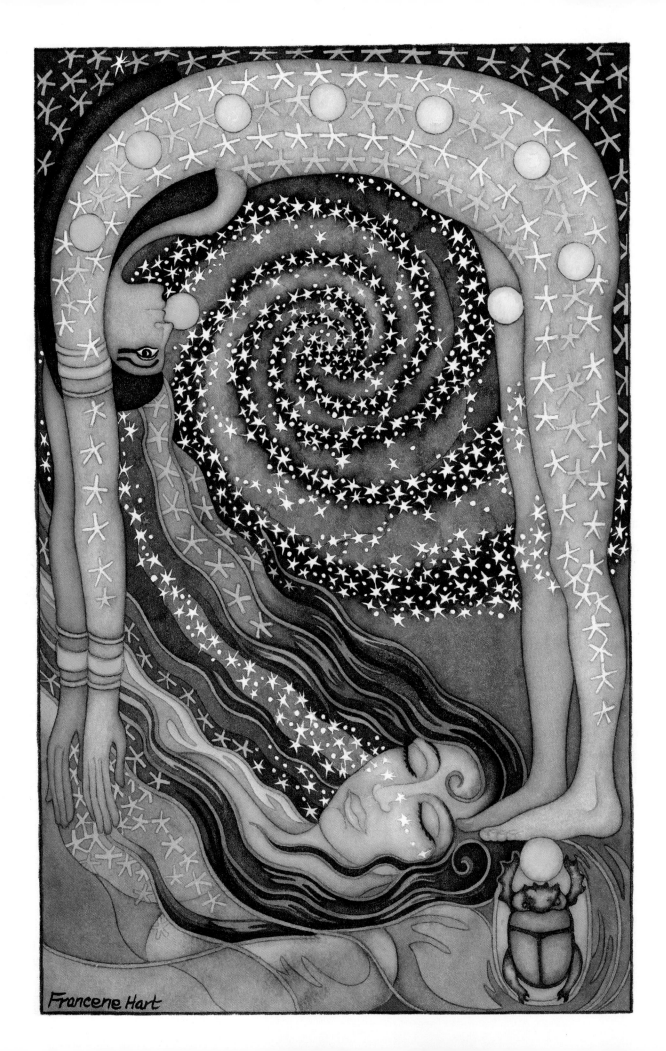

Francene Hart

the obscure position on of this partially flooded 6,000-year-old temple where the flower of life is carved with laserlike accuracy on the wall of this otherwise unadorned structure. It is believed that we would not be able to replicate this technique today. The flower of life and palpable spirit of place at this temple dedicated to resurrection adds to, rather than solves ancient mysteries.

Two hours farther we arrived at Dendera and its temple dedicated to Hathor. The ceiling was decorated with a complex and detailed star chart depicting the goddess Nut and elements of the zodiac. Much of the original paint could still be seen on this beautiful ceiling. In a narrow hallway beneath

NUT AND THE COSMIC DREAM, 2009

The sky goddess Nut was an important part of the resurrection myth and believed by some to be the "original mother." She swallows the sun at the end of the day and births it again from her womb every morning. She arches over the sky and is always filled with stars.

Expanding
Artistic Vision

the Temple of Hathor at Dendera were inscriptions depicting a bulblike object that some have suggested is reminiscent of an early lightbulb, while others say it is a lotus flower bulb, an idea supported by another panel showing the bulb opening into a lotus blossom. Inside the "bulb" a serpent forms a wavy line emanating from a lotus flower. Whatever the accurate story may be, it is a beautifully carved wall. This was a wonderful touring day!

A day of rest in Luxor, a sleeper train to Cairo, and a second train brought us to Alexandria. We stayed in a historic hotel on the bay where the Lighthouse of Alexandria, one of the seven wonders of the ancient world, once stood. We decided to visit some true desert, so traveled to the Bahariya Oasis. We enjoyed this quiet oasis, then took a beautiful five-hour bus drive across stark desert back to the teeming population hub that is Cairo. On our last day we enjoyed the color of the city, Al-Azhar Mosque, and Khan Al Khalili market. It was a bit difficult to believe this epic adventure had come to completion.

Crop Circles and Standing Stones, Scotland and England, 2009

Having Scottish ancestry would be reason enough to visit the British Isles. With visits planned to standing stones and crop formations, this promised to be a powerful, awe-filled journey. Another romantic meeting in a foreign airport began our travel. After a night of reunion and time walking around the historic city of Glasgow, we proceeded north on the West Highland Railway. Said to be the most scenic train journey in Scotland, it ambles through magnificent lochs and mountain scenery. On through Harry Potter territory, we spent the night in the Gaelic village of Mallaig on the west coast. The morning found us on a short ferry to the Isle of Skye, then a Day Rover fixed-price bus through scenic countryside and rough mountains along the rocky ocean to the village of Uig, where we spent the night. Waking early we were greeted by a soft, misty morning and walked the shoreline to the next ferry, then on to the Isle of Lewis. On Lewis the bus took us through lovely sparsely populated countryside filled with grazing sheep and locals harvesting peat bogs. We were heading toward Callanish (*Calanais* in Gaelic).

We went to the Isle of Lewis in the Outer Hebrides expressly to visit Callanish and were not disappointed. This was our first standing-stone site. Callanish is a cross-shaped setting of standing stones erected in the late Neolithic era as early as 3400 BCE. This location was a hub for ritual activity during the Bronze Age as both an astronomical observatory and a sacred temple. Though not large, it holds significant energy. Each stone has a strikingly unique personality. I love communicating with rocks, and sitting beside and within this stone circle felt like talking with old friends. We were the only visitors for a couple of hours and fell in love with this place of sacred stones.

It is generally believed that the ring also functioned as an astronomical calendar associated with the moon. In the painting *Callanish Stone Circles*, the vertical stones intersect a circle within an ellipse. The ellipse shape is important because it corresponds to the orbit of the Moon around Earth, as well as the orbits of the

Callanish Stone Circles, 2009

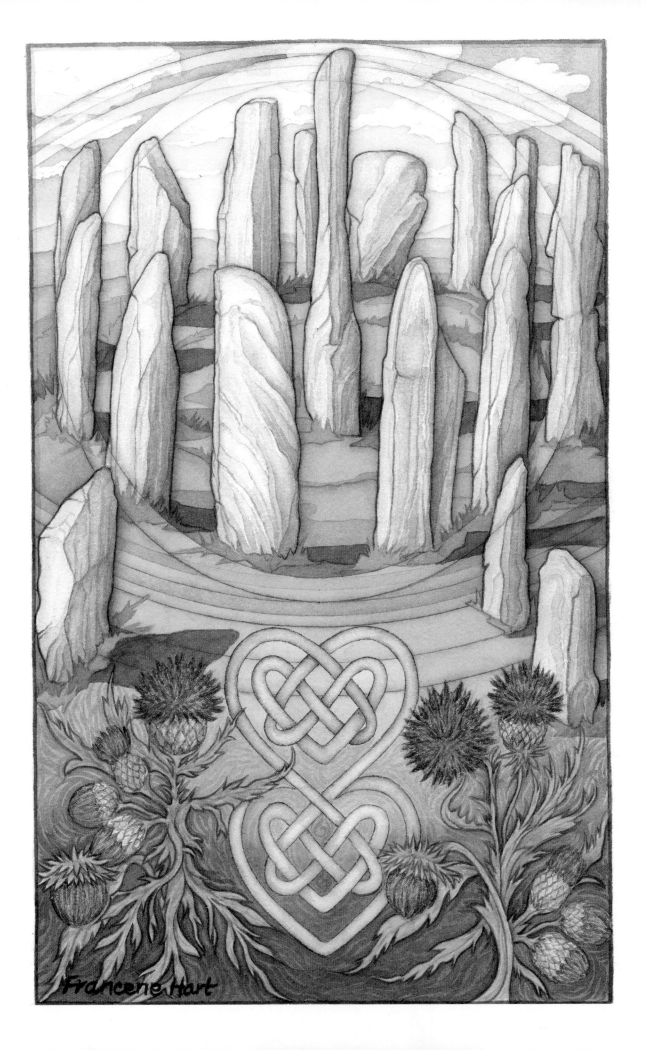

Francene Hart

planets around the Sun. The thistle is Scotland's national emblem and the Celtic knotted hearts here are meant to symbolize the continuity of love entwined that has no beginning and no end.

The next ferry brought us to cold, windy, remote, gorgeous Durness, the most northwesterly village on mainland Britain in the highlands of Scotland. The hostel where we stayed required us to vacate for most of the day, which encouraged a walk through sleet and wind along a splendid panoramic rocky coast. Gorgeous seascapes, nesting birds, stunning sand dunes, and lots of seals were gifts on this cold blustery day.

In most parts of Scotland we used public transportation, preferring not to drive on the left side of the road. However the remoteness of Durness required a day of hitchhiking along the wild northern Scottish coast to Scrabster, then catching a ferry to Orkney Island. As the ferry embarked, the long summer's evening presented us with stunning golden light and views of several iconic rocky sea stacks, orcas, and puffins.

Orkney Island contains some of the oldest and best-preserved Neolithic sites in Europe. Here we did decide to rent a car because the sites are widely separated and there is scarcely any traffic. We stuck to the back roads and headed for Skara Brae, Europe's most complete prehistoric village, a UNESCO World Heritage Site, and one of four sites making up "The Heart of Neolithic Orkney." The other sites in this group include a large chambered tomb called Maeshowe and two ceremonial stone circles, the Stones of Stenness and the Ring of Brodgar. This group constitutes a major prehistoric cultural landscape that gives a graphic depiction of life in this remote far-northern Scottish archipelago some 5,000 years ago. Each of the sites is different, and each is hauntingly beautiful.

We ferried back to mainland Scotland. On the bus again,

CALLANISH STONE CIRCLES, 2009

It is generally believed that the ring functioned as an astronomical calendar associated with the moon. The ellipse shape here is important because it corresponds to the orbit of the Moon around Earth, as well as the orbits of the planets around the Sun.

we moved through gorgeous green countryside visiting tiny villages and grand historic castles. Edinburgh castle and the smaller Rosslyn Chapel were highpoints. Thanks in part to the popularity of author Dan Brown's book, *The Da Vinci Code,* and film of the same name, Rosslyn's priceless treasures are being restored.

We stayed a couple of nights beside the deep murky lake in the Scottish Highlands named Loch Ness. Although we did not see the infamous monster, it was easy to appreciate the mystery of this location. Busing onward to England, I felt a bit sad to leave Scotland, yet was excited to see crop circle formations.

England

Before we arrived in crop circle country, there were more beautiful stone circles to visit, including Castlerigg stone circle in the county of Cumbria. The spectacular site offers a panoramic view of rugged hills. Here I came to fully recognize that each of the unique stone circles we were visiting was created for a specific sacred purpose that included the local topography and definitely was connected to the spirit of place.

Crop Circles

For years I had been fascinated by the extraordinary geometric patterns that appear in fields, primarily in England, known as

crop circles, agriglyphs, or landscape art. My studies in sacred geometry hastened a desire to experience this phenomenon first-hand. Theories abound as to who may be producing them and there is much conjecture about their meaning. Some say they are created by intelligent alien beings or electromagnetic energies; others insist they are made by locals with a board and string. Whatever their origin, nearly all of the formations include exquisite geometry. I see them as a form of communication created in the language of light called sacred geometry. The language is the source, not necessarily who or what physically creates them.

As it was close to summer solstice I secured a room in a lovely guesthouse near Avebury. The following morning our host kindly dropped us at our first crop circle, called the Phoenix. Though it was created more than a week prior to our arrival, we definitely could feel the energy and it made a wonderful start to our circle adventures.

Noticing that this formation was located in a field adjacent to an ultralight airstrip, we decided to see what the countryside and crop glyphs might look like from above. Wow! This was the absolutely best way to view the phenomena. It was incredible to see more than fifteen crop circles from the air, several created just the night before.

One of the most spectacular was located near West Kennet Long Barrow, where we had enjoyed lunch the day before. While sitting atop this ancient burial mound, my partner sensed and saw orbs in the clouds and in the bushes. Often accounts of circle creation include orbs or moving lights, so this was quite exciting. We walked a long way back to Avebury and the Long Barrow location.

YIN/YANG

We were thrilled by the sight of the gorgeous double yin/yang crop formation we saw from above. Located on a beautiful sloped green hillside, it was created just before dawn on this, the summer solstice. Back from our flight, when we stepped into this formation there was a tangible sense of moving energy. Walking through the spiraling lanes, touching the crests of young barley, my hands began to tingle . . . and did not stop for several days. There were areas in the swirls arranged in a unique textured display, some standing, some laid flat in a complex intentional pattern.

**Expanding
Artistic Vision**

When the light on the hillside shifted, the entire formation seemed to shimmer and move. I decided to step into the portion that is textured and energetically moving against the grain. Instantly it felt as if I had stepped into a rapidly moving current. Whatever you believe about these phenomena, they are powerful symbols.

More than simply a painting about crop circles, *Wisdom of the Circle Makers* embodies a message of balance and celebration of nature and a sense of wonder at life's mysteries.

The next day we took a bus to Salisbury. Then at a suggestion from locals we walked to Stonehenge via a farm trail through forest and fields. This is an impressive way to approach the famous stone circle without being immersed in crowds. One day prior, twenty thousand visitors had been here celebrating summer solstice. Walking as we did afforded us the long view of the surrounding countryside and many mounds that have more recently been discovered to be a part of this impressive sacred site. There were more sacred site stops, including Old Sarum and the city of Bath, then a bus to London and a visit to the British Museum, where we saw many antiquities brought here from locations we had visited around the planet.

Being gardeners we couldn't miss the 250-year-old Kew Botanical Gardens before heading to mainland Europe. It was a unique experience sitting in a bus inside a container traveling under the English Channel. After another bus ride and a brief visit to Amsterdam, with its famous Bull Dog Café and the wonderful Van Gogh Museum, we headed for Paris.

WISDOM OF THE CIRCLE MAKERS, 2009
Circles, spirals, and a flower of life express the
moving energy in the crop circles.

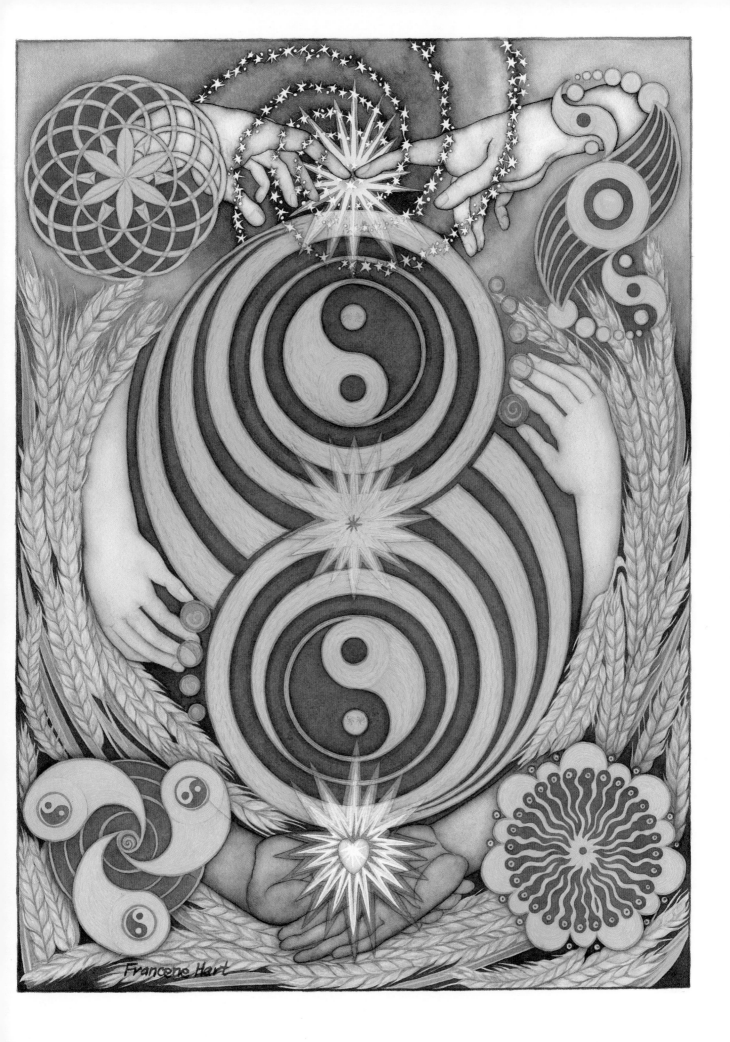

Francene Hart

The controversial glass and metal pyramid designed by renowned architect I. M. Pei welcomes visitors to the Louvre Museum and serves as its main entrance.

Cathedrals and Museums of Paris

Even hostels in Paris are expensive; however booking ahead afforded us a private room with a classically Parisian balcony, which added a superb aspect to the finale of this journey. We spent the last days walking all over Paris. I am generally not at my best with city energy. However Paris was beyond others for culture and beauty. We wandered many hours through the halls of the Louvre.

Wonderful as the Louvre is, an inspiring afternoon spent in the Musée d'Orsay was phenomenal, making this museum my favorite. My studies of sacred geometry demanded that we visit Chartres Cathedral, considered one of the finest examples of French-Gothic architecture and the site of a famous labyrinth, so we took a train out of the city to that gorgeous cathedral.

Two final days back in romantic Paris strolling along the Seine, visiting Notre Dame, and exploring the colorful Montmartre district and the Sacré-Coeur basilica completed our wanderings. These months were an exciting, dreamlike adventure, but now I was eager to return to my quiet life in Hawaii and resume painting.

Central America, 2010

It's always a pleasure to be headed to Central America. This time the focus was Belize through Costa Rica. Our plan was to visit a few of the more southern Maya ruins and have some Caribbean coast adventures. While enjoying the lovely tourist island of Ambergris Key off the coast of Belize, we came to realize that our hoped-for snorkeling and whale shark sightings might not be possible. The waves were turbulent or our timing was off, so we adjusted our desires and experienced other wonders. Being able to transcend expectations and gracefully change plans is an excellent travel skill.

Back on the mainland of Belize, we stopped in Orange Walk and booked a boat up the New River to the preclassic Mayan temples at Lamanai. This river is habitat for numerous types of fish, birds, and monkeys as well as crocodiles. At the site there is a structure that dates back to 625 CE, the Jaguar Temple, named for its boxy jaguar features. The pyramids here are quite striking.

We bussed on through rural Belize to Maya Center, pleased to be headed toward Cockscomb Wildlife Sanctuary and Jaguar Preserve, and our second jaguar sighting in the wild.

Second Jaguar Sighting, Cockscomb Basin Wildlife Sanctuary, Belize

Curiously enough, the information we read about Cockscomb Basin Wildlife Sanctuary in southern Belize, also known as the jaguar preserve, said, "Do not expect to see a jaguar!"

We spent the night in a very rustic bunkhouse, planning to rise early in hopes of viewing rain forest wildlife that is virtually

LABYRINTH

invisible during most of the day. Dawn was a noisy affair of bird, insect, and animal sounds, which helped us rise early and get out on the trail. We were the only overnight visitors, so had the early morning to ourselves. Some distance into the hike we saw what appeared to be fresh cat scat, which felt like an encouraging sign. We stopped where the trail looked out over a river. Several small river otters were frolicking there, seemingly oblivious to our presence. James began snapping photos, then noticed his camera battery was very low and ran back to the bunkhouse for a spare. I waited on the riverbank, enjoying the early morning. While meditating and watching the beautiful jungle, it spontaneously occurred to me that I hoped James would return in time to see the jaguar. He returned shortly and we walked a bit farther to a sandbar in the river. As we paused to look back to where I had been sitting, there was our jaguar crossing the river. He turned and looked at us, then after a few moments flicked his long tail and bounded up the riverbank to exactly my former spot. Could this possibly have been mere coincidence? In any event, it was a privilege to see this magnificent cat on his home turf.

Rainforest Neighbors honors the diversity of the Central American rain forest. All these creatures, including my jaguar spirit guide, revealed themselves in this amazing place.

We stopped for rest and good food in Placencia, then took time for a boat trip to Laughing Bird Key for snorkeling. The waves were rough so we moved on again.

Inspired by the culmination of a morning yoga session at the ocean's edge in Placencia, the figure in *Standing in the Light* stands with arms pointed to the heavens, welcoming a new day. Dazzling multicircular geometry borrowed from a 2010 crop circle formation emanates brilliant color

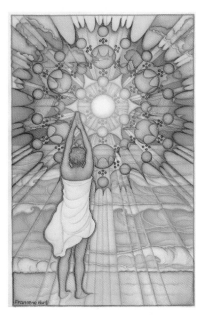

STANDING IN THE LIGHT, 2010

RAINFOREST NEIGHBORS, 2010

As we paused to look back to where I had been sitting, there was our jaguar crossing the river. He turned and looked at us, then after a few moments flicked his long tail and bounded up the riverbank to exactly my former spot.

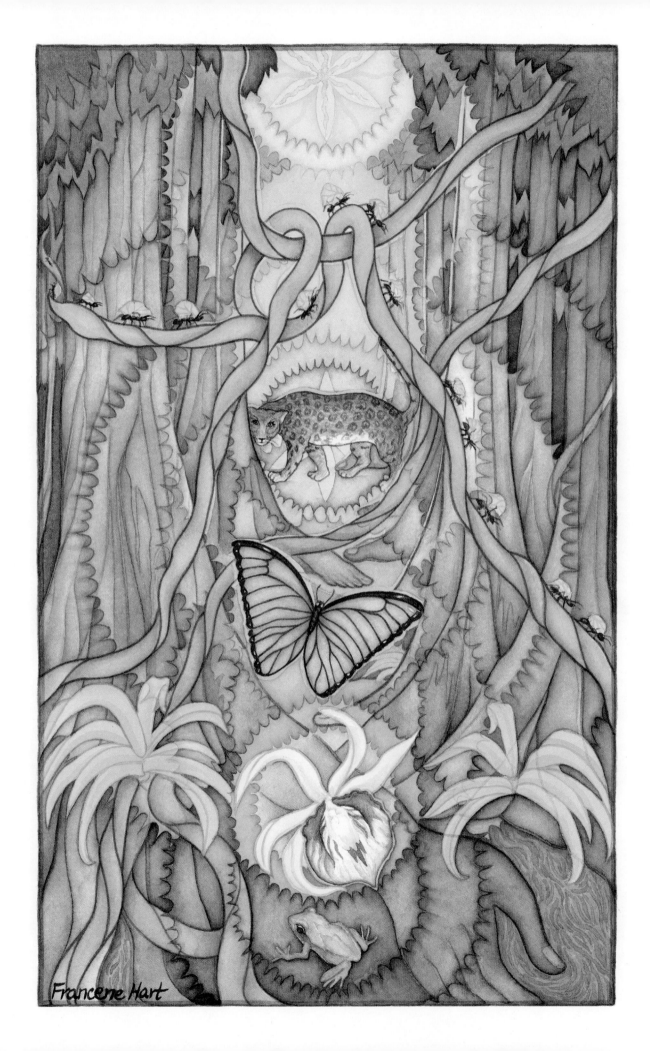

Francene Hart

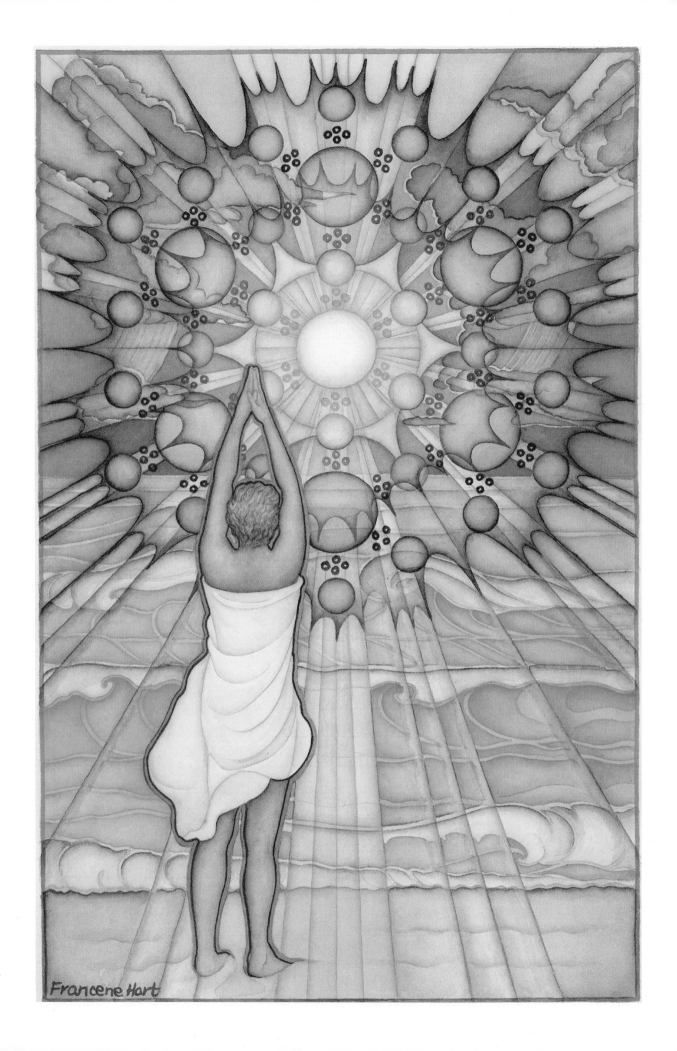

and information, enhancing the potential of another radiant dawn.

On we went to Nim Li Punit and Lubaantun, two more southerly Mayan ruins. Unlike other Maya cities of the era, which are mostly built of limestone, the structures at Lubaantun are constructed primarily of large, black slate stone blocks laid without mortar. It also has the rounded corners of a step pyramid, which is rare in Maya temple construction.

This is the site where the famous Mitchell-Hedges crystal skull allegedly was found. I love a good mystery and try to feel into that possibility; however the likelihood that the crystal skull was found at Lubaantun did not feel correct to me. Nevertheless, it is a beautiful sacred place.

Honduras, Nicaragua, and Costa Rica

We crossed overland via several bus changes into Honduras. On our way to Utila we had to pass through the frightening city of San Pedro Sula, said to be the most dangerous city in the world due to gang and drug crime. The hostel was filthy and there were gunshots in the streets. We were relieved to make it to the lovely Caribbean island of Utila, where we were able to enjoy a snorkel with a local dive boat. Yet again, the waters were too rough for boats to navigate into deep water to look for whale sharks. Those magnificent creatures remained elusive. Perhaps it will be one of their rare visits to Hawaii that will finally fulfill my dream of seeing whale sharks.

We continued on to the Copan, among the most southerly of the ancient Maya cities. It is known for a superb stairway, ball court, and many exquisite stela (tall stone sculptures), as well as a unique temple called Rosalila. The Maya had a practice of

STANDING IN THE LIGHT, 2010
Dazzling multicircular geometry borrowed from a 2010 crop circle formation emanates brilliant color that warms, illuminates, and energizes.

building temples upon temples, encasing intentionally collapsed remains of former pyramids, and adding an additional layer on top. Rosalila is unique in that the interior of this pyramid was not demolished before being built upon, and was discovered virtually undamaged inside the later structure. Constructed in the early classic period, it is an almost completely preserved example of the art and architecture of this era. The facades of the temple are elaborately decorated with complex religious and cosmological messages and lots of brightly colored paint. There is a beautiful reconstruction of Rosalila in the museum on site.

It seems that everywhere we went, Honduras was suffering from power outages, chaotic bus connections, and questionable encounters. We were in and out of Tegucigalpa and on to Nicaragua as soon as we were able to find connections. A first-class bus took us from Managua through a spectacular thunderstorm to the colonial city of Granada. Planning to stay here for a rest, we walked to Lake Nicaragua and found the water to be foul. We felt that perhaps this part of Central America was simply not welcoming us. I will not dis any location and know it is likely that at another juncture the experience might be totally different. We found a French tour guide who said he would take us to Costa Rica for gas money as he was headed that way anyway. We shuttled with him through the border and were extremely grateful for his local expertise as the border crossing is chaotic and hugely congested. Had we been traveling by local bus, this border crossing would have taken innumerable hours.

Now beyond the range of Mayan civilization and sacred temples, we relaxed into the beauty and ease of Costa Rica. We were traveling toward Volcán Arenal. At 5,437 feet, Arenal grandly looms over green hillsides and has been continually active since 1968. We found a room in La Fortuna with a picturesque view from our bed of Arenal's classic volcanic cone, then headed to Arenal Volcano National Park. The park is quiet with a beautiful jungle trail leading to a volcano viewpoint, which is deemed a safe distance from which to watch the show. We spent several

hours being highly entertained watching Arenal spit huge boulders from her cone. We laughed as they came leaping and bounding down the slope. The following day officials closed that part of the park due to dangerous volcanic activity, so we felt fortunate to have enjoyed this display.

Orchid Volcano was inspired by this visit. The painting holds the energy of planetary change embodied in volcanoes all over planet Earth. A lovely orchid graces the scene. Geometry borrowed from a crop formation exactly echoes the volcano's energy. The triangle that is the volcano is echoed above it, while intersecting circles suggest the continually evolving nature of the life force.

Moving ahead, we traveled by van and boat through the Costa Rican countryside to visit the Santa Elena Cloud Forest Reserve. Spending many hours wandering through green misty dripping jungle definitely nurtured my soul. The following day we found ourselves enjoying another wonderful cloud forest at Monteverde. Cloud forests are rare worldwide, occurring solely within tropical or subtropical mountainous environments where the atmospheric conditions allow for a consistent cover of clouds. The forest is dense, and though we heard many birds and other unidentified creatures, we saw only iridescent hummingbirds whizzing by, appearing, then disappearing into the mist and greenery. There is a nurturing feel to these cloud forests.

On to Manuel Antonio where we spent two days and long hours exploring the stunning Manuel Antonio National Park. The park includes a charming combination of rain forest, beaches, and coral reefs, which were quite different from the cloud forests we had recently enjoyed. The beaches are beautifully lined with lush forest. It rained all day; however that did not diminish our enjoyment. The forest is home to sloths, iguanas, and the rare and adorable squirrel monkeys. Blue morpho butterflies appeared again and again, adorning the jungle greenery with their iridescence.

A bit weary from long travel we decided to make Uvita and Marino Ballena National Park our most southerly destination.

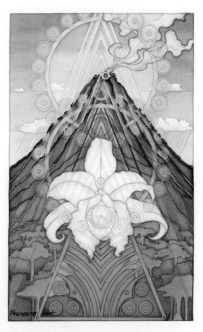

Orchid Volcano, 2010

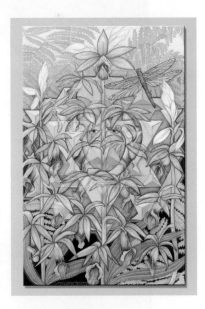

Wild Orchids

Expanding
Artistic Vision

165

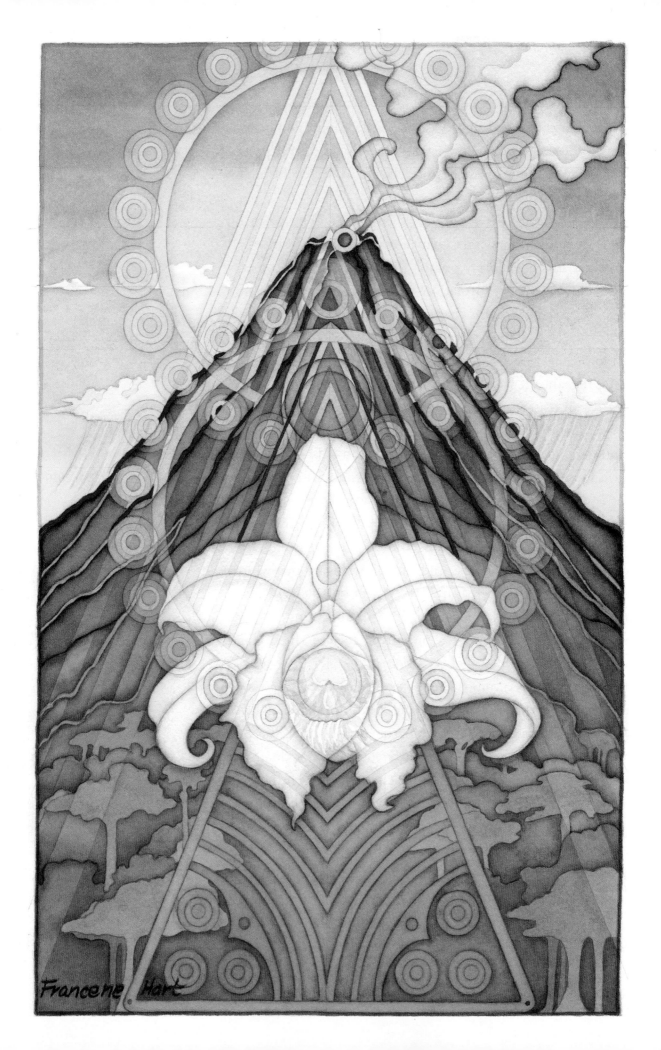

Francene Hart

Named for both the humpback whales that migrate here each winter and a beautiful spit of land that looks like a whale's tail, Marino Ballena beach was gorgeous and deserted. We walked a distance and settled into the sand. Having been warned about theft we left all money and documentation at our guesthouse. James went into the water and I relaxed for what seemed like only a moment, when out of the corner of my eye I caught movement, then turned quickly to see a young man with his t-shirt pulled over his head running into the jungle with our snorkel gear and sandals. James ran back to the park gate to make a report, and one of the guards headed off in his dune buggy . . . in the opposite direction from where James had pointed. There would be no thief caught here today, and they may all have been in cahoots. Though it felt like an affront, we were fortunate we didn't lose more. Now it was time to go home.

United States Southwest

After many international adventures it was time to explore some national parks in the United States. We started our Southwest tour with a visit to my sister who lives in Las Cruces, New Mexico. I had visited years before and was pleased to have James along this time. Marglyph is an extraordinary jewelry artist and rock art aficionada, and my gentle, creative brother also joined us during both visits, so it became excellent family time.

We began these adventures with visits to several petroglyph sites. My favorite was the Three Rivers petroglyph site, located on a long, basalt ridge rising from the upper Tularosa Basin at the base of the Sacramento Mountains. In the distant past, three rivers united in a confluence in this location, hence the name. It is one of the few locations in the Southwest set aside solely to honor

Orchid Volcano, 2010
This painting holds the energy of planetary change embodied in volcanoes all over planet Earth.

the fabulous rock art. Visitors have extraordinary access to closely view many of the more than 21,000 glyphs that have been documented here. The petroglyphs at Three Rivers were created by the Jornada Mogollon people, who used stone tools to remove the dark patina on the exterior of the rock, revealing lighter-colored stone beneath. These native artists produced exquisite images of birds, humans, animals, fish, insects, plants, and numerous geometric and abstract designs that remain beautifully intact. Both visits to Three Rivers were filled with wonder and inspiration for my art.

Stone Stories was inspired by the incredible landscape and huge array of petroglyphs at Three Rivers. The step-fret/pyramid pattern that appears in indigenous art here and elsewhere around the planet mirrors the glyphs of the rock art. The roadrunner, considered a good luck symbol, is gazing at one of several glyphs with fertility themes.

The following day we visited another lovely rock art site called Pony Hills, and on the way back encountered a wild sandstorm, something we do not see in Hawaii. We then departed for some weeks of exploring national parks around the American Southwest. First we stopped at River Bend to soak in some lovely hot springs before heading toward Bandelier National Monument. Again we encountered a sandstorm and this time the lack of visibility caused us to stop early and find a motel. Even with the windows closed tight and wet towels lining the cracks, dust filled the room, and the storm didn't abate until the next morning.

Bandelier is situated between 3,000 feet altitude and 10,000 feet and protects ancestral pueblo archaeological sites. We enjoyed a day of hiking the trails and viewed a number of ancestral pueblo homes, kivas, rock paintings, and petroglyphs. We intended to camp; however it was quite cold so we opted to spend the night near Giggling Springs hot springs. I do love hot springs.

STONE STORIES, 2006
The step-fret/pyramid pattern that appears in indigenous art here and elsewhere around the planet mirrors the glyphs of the rock art.

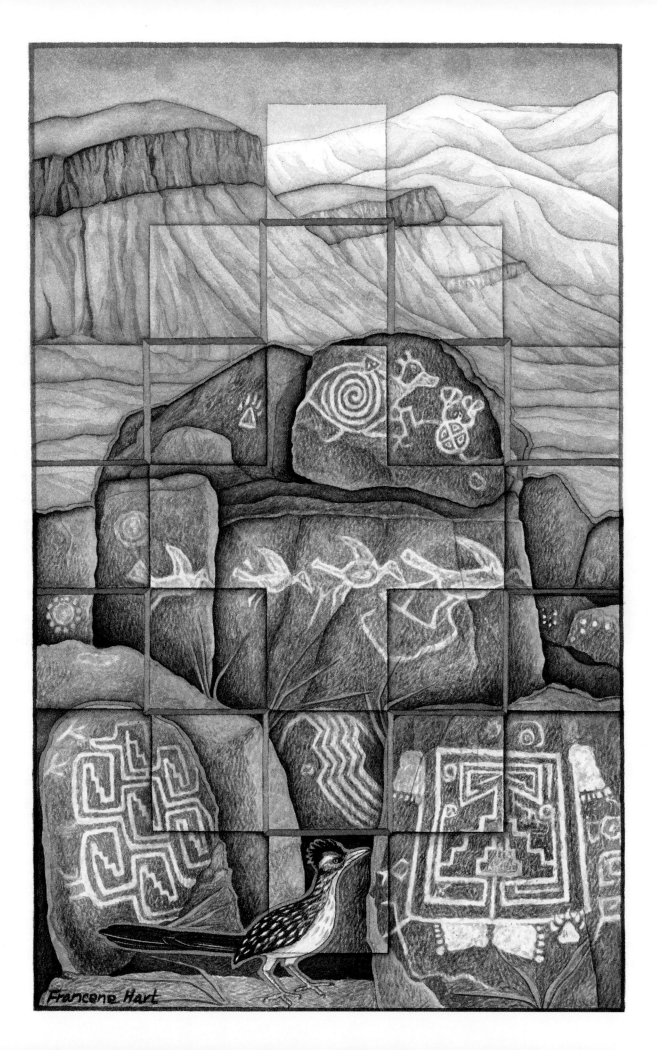

Francene Hart

Our next call took us to Chaco Culture National Historical Park in northwestern New Mexico. Accessible only by twenty miles of very rough gravel and dirt road, this is not a park for a casual visit. However at the end of this road there is a sweeping collection of outstanding ancient ruins. A major center of ceremony and trade for the prehistoric Four Corners area, it is one of the most dramatic ancient sacred sites in New Mexico. Because of the road we decided to camp two nights and take time to deeply feel this spectacular place filled with kivas (ceremonial chambers built partially underground) and rock art.

We set up camp and enjoyed a sunny afternoon hiking. The following morning we woke to 18°F temperatures. Brrrr! We made coffee and drove to a fabulous vista of Fajada Butte, which rises nearly 480 feet above the canyon floor and is a site of ceremonial importance for the Chacoan people. At one point in time visitors were allowed to climb a long ramp up the butte to a site known as the Sun Dagger and view spiral petroglyphs that revealed the changing of the seasons to Anasazi astronomers a thousand years ago. At summer solstice a vertical shaft of light pierces the main spiral precisely at its center. At winter solstice, two shafts of light bracket the same spiral.

In 1989, erosion of the clay and gravel around the base of the stone monoliths, due to human passage, caused them to slip. As the slabs inched down the steep slope of the butte, the Sun Dagger shifted. Having marked the passage of seasons for many centuries, it lasted only ten years after its discovery. Though it is no longer possible to climb the trail and sad to realize how damage due to human intrusion is altering sacred sites, it is nonetheless an extraordinary place.

The majesty of the landscape and many petroglyphs inspired *Sun Dagger,* which pays homage to the solstice sunlight piercing

Sun Dagger, 2013
The majesty of the landscape and many petroglyphs inspired this painting that pays homage to the solstice sunlight piercing the petroglyphs.

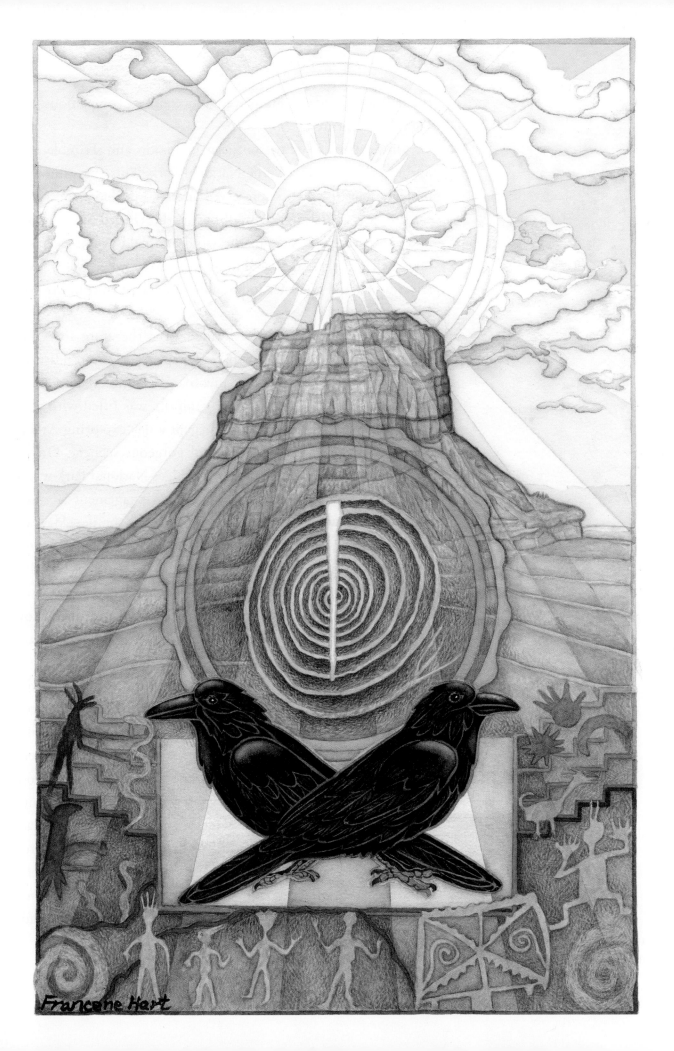

Francene Hart

the petroglyphs. Two ravens were our constant companions during this adventure.

Onward we went to southern Colorado and Trimble Hot Springs, then to Mesa Verde National Park. This stunning park protects some of the best preserved ancestral pueblo archaeological sites and massive cliff dwellings in the United States. Long hikes to petroglyph sites in the wind and cold prompted us to take shelter at the Far View House in the park where we enjoyed a warm bed and gourmet food. Sometimes a bit of comfort goes a long way.

Rested and renewed we headed over the state line into Utah and made a brief visit to Newspaper Rock State Historic Park, then toured through Canyonlands National Park. The drive was highly scenic yet every campsite was filled with rock climbers. We slept in Moab, then spent a day exploring Arches National Park's fabulous views and gorgeous scenery. On we went to Butler Wash, then Natural Bridges National Park where we were directed to a Bureau of Land Management site and camped in a sweet secluded valley. Off again the next day, we toured through Monument Valley and eventually Zion National Park. Zion Canyon, which is fifteen miles long and up to half a mile deep, is cut through reddish- and tan-colored Navajo sandstone by the north fork of the Virgin River. We camped (now warmer) and utilized the park shuttle to tour gentle waterfalls and gorgeous outcroppings.

Finally, we made our way to Arizona and Grand Canyon National Park. After so many geological wonders I was not certain I would be impressed. However upon first sight the Grand Canyon revealed itself in magnificent beauty and grandeur almost beyond comprehension. We camped, yet again it was cold for these wimpy residents of Hawaii. We did enjoy the warmth of the day and the incredible wow of the wonder of this magnificent place. One of our most amazing experiences occurred as we were standing at the canyon rim enjoying the spectacular view. Rising up directly before us on the thermal updraft soared two California condors. These enormous, impressive birds made for a perfect climax to our tour of national parks.

I am so grateful to our country's National Park Service for their mandate of protection for these extraordinary parks, as well as continued visitor access to the most amazing treasures our home country has to offer. It is my prayer that they continue to be protected.

I am honored to share these spiritual adventures. Travel has been a deep well of inspiration on so many levels and has happily inspired many paintings. My intention is to continue to experience and be inspired by travel adventures for decades to come.

PELE'S SUMMONS

Finding Home in the Waters of Hawaii

Heed the Call . . . Move to Hawaii

In 2001 accepting an invitation to facilitate a sacred geometry workshop on the Big Island of Hawaii initiated a life-transforming experience. I had not previously desired to travel to Hawaii, since from a midwestern perspective Hawaii looked like high-rise hotels and busy beaches.

Leaving the midwestern airport at twenty degrees below zero on a February morning was the beginning of an extraordinary shift in reality and location. Generally I *see* but do not particularly hear calls of spirit. Stepping off the airplane that night into warm tropical air, I heard a loud voice say, "Home!" Looking around to see who might have spoken, a realization came that it must have been Hawaii Island, or perhaps Pele herself, bestowing this simple message. It was a pivotal moment when the Divine spoke clearly and the path to the future invited a radical shift. I had traveled quite a bit, but an event such as this had never before occurred.

As it turned out the location for the workshop was not high-rises and busy beaches, rather a quiet community in rural North Kohala. Relaxing and enjoying the warmth of this first tropical evening became a source of surprise and wonderment. Out of soft silence reverberated the sound of tail slaps and the exhalations of breathing bodies. It was whale season in Hawaii, and even though the ocean was almost a mile from where I sat, the sounds

were superb. This felt like a verification of the "home" in Pele's message.

Following the workshop my hostess and her children led me on a tour of the island. We visited several of the varied environments of the Big Island, including deep tropical forest and wonderful wild coastlines. On this journey I was introduced to the source and creative power of Hawaii's most active volcano. We visited Volcanoes National Park where at that time it was possible to walk across barely cooled lava at the bottom of Chain of Craters Road to view the current eruptive flow. It was breathtaking to see molten lava flowing and glowing in the darkness as we followed markers placed by the park service to a location deemed a safe distance from the active front. Both children had attended the sacred geometry workshop, and at one point the call was, "Look, Pele is creating a pentagon!" There clearly was a pentagonal-shaped volcanic flow cascading down the mountain.

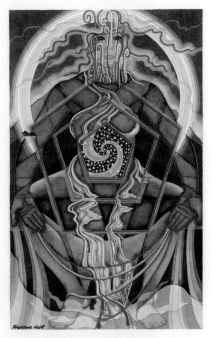

PELE'S SUMMONS, 2001

This became the inspiration for my first Hawaii painting named *Pele's Summons.* Pele, goddess of fire, lightning, wind, and volcanoes, has a profound effect on virtually every person who enters her realm. I am one of many who have felt her summons. Her home is believed to be Halema'uma'u crater in Volcanoes National Park, and the frequent eruptions of lava are said to be a reminder that she is alive and still at home here.

Pentagons embody power, excellence, strength, and protection. This pentagonal-shaped star portal connects her and you with every particle of creation.

I enjoyed ten days in Hawaii facilitating the workshop and exploring the island and returned to Wisconsin filled with a knowing that a major shift was about to take hold of my life. I am not prone to radical moves. I had lived in the woods for more than twenty-five years; however this was a summons I could neither deny nor resist.

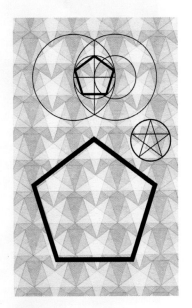

PENTAGON

Back in the forest the question kept arising, "What am I doing?" The answer was always, "Trust yourself." There remains some sadness for the upset caused by my departure from a life that might have stayed the course had I not left. Though not an easy choice, this decision was essential to a new chapter opening

Pele's Summons

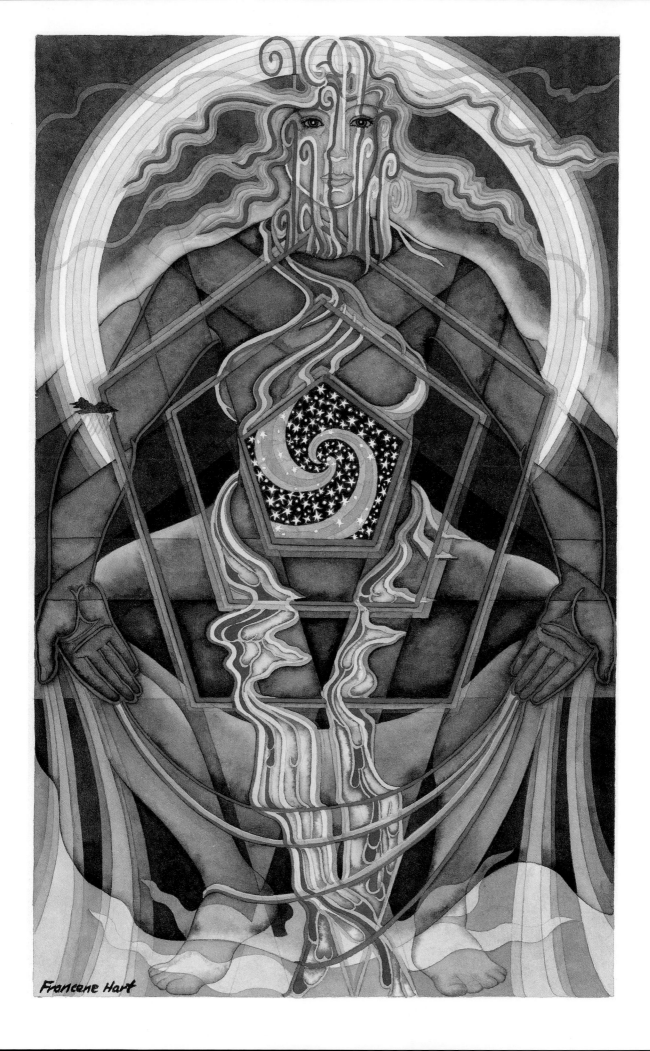

Francene Hart

before me. I took an enormous leap of faith, and Hawaii became home.

I had not been in Hawaii long when a vision occurred that imparted a lasting capacity to see. I hadn't yet learned to be comfortable in the ocean, yet felt a strong pull toward her. A tiny private beach alcove near one of the island's historic parks offered an ideal sanctuary where I learned to relax into communication with the sea. This became a place of daily meditation and art. One day while walking through the partially reconstructed village on the way to my secret beach, I felt an undeniable presence. Out of the corner of my eye, faintly materializing, were a number of traditionally clad villagers. They appeared not fully solid and seemed to have neither sense of nor concern about me. Looking at them directly caused them to fade, yet when viewed peripherally they continued to go about the business of their everyday lives. By maintaining a quiet vibration, I was able to witness a doorway opening to another time. I am grateful to have discovered this access point and continue to utilize it when traveling elsewhere to help connect with ancient peoples and the spirit of place.

When I moved to Hawaii, people told me that Pele, as the volcano goddess of Hawaii, either embraces you or spits you out. Many individuals cannot deal with the powerful dynamic energy of the island and end up leaving after a short time. It is not about whether you arrive wealthy or penniless. It is the manner in which the potent resonance of the island touches your heart and soul. As much as it is paradise to visit, Hawaii is not for everyone.

For several years it felt necessary to ground myself as a resident and be certain that Pele was indeed embracing me. It was also essential to know I would be able to make my way financially and continue to paint and follow this divine path. I remain in a state of gratitude and appreciation as the blessings of Hawaii continue to regenerate and embrace my life.

GRATITUDE

PELE'S SUMMONS, 2001
Renowned for her fiery temperament, the goddess Pele has a profound effect on virtually every person who enters her realm. Pentagons embody power, excellence, strength, and protection.

Pele's Summons

177

Heart of Aloha

The word *aloha* commonly means hello or good-bye and love. When considered in more depth it also means affection, compassion, mercy, sympathy, kindness, sentiment, beloved, and much more.

During this time my life and creative work underwent powerful changes. As I connected with the land (*aina*) and sea (*kai*), it also felt important to connect with the beauty of the culture. As a new resident I wanted to be cautiously respectful not to transgress tradition or think that I had any intrinsic right to live here. The island's rich culture and varied environments encouraged me and offered inspiration for many new paintings.

Inspiration for *Compassionate Pele* came during meditation. Initially this vision of the volcano goddess felt a bit uncertain. Was it right to share the idea of Pele as compassionate? Legends speak of her actions being powerful, yet also vengeful and unforgiving. I was a bit concerned that this alternative depiction could be seen as an insult to tradition; however the message was clear that she is maturing and becoming more loving and compassionate.

While living in Hawaii I encountered a powerful Hawaiian woman, Haleaka Iolani Pule, known as Aka, who became a dear friend. When I rather shyly told her about my vision of Pele, she laughed her big laugh, hugged me with her magnificent warmth, and told me that many native Hawaiians were also receiving the vision of a more compassionate Pele. She had a large presence, and from that moment it became my intention to create this vision of Pele as an energetic portrait of the beauty that was uniquely Aka's essence. When Aka first saw *Compassionate Pele* she identified with the representation of the goddess. Energetically *Compassionate Pele* was definitely Aka. In the summer of 2014 while touring Europe and sharing Hawaiian wisdom, Aka passed

Compassionate Pele, 2002
Legends speak of Pele's actions being powerful, but it became clear in a meditation that she is maturing and becoming more loving and compassionate.

Pele's Summons

178

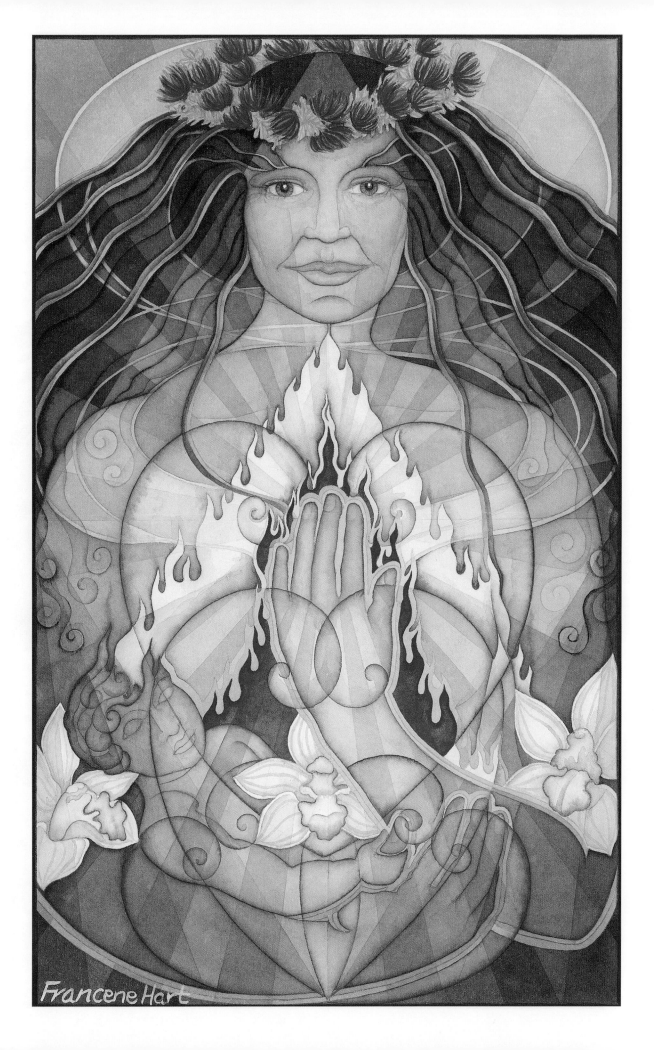

Francene Hart

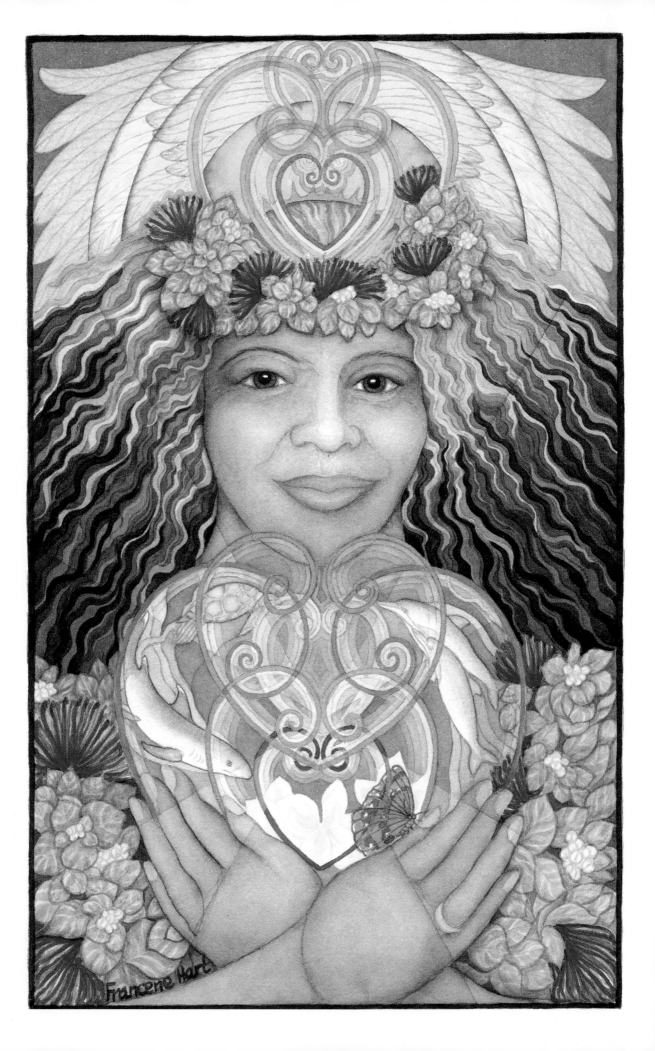

Francene Hart

to the realms of her ancestors. We know that she will be compassionately teaching and sharing aloha always. It is those magnificent hugs that we will miss most.

Heart of Aloha, painted in 2014, honors my beloved friend and amazing emissary of aloha. As I painted, I felt Aka poignantly present. I trust I have shared some of her extraordinary spirit. She touched the lives of thousands of people around the planet with her Mission Aloha, through which she shared Hawaiian traditions, including Ho'oponopono, the ancient Hawaiian practice of forgiveness and reconciliation.

Aka spoke that, "[Aloha] is about knowing who you are and knowing what you are here to do, what you are here to contribute to this world. . . . It is within us, inside of us. Our true challenge is bringing our spirit together with our mind to be able to give with our heart. Most people receive with their hearts. The hearts are the givers. This is how we give, how we share. It comes from the heart . . . and it is our innate sense to love unconditionally." Aka's family are traditional guardians of Kealakekua Bay where dolphins love to play. Her family's *amakua* (spirit animal) is shark. Both are included in this painting as well as the butterfly, which I added because her husband called her his butterfly of transformation.

Ho'oponopono Sunset honors this potent ceremony declaring forgiveness for self and all beings. An ancient Hawaiian practice, *Ho'oponopono* essentially means to bring clarity and right action to relationships and to set things right. Rainbow geometry of the ancient tantric Sri Yantra enhances the beauty and meditative intention of the painting and offers this simple prayer:

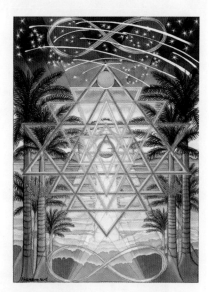

"I forgive myself and all beings for every misthought, word, or action that occurred in this day. I acknowledge the universe is unlimited potential and all is transpiring in perfect divine order at this time."

Ho'oponopono Sunset, 2001

Heart of Aloha, 2014

Aka shared that Aloha is about knowing who you are and knowing what you are here to do, what you are here to contribute to this world. It is our innate sense to love unconditionally.

Pele's Summons

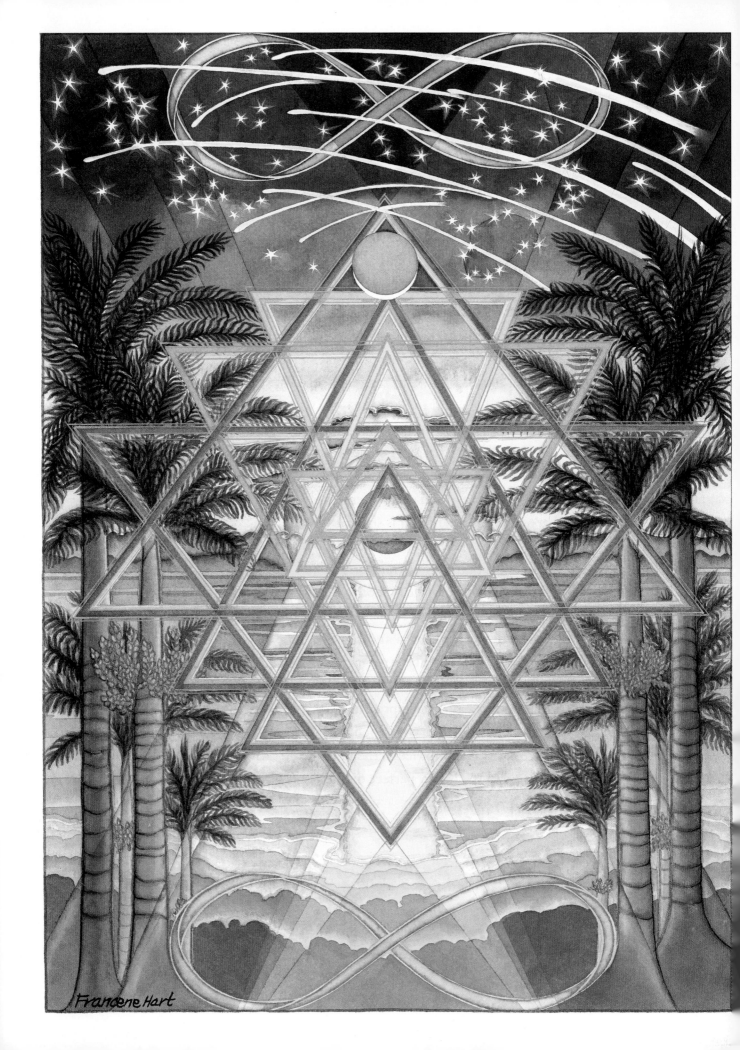

Kilauea volcano on the Big Island of Hawaii has been continuously erupting since 1983. She is a living presence and constantly in process of transformation. Flowing into the ocean, breaking into fountains in the backcountry, or taking homes and roads, this dynamic force of nature is a source of continual awe and wonder. When I first arrived in Hawaii, Kilauea's summit, Halema'uma'u crater, was quiet with only a few wisps of steam rising from the caldera floor. In 2008 she opened a portal forming a small lava lake. In 2015 this lava lake increased greatly in size, at one point putting on a grand show of dancing, sloshing lava overflowing the lake's brim into the larger surrounding caldera. She grew quiet again, but it is always temporary. Residing on this continually transforming island helps those who live here appreciate the potential for change that is constantly at work, both energetically and physically.

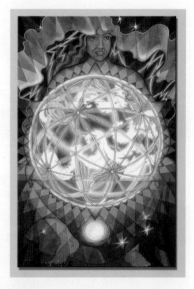

GAIA, OR EARTH GRID

Living on a Major Node of the Earth Grid

Hawaii sits on a node of the planetary grid system. The concept of the Earth as a geometric shape goes back in history at least to the Pythagorean school of thinking in ancient Greece. The geometry of the Earth grid is a dodeca-icosahedron. Energy vortexes and sacred sites abound where these geometries intersect. The Big Island rests at about 19.5 degrees north latitude, a potent position on this grid. Junctures on the Earth grid are energetically and physically activated. Hawaii's seismic activity accentuates the intensity and potential for change that abounds where nodes occur. For this reason it provides a dynamic location for engaging in healing and transformation.

Legend tells of a healing triangle that exists in the part of Hawaii where I live. When researching the concept I encountered various renditions of the story, yet wanted to remain true to the spirit of the healing energy. What I came to know is that it is

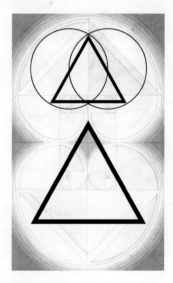

TRIANGLE

HO'OPONOPONO SUNSET, 2001

Rainbow geometry of the ancient Tantric Sri Yantra enhances the beauty and meditative intention of the painting.

Pele's Summons

183

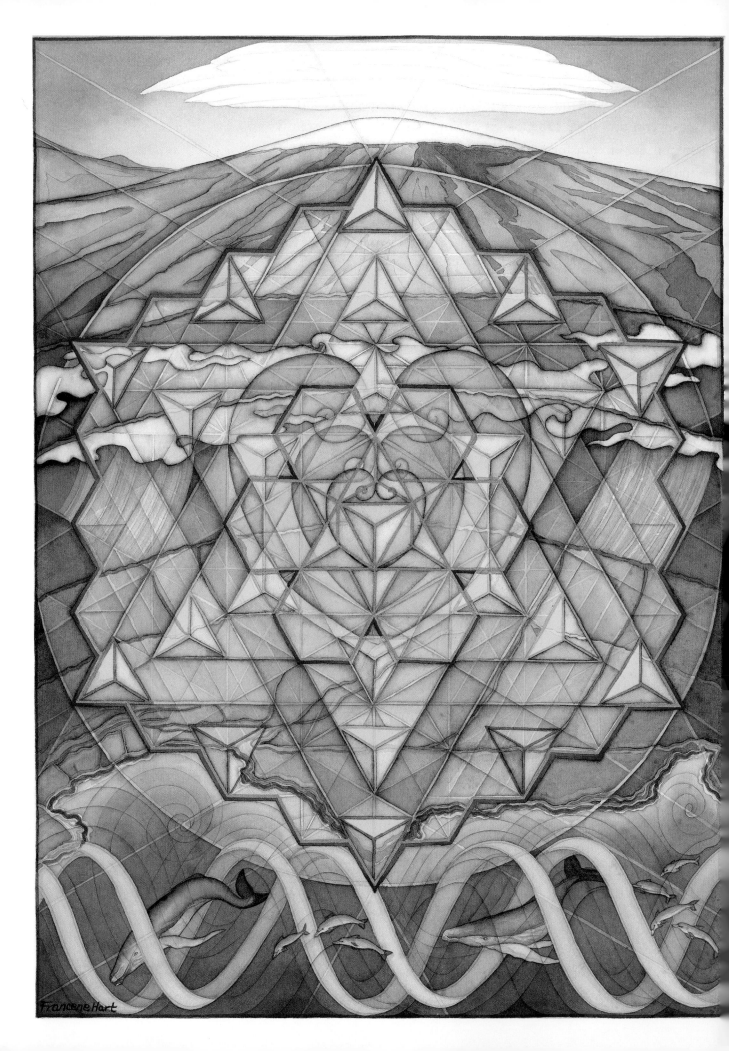

Francene Hart

not a flat physical locality, rather the healing triangle of Hawaii is multidimensional and holographic. More than physical, it represents a natural synergy between location and transformation.

Healing the Heart was inspired by the Big Island of Hawaii, where deep levels of healing have occurred for me. This painting is intended to enhance healing the heart on personal, planetary, and multidimensional levels. Mauna Loa topped with snow and a lenticular cloud formation sits at the apex of the healing triangle. The base and visible coastline progresses from Kealakekua Bay to the City of Refuge at Honaunau. Dolphins and whales frolic in the DNA-like sine wave that moves through the foreground. The beautiful geometric configuration depicted in this painting, when considered in three dimensions, is made up of sixty-four tetrahedrons and, according to friend and visionary physicist Nassim Haramein, is "the hyperdimensional fractal geometry of space-time. The matrix is a 3D Koch curve of vector equilibriums. It is the crystal at the core of the Earth."

Mermaids and Turtles

I have always known that I am a water person; however I was frightened by an experience in early childhood and developed an irrational fear of water. When I arrived in Hawaii, I considered myself a non-swimmer. In the Midwest I would splash around in lakes that stayed cold for most of the summer, but was never comfortable there. Yet in meditation or shamanic journeying, I always seemed to enter through water. In my heart I knew I could swim, but simply had been unable to access that ability. When I entered Hawaii's tropical waters with snorkel gear, a significant shift occurred. I could see and breathe, and the salt water embraced and held me up. Perhaps I had simply been trying to swim in the wrong waters. It was an initiation. I experienced a personal

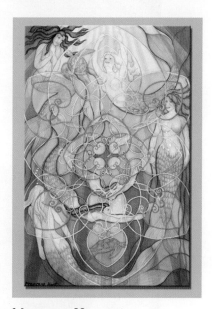

MERMAID HEARTS

HEALING THE HEART, 2003
The beautiful geometric configuration depicted in this painting is the hyperdimensional fractal in the geometry of space-time.

Pele's Summons

185

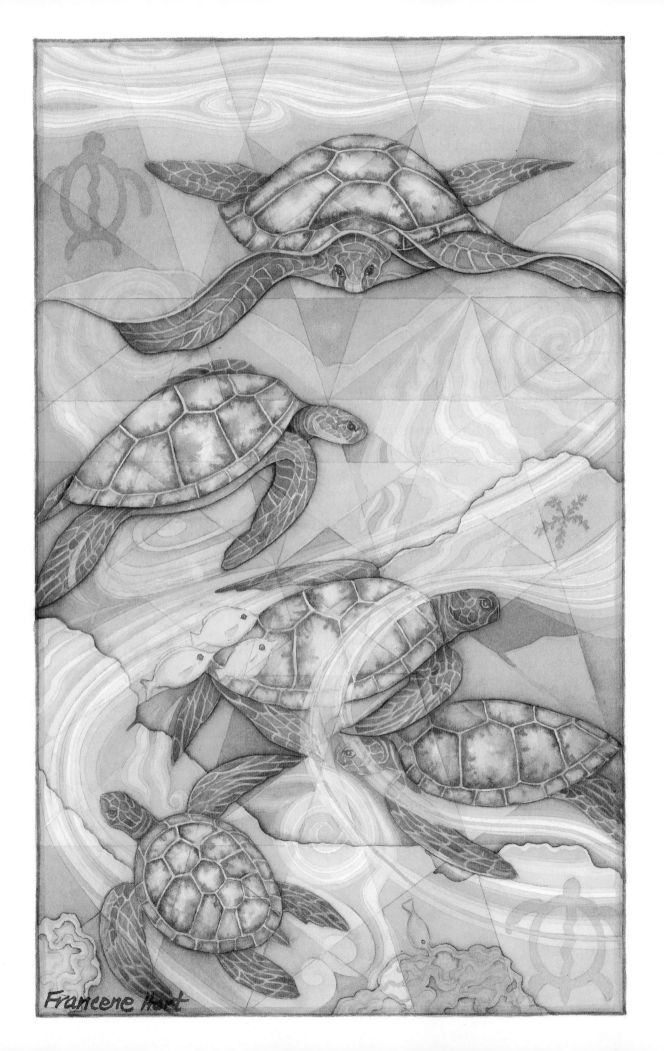

Francene Hart

conversion to the wonders of this phenomenal salt medium and became a born-again mermaid.

A frequent ocean encounter for many people in Hawaii is an eye-to-eye meeting with green sea turtles. Due to their gentle nature and relaxed attitude when swimming next to snorkelers, they become everyone's favorite. Every single time I encounter one of these gentle spirits, it feels like a blessing of tranquillity and peacefulness.

Gentle Spirits honors the joyous experience of being in the ocean with green sea turtles. Watching them glide by like water angels and looking into their peaceful, conscious eyes offers a wonderful lesson in slowing down and simply being. Pentagonal star geometry celebrates these five gentle spirits.

Many devoted swimmers refer to themselves as mermaids. When depicting swimming in the ocean, I prefer the mermaid-man analogy as it has a more lyrical feel than a human snorkeler. I love the freedom snorkel gear offers, yet occasionally wish for gills and a tail.

Mermaid Dreamtime depicts a sleeping mermaid who is surrounded by green sea turtles, yellow tang, speckled scrawled filefish, and striped Moorish idols. She dreams the dream of clean, balanced oceans and the love and protection of friendship. Spirals fill the scene with flow.

Swimming with Dolphins

In 1990, several years before I moved to Hawaii, I created a painting called *Swimming with Dolphins* to honor a dear friend who passed during a diving mishap in Jamaica. At that time I never dreamed one day I would experience this privilege. This beautiful

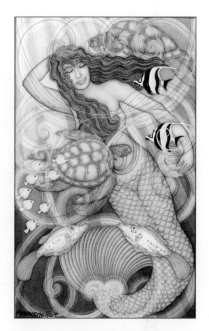

Mermaid Dreamtime, 2008

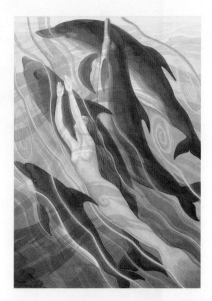

Swimming with Dolphins, 1990

Gentle Spirits, 2002

Watching green sea turtles glide by like water angels and looking into their peaceful, conscious eyes offers a wonderful lesson of slowing down and simply being. Pentagonal star geometry celebrates these five gentle spirits.

Pele's Summons

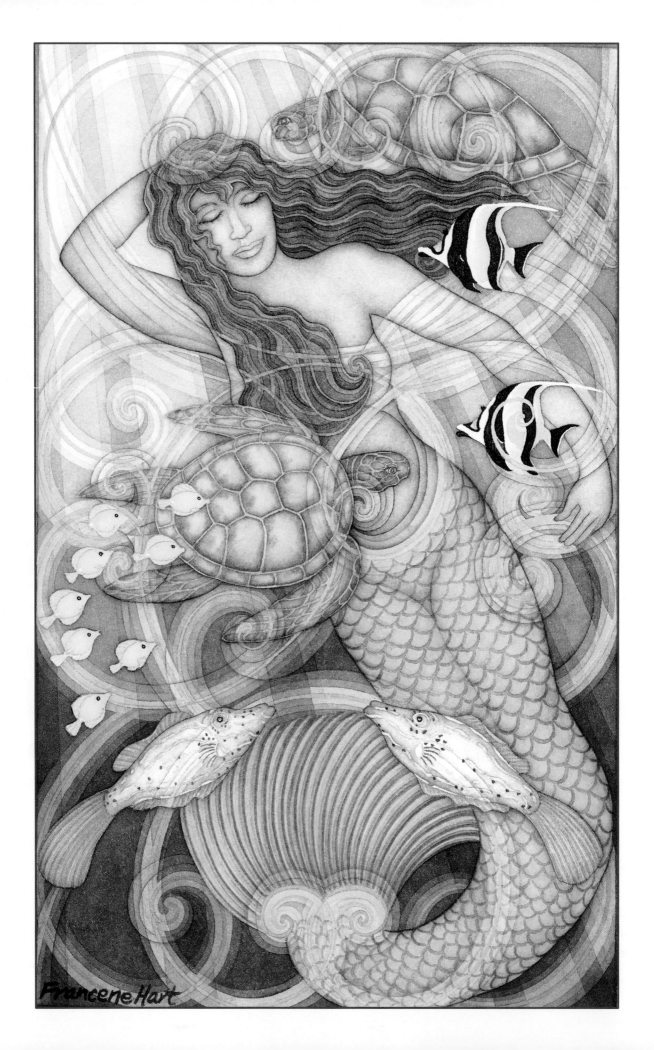

Francene Hart

mermaid surrounded by a pod of bottlenose dolphins imparts a sense of joy and freedom within loving friendship and interspecies communication.

Two of my mermaid girlfriends patiently introduced me to the fascination of swimming with dolphins. Initially I thought such large mammals might frighten me. However my first close encounter with Hawaiian spinner dolphins was one of instant joy and familiarity.

As I became more accustomed to their enthusiastic, often boisterous exchanges, I began to notice that dolphin interactions often create geometric patterns. These complex communications wholly reveal dolphins' extraordinary intelligence. They swim close together in graceful pods, playing, singing, and generating beautiful geometries as they interact. It was a delight when friends excitedly told me they had seen our dolphin friends forming a merkaba. As noted earlier, the merkaba combines two tetrahedrons facing opposite directions, uniting active yang energy and receptive yin energy. In sacred geometry the merkaba is known to be an instrument of expanded awareness, a time-space vehicle for multidimensional travel and a path toward ascension. It was wonderful to design this aspect of their behavior into the painting *Dolphin Merkaba*.

Quite often swimmers have experiences of alternative realities or even finding themselves in other dimensions while swimming with dolphins. Individuals tell stories of misplacing time or even sense of place when surrounded by dolphins.

Interdimensional Escorts was guided by an exceptional occasion when the dolphins offered just such an interdimensional experience. A few of my more talented friends are able to dive deep, roll over, and blow a unique type of bubble, which then drifts slowly to the surface looking like a mercurial tube torus. Sometimes we are able to dive through them as they float slowly

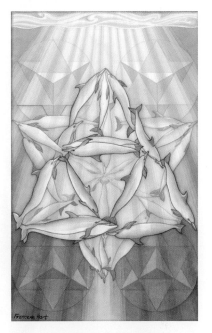

Dolphin Merkaba, 2002

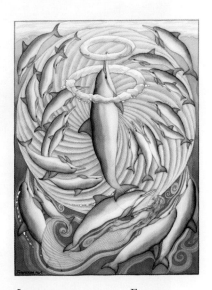

Interdimensional Escorts,
2009

Mermaid Dreamtime, 2008

A sleeping mermaid is surrounded by sea life
as she dreams of clean, balanced oceans.

Pele's Summons

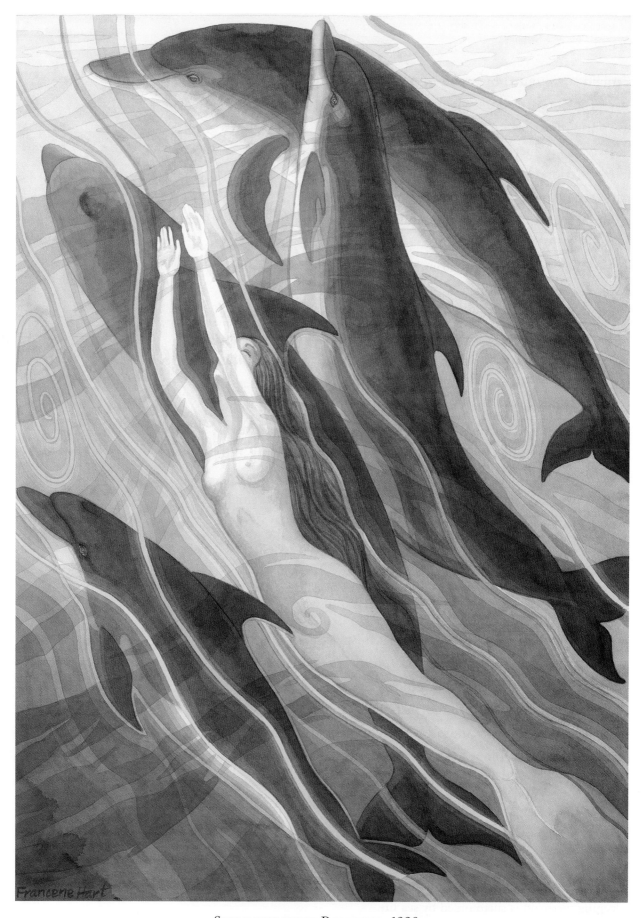

SWIMMING WITH DOLPHINS, 1990

This beautiful mermaid surrounded by a pod of bottlenose dolphins imparts a sense
of joy and freedom within loving friendship and interspecies communication.

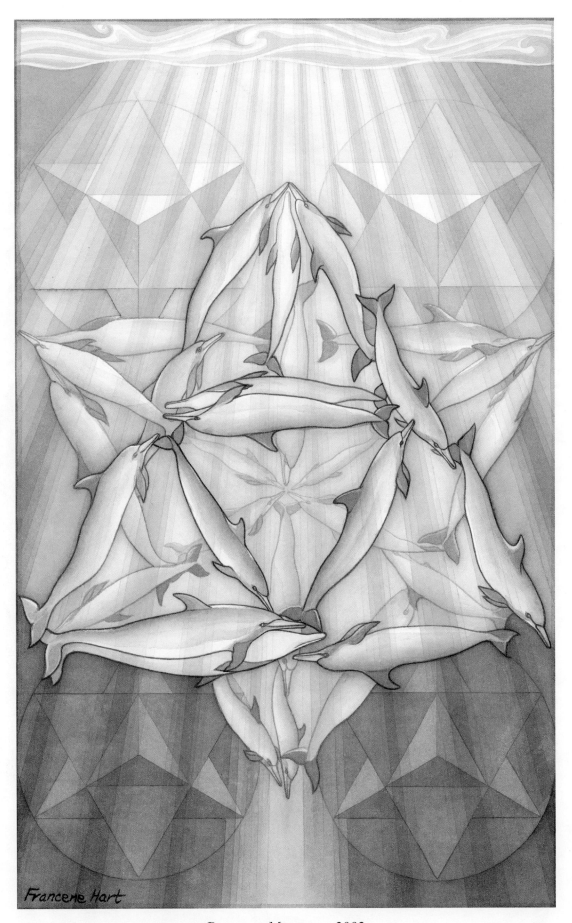

DOLPHIN MERKABA, 2002

Our dolphin friends formed a merkaba. In sacred geometry the merkaba is known to be an
instrument of expanded awareness, a time-space vehicle for multidimensional travel.

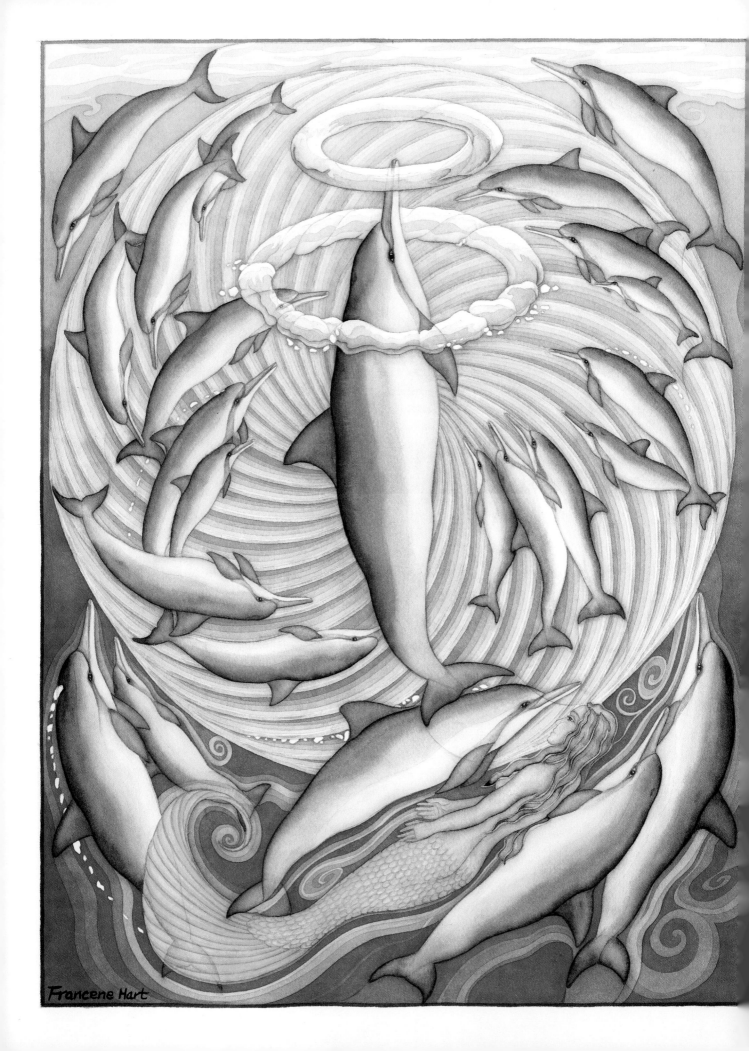

Francene Hart

upward, which is great fun. I had not seen dolphins do this until one day when the water was bursting with one of the most ecstatic dolphin performances I had seen from our wild friends. Spinning, swirling, leaping, making love, and just having fun, they prompted an interdimensional encounter. As I looked down from above at this rapturous romp, a very large dolphin popped out a torus bubble, then came up through it. Wow!

I have had the great privilege of swimming with these incredible light beings many times during my years in Hawaii. It has been a love affair that has inspired a number of paintings. At this point I have stepped back to a certain extent from this activity, because I see there is growing pressure on the dolphin population due to the increasing number of people who desire to have this extraordinary experience. I won't say not to try to swim with dolphins. However I do stress there are ways to have an experience without disrupting their social behavior or sleep patterns. Hawaiian spinner dolphins feed in cold water at great depths at night and come into sheltered warmer bays during the day to play and sleep. It is important that they have this rest period.

In any wildlife encounter, the key is respect. If you decide to seek a dolphin swim anywhere on the planet, check with locals and find out what is considered respectful dolphin etiquette. I always love to see these incredible wild creatures frolicking in their natural environment. It is my intention to be a considerate observer and disturb them as little as possible.

Deep respect for dolphins and the ocean initiated this romantic depiction titled *All-Embracing Love*. The intimate embrace of this mercouple, encircled by dolphins and sea turtles and twined with spiraling bubble columns, embodies an expanded vision of sacred relationship. Allowing ourselves to be rocked by tide and current and passionately stroked by wave upon wave can offer the experience of a deep, energetic, sensual relationship with self and

DOLPHINS, EMISSARIES OF LOVE

ALL-EMBRACING LOVE, 2004

INTERDIMENSIONAL ESCORTS, 2009
Spinning, swirling, leaping, making love, and just having fun, dolphins prompt an interdimensional encounter.

Pele's Summons

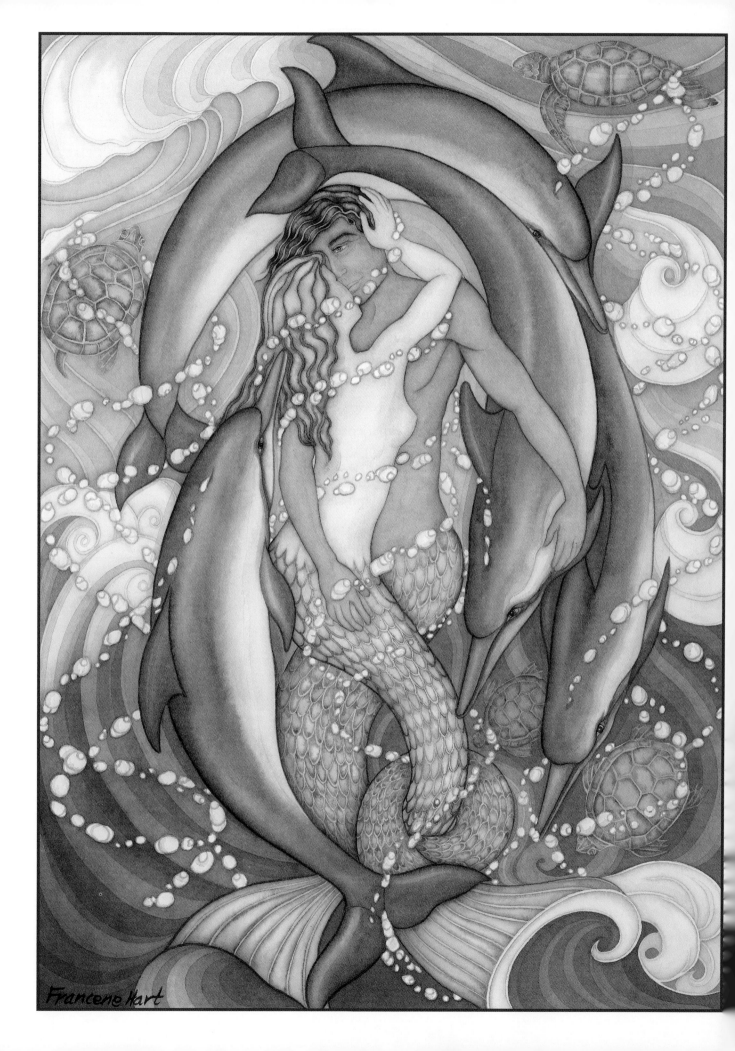

Francene Hart

all beings. The ocean is a wondrous place to learn to be present, heart and soul.

Whales, Sharks, and So Much More . . .

An astounding number of aquatic creatures inhabit the waters surrounding Hawaii. Large numbers and varieties of fish, octopus, ray, eel; several kinds of shark; and of course the beloved whales find home within this archipelago.

Reef Neighbors speaks to the wondrous variety of inhabitants on the reef. One of the delights of a regular swim ritual is that you never know who may appear next. One day while I was floating just above three green sea turtles, a gorgeous white-tipped reef shark glided into the scene. Looking again, I noticed a spotted eagle ray had joined the gathering. Some days it is lovely fish and rays of light. Some days it is pure magic.

I painted *Octomotion* to celebrate the always-delightful experience of seeing an octopus. This generally only happens if you are fortunate enough to see one moving to a new location. Octopuses are known for their ability to swim with fluidity and disguise themselves as they crawl across the reef. They can pull their arms into tightly coiled spirals or stretch them beyond what seems possible. The mantle can take on the spiky appearance of seaweed or the bumpy texture of coral in a remarkable show of nearly instantaneous transformation. The octopus is the eight-legged master of motion and flexibility. If you are blessed to see one, it will most likely be during the dance of octomotion. Eight-sided star geometry completes the theme of this painting.

And, of course, the much-loved humpback whales bless Hawaii and call it their winter home. Every year the northern

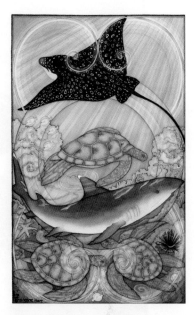

REEF NEIGHBORS, 2007

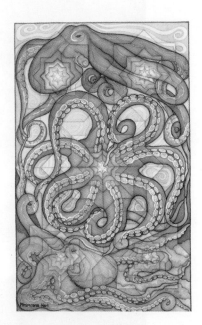

OCTOMOTION, 2007

ALL-EMBRACING LOVE, 2004

Allowing ourselves to be rocked by tide and current and passionately stroked by wave upon wave can offer the experience of a deep, energetic, sensual relationship with self and all beings.

Pele's Summons

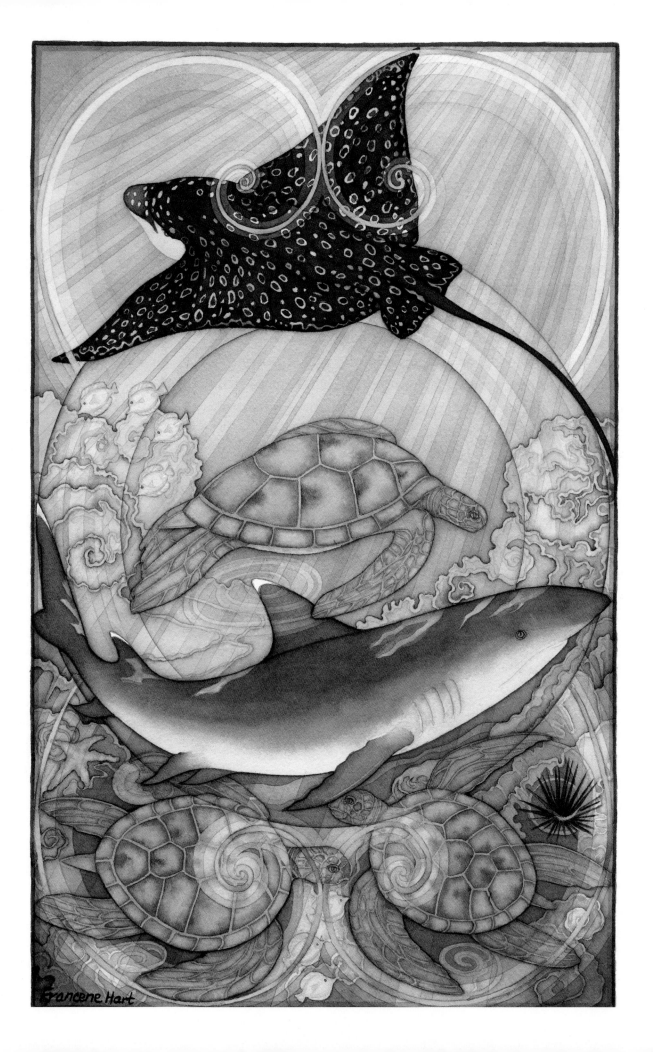

Francene Hart

humpbacks travel 3,500 miles south from their feeding grounds in Alaska to calve and mate. They do not eat for several months while they are visiting, but they breach, blow plumes of spray, spy hop (lifting their heads above water to have a look around), and wave their pectoral fins. They love to engage in what we humans see as exciting, exuberant displays. It is heartwarming when they return to Hawaii each year and a bit sad when they depart again for Alaska for their summer feeding season.

One morning while swimming in the beautiful blue ocean with some friends, we mermaids experienced a surprise meeting. We had followed a pod of dolphins into very deep water and had no idea whales had entered the bay. It is difficult to see whales beneath the surface because their coloration provides excellent camouflage in moving water. Slowly, almost as if in a movie fade in, a humpback mother and calf appeared directly before us. This encounter was among the most exciting, joy-filled moments I have ever experienced, and it inspired *Infinite Wisdom*. Infinity symbols and spirals highlight the appreciation that whales are wisdom keepers and their access to that wisdom is infinite.

Whale Song was inspired by a message posted by a friend that included the stunning patterned central image of this painting. Surrounding this center configuration, eight whales cavort in the waves. The central image is said to be fashioned after the cymatic signature of the humpback whale song.

Cymatics is a vibrational phenomenon that makes sound and vibration visible using their integral geometries. The humpback whale song continually changes, so this pattern might be considered to be a moment, perhaps a note, within the whale's melody. The original cymatic figure was dark in the middle, which somehow did not feel right. As I was meditating on this dark center, it was as if a whale eye came staring from the depths of creation.

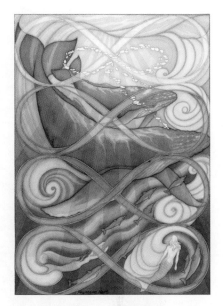

INFINITE WISDOM, 2005

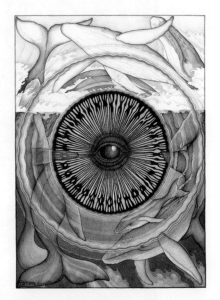

WHALE SONG, 2014

REEF NEIGHBORS, 2007

One of the delights of a regular swim ritual is that you never know who may appear next.

Pele's Summons

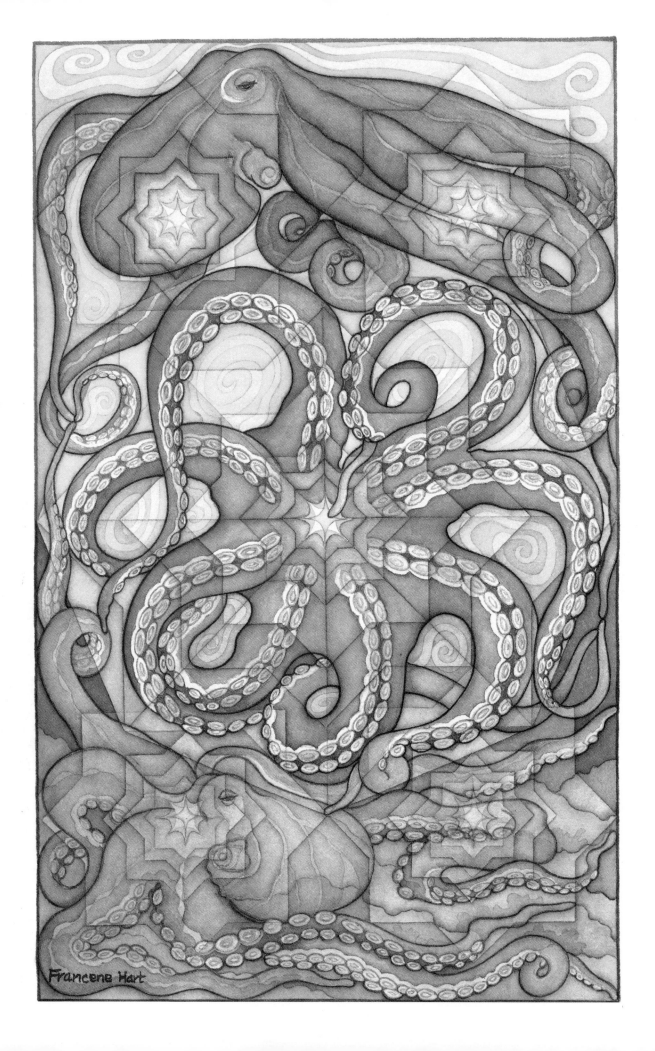

Francene Hart

This was the "aha" of a creative moment. It is said that if you look into the eye of one of these great beings, you will be forever changed.

Ocean as Meditation and Medicine

Swimming in the great ocean has become a meditation and prayer for me. It provides exercise and feels like medicine. Days without my morning swim can feel off, so I do my best to stay true to this daily ritual, except, of course, when I am traveling. The peace provided and messages received while moving this physical body through waters whose salinity echoes that of our own is a privilege I value immeasurably.

It is often disheartening to see the changes Earth's oceans and her inhabitants are experiencing. Visualizing these sacred waters as balanced, abundant, and whole is an everyday prayer offered from the heart in the hope that humans may yet learn to live with respect and reverence for all beings and environments. It is believed that whale song encircles our planet. That visualization helps me envision the oceans as the planetary energetic superconductor. Just as the whales send out their song, we may be able to consciously send our prayers out and around the entire globe.

Water Consciousness

Perhaps the most vital component for life, water is so abundant on Earth that many humans take it for granted. We drink, bathe, swim in, and enjoy the marvels of water. By cultivating an awareness that everything has consciousness, it becomes easy to embrace water as conscious and part of our sentient universe. Scientists have concluded that many properties of water are unique and cannot be explained entirely by the laws of physics.

OCTOMOTION, 2007
Octopuses are known for their ability to disguise
themselves. The mantle can take on the spiky appearance
of seaweed or the bumpy texture of coral in a remarkable
show of nearly instantaneous transformation.

Pele's Summons

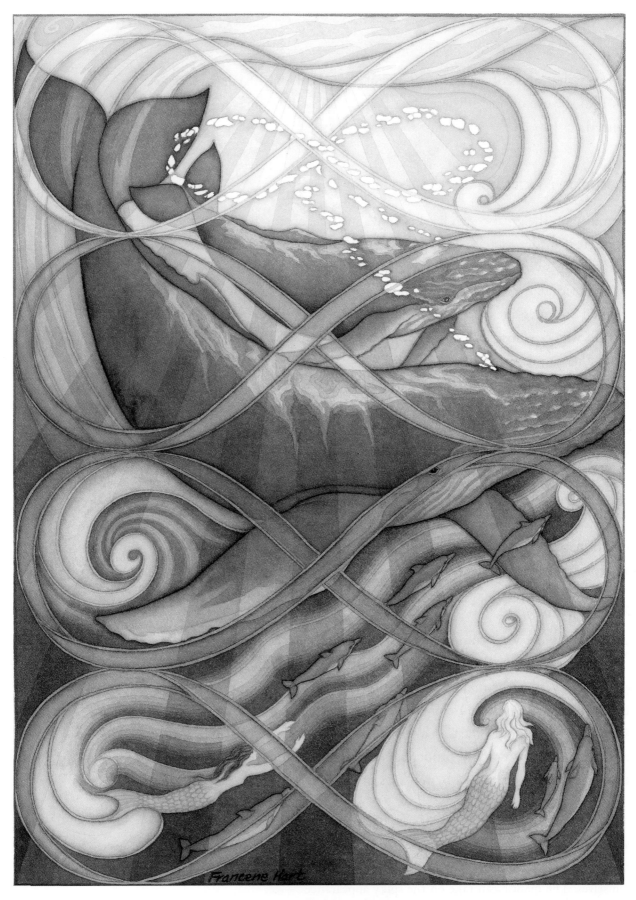

INFINITE WISDOM, 2005

We had followed a pod of dolphins into very deep water and had no idea any
of the well-camouflaged humpbacks had entered the bay. Slowly, almost as if
in a movie fade in, a humpback mother and calf appeared directly before us.

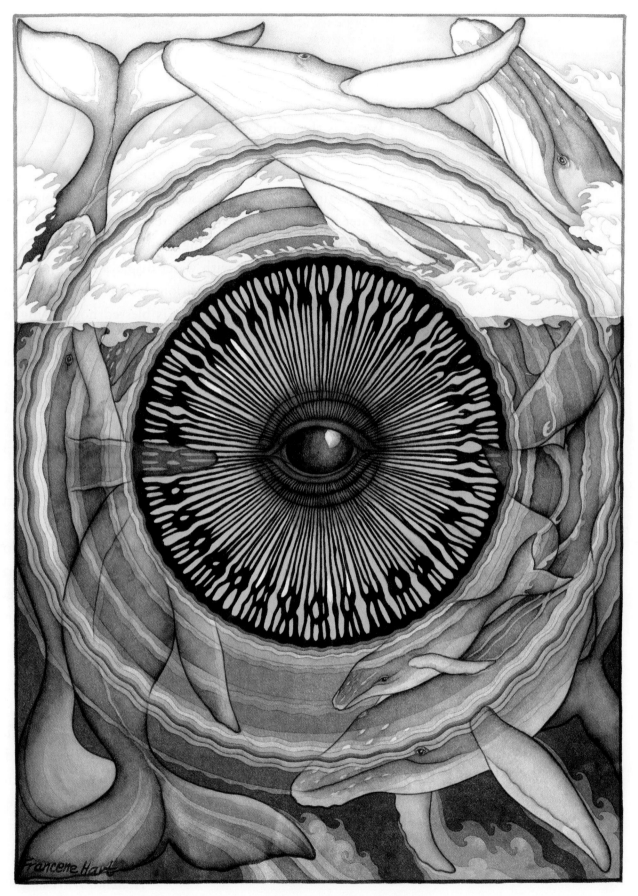

WHALE SONG, 2014

Cymatics makes sound and vibration visible. The humpback whale song
continually changes, so the pattern in this painting might be a moment,
perhaps a note, within the whale's melody.

For example:

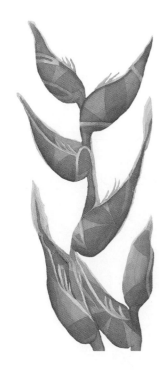

- Water is the only known element that can exist in three forms: liquid, solid, and gas.
- Unlike other elements, the density of water increases below the freezing point but decreases above the freezing point.
- Water has a kind of memory. It retains a record of things that happen in its surrounding environment, and anything that comes in contact with water displays a resonant pattern that reflects its composition. Water that is polluted records this insult. Water that is blessed holds a higher vibration.
- The structure of water is more important than its elemental composition.
- Not only does water have memory, but its structure is affected by emotions.
- Adding positive emotions to water, be it the glass you drink from, the river you sit beside, or the vastness of an ocean, can change its vibration and viability. Studies by Dr. Masaru Emoto demonstrated that the energy of our thoughts and emotions has a direct effect on the geometric structure of water molecules within ice crystal formations. In his experiments Dr. Emoto found that positive emotions generated beautiful, delicate ice crystals, whereas negative emotions produced ice crystals that were misshapen and unpleasant.

In 2003 I was called to create a waterfall painting, and I was inspired by a gorgeous waterfall located in a remote valley on the Big Island of Hawaii. It is said that this location was a powerful place of healing in ancient Hawaii. These *Healing Waters* cascade gracefully over seven individual pools that are accented by circles indicating chakra colors. The energy is green and soothing.

HEALING WATERS, 2003
The healing waterfall cascades gracefully over seven individual pools that are accented by circles indicating chakra colors.

Vibrant orange heliconias and hands reach upward on both sides of the cascading water. The flower of life matrix is delicately embedded in the background and informs the viewer in subtle, ever-changing ways.

The Water Consciousness Trilogy

My growing relationship with water and understanding of water consciousness inspired me to complete the only triptych, or series of three related paintings, I have ever created. It took nearly eight months researching and painting to complete the Water Consciousness Trilogy. Seeking to include many of the concepts regarding the distinctive qualities of water and water consciousness, I packed multiple visions into this series. The intention was to venerate this remarkable element.

Ice Meditation is the left-hand image of the Water Consciousness Trilogy. This painting honors the solid state of water. The delicate ice crystal in the center represents positive emotions in crystalline frozen form. Both the downward facing triangle and icosahedron (polyhedron with twenty faces) are symbols for water. The iceberg reveals its greater part below the water while auroras—electrically charged particles that collide with gasses, causing the aurora borealis—light up the starry sky. Below the ice crystal are flow beings. Moving through the trilogy, they are able to adapt to the mutability of water and of life.

The central image of the trilogy is *Motion of the Ocean*. About two-thirds of the Earth is covered with water, most of it ocean. Water vapor rises from the sea becoming clouds, returning to the ocean as rain, sharing its memory as it receives and transmits information through this natural cycle.

Big waves hold universal fascination. Surfing the waves here are the flow beings. The lower portion of the painting represents the global conveyor belt, which is a constantly moving system of deep-ocean circulation driven by temperature and salinity. Also called thermohaline circulation, it mixes nutrients throughout the oceans, helping to keep inhabitants vibrant and nourished.

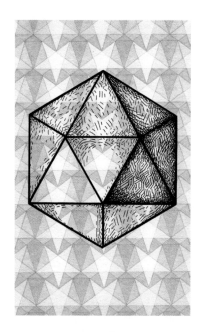

ICOSAHEDRON

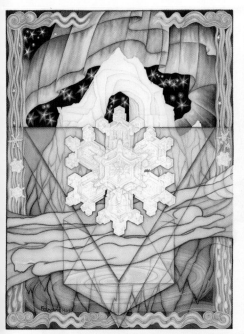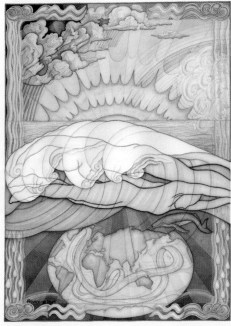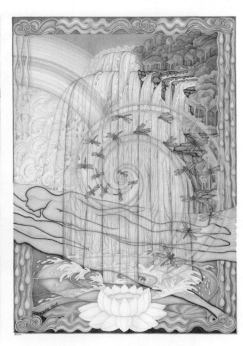

WATER CONSCIOUSNESS TRILOGY, 2012: *ICE MEDITATION* (LEFT),
MOTION OF THE OCEAN (MIDDLE), *FRESH SPLASH* (RIGHT)

Fresh Splash is the right-hand image of the trilogy. Fresh water is essential for the nourishment of all terrestrial beings. As water is filtered through the rain forest, its freshness cascades down a spectacular waterfall. Water vapor and rainbows rise from this turbulence as the water splashes into a spiral pool from which a golden spiral of dragonflies emerges. Twenty-one dragonflies honor the Fibonacci series, which is a template for the proportions of the golden spiral. The water lily embodies our potential for enlightenment. Flow and transformation abound, and flow beings continue to move through the trilogy.

Pele's Summons

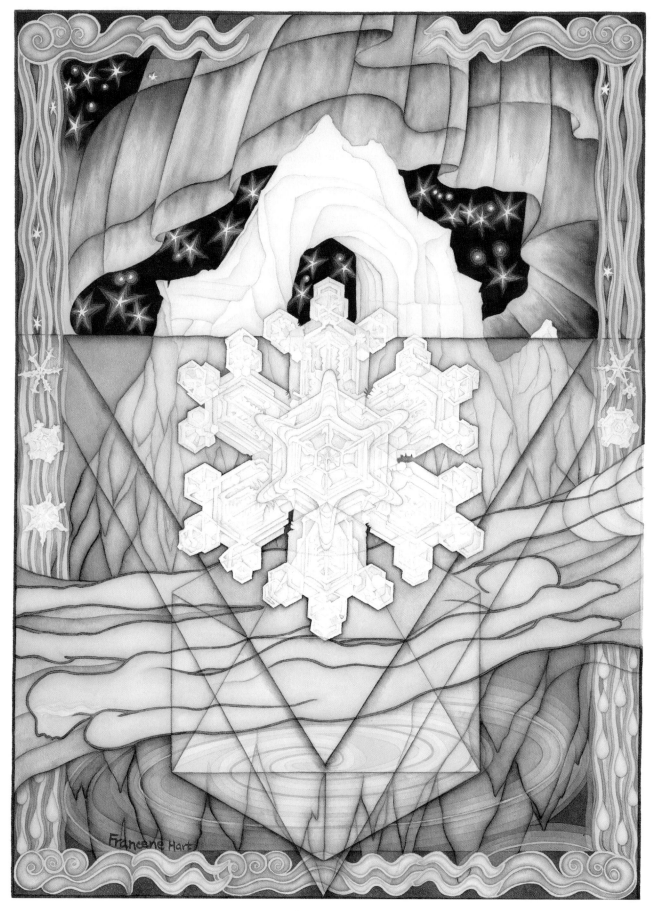

Ice Meditation, 2012

The delicate ice crystal in the center represents positive emotions in crystalline frozen form. Both the downward facing triangle and icosahedron are symbols for water.

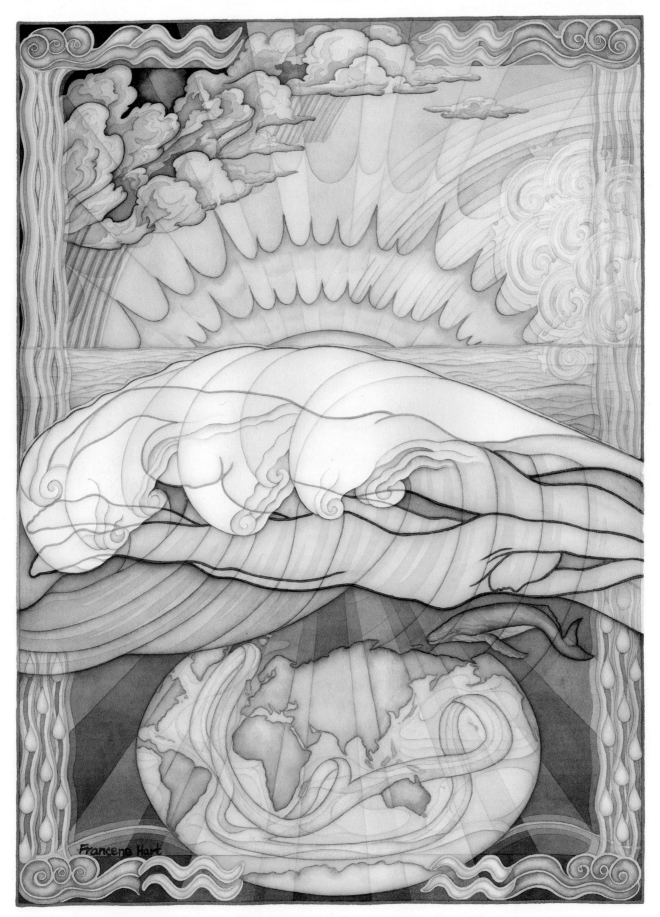

MOTION OF THE OCEAN, 2012

The global conveyor belt in the lower third of the painting is a constantly moving
system of deep-ocean circulation driven by temperature and salinity. It mixes
nutrients throughout the oceans, helping to keep inhabitants vibrant and nourished.

FRESH SPLASH, 2012

Water vapor and rainbows rise from the turbulence as the water splashes into a spiral pool, from which a golden spiral of dragonflies emerges. Twenty-one dragonflies honor the Fibonacci series that is a template for the proportions of the golden spiral.

FINAL OFFERING

This volume represents a small portion of the inspiration that has invigorated great numbers of paintings over the course of this lifetime. Wonder-filled life adventures have fueled immeasurable contributions to the art that has flowed and will continue to flow from my heart and soul. It is with profound humility that I share with you one final painting and the awareness it embodies.

In *Passion and Compassion* Pele, passionate goddess of Hawaii, joins Quan Yin, goddess of compassion, to create a union that offers new meaning to intense creative energies. This is the only image I have ever painted that is completely reversible. Pele touches the cheek of Quan Yin as Quan Yin returns this tenderness. They unite in a center of fiery heart-centered energy, sharing the pearl of wisdom within the lotus of contemplation and potential. Each has her own familiar, or spirit, often embodied in an animal who stands guard: Quan Yin her dragon and Pele the *koa'e kea,* a white-tailed tropical bird that lives in her volcanic caldera. Passion and compassion are powerful forces. When guided by love they will transform the world.

I wholeheartedly honor the visionary potential in each and every individual. My dedication to you is that you allow your personal creative passion to ignite inspiration and guidance and that you integrate these visions into all that is your life's work. May you also nurture a sense of resilient compassion for yourself and all beings.

Thank you from my whole heart.

PASSION AND COMPASSION, 2002

Passion and Compassion, 2002

Pele, passionate goddess of Hawaii, joins Quan Yin, goddess of
compassion, to create a union that offers new meaning to intense
creative energies. They unite in a center of fiery heart-centered energy.
This is the only image I have ever painted that is completely reversible.

Final Offering

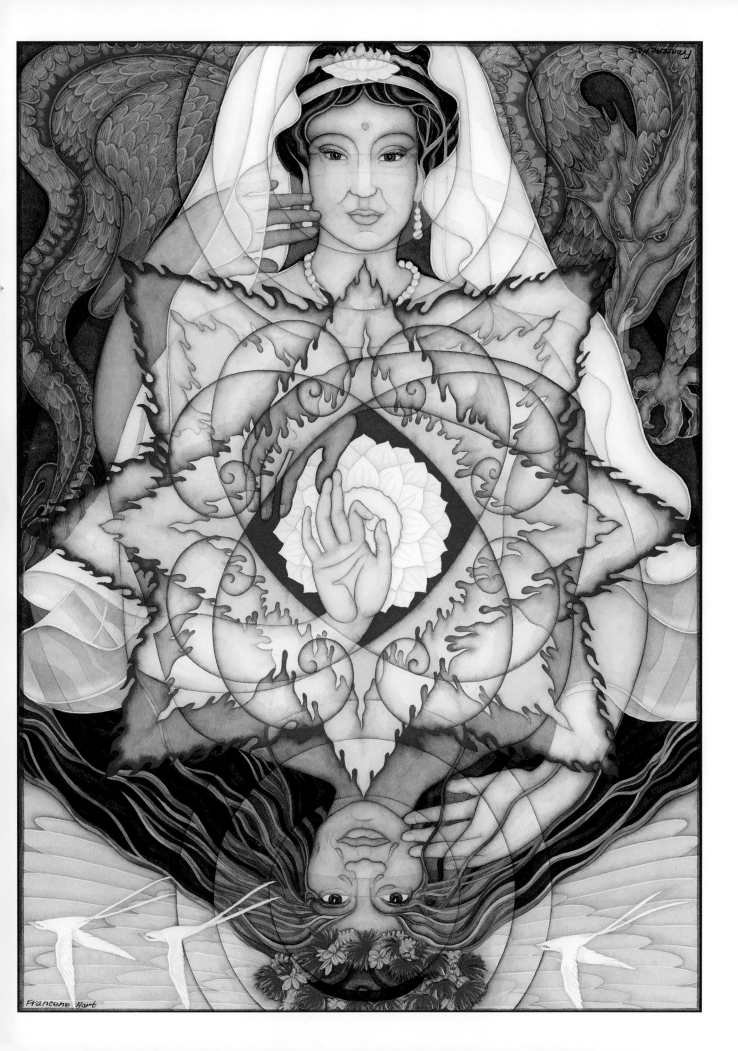

Francene Hart

Books of Related Interest

Sacred Geometry Coloring Book
by Francene Hart

Sacred Geometry Oracle Deck
by Francene Hart

Sacred Geometry Cards for the Visionary Path
by Francene Hart

Sacred Geometry of the Earth
The Ancient Matrix of Monuments and Mountains
by Mark Vidler and Catherine Young
Foreword by Rand Flem-Ath

Power Animal Meditations
Shamanic Journeys with Your Spirit Allies
by Nicki Scully
Illustrated by Angela Werneke

Animal Messengers
An A–Z Guide to Signs and Omens in the Natural World
by Regula Meyer

How the World Is Made
The Story of Creation according to Sacred Geometry
by John Michell
with Allan Brown

The Golden Number
Pythagorean Rites and Rhythms in the
Development of Western Civilization
by Matila C. Ghyka
Introduction by Paul Valéry

INNER TRADITIONS • BEAR & COMPANY
P.O. Box 388
Rochester, VT 05767
1-800-246-8648
www.InnerTraditions.com

Or contact your local bookseller